LIKE, MAN, I'M TIRED OF WAITING, 2001

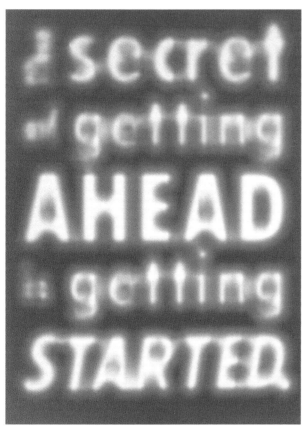

THE SECRET TO GETTING AHEAD IS GETTING STARTED, 1994
C-PRINT; 40 x 29 INCHES
COURTESY OF THE ARTIST AND BLUM & POE, SANTA MONICA

Senior Editor/Cheflektorin: Lisa Mark
Editor/Lektorin: Jane Hyun
Assistant Editor/Lektoratassistentin: Elizabeth Hamilton
Design/Graphische Gestaltung: Purtill Family Business
Translations/Übersetzungen: Hans-Jürgen Schacht, Ralf Schauff
Color separations/Reproduktionen: C + S Repro, Filderstadt
Printing/Gesamtherstellung: Dr. Cantz'sche Druckerei,
Ostfildern, Germany
Published by/Erscheinen im: Hatje Cantz Publishers,
Ostfildern-Ruit
www.hatjecantz.com

COVER: *CHAIR #1*, 1995, DETAIL

SAM DURANT

CONTRIBUTORS
MICHAEL DARLING, RITA KERSTING, KEVIN YOUNG

THE MUSEUM OF CONTEMPORARY ART, LOS ANGELES
KUNSTVEREIN FÜR DIE RHEINLANDE UND WESTFALEN, DÜSSELDORF

HATJE CANTZ PUBLISHERS

This publication accompanies the exhibitions *SAM DURANT*, organized by Michael Darling and presented at The Museum of Contemporary Art, Los Angeles, 13 October 2002– 9 February 2003; and *SAM DURANT*, organized by Rita Kersting and presented at the Kunstverein für die Rheinlande und Westfalen, Düsseldorf, 18 January–30 March 2003.

SAM DURANT is made possible in part by generous support from Audrey M. Irmas, the MOCA Contemporaries, Janet Karatz Dreisen, and David Hockney.

Die Ausstellung im Kunstverein für die Rheinlande und Westfalen, Düsseldorf, wurde großzügig unterstützt durch

Ständiger Partner des Kunstvereins

4

RHEINISCHE POST

BBDO
GROUP GERMANY

ISBN: 0-914357-81-6 (MOCA)
3-7757-9120-5 (Hatje Cantz Publishers)

Library of Congress Cataloging-in-Publication Data

Durant, Sam, 1961–
 Sam Durant / organized by Michael Darling and
 Rita Kersting.
 p. cm.
 In English and German.
 Published to accompany an exhibition held at the Museum
 of Contemporary Art, Los Angeles, Oct. 13, 2002–Feb. 9,
 2003 and at the Kunstverein für die Rheinlande und
 Westfalen, Düsseldorf, Jan. 18–Mar. 30, 2003.
 Includes bibliographical references.
 ISBN 0–914357–81–6 -- ISBN 3–7757–9120–5
 1. Durant, Sam, 1961---Exhibitions. I. Darling, Michael. II.
 Kersting, Rita. III. Museum of Contemporary Art (Los
 Angeles, Calif.) IV. Kunstverein für die Rhienlande und
 Westfalen. V. Title.

N6537.D87 A4 2002
709'.2--dc21
 2002026390

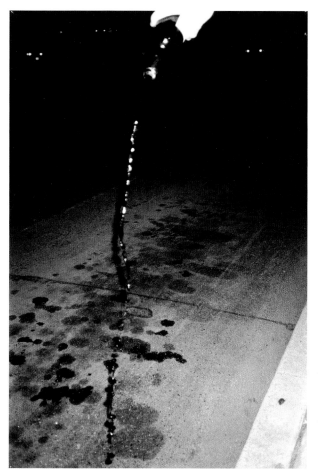

EMPTY #21, 1993
C-PRINT; 30 x 20 INCHES
THE MUSEUM OF CONTEMPORARY ART, LOS ANGELES
GIFT OF THE ARTIST

FOREWORD/VORWORT 7
Jeremy Strick

FOREWORD/VORWORT 8
Georg Kulenkampff

SAM DURANT'S RIDDLING ZONES 10
SAM DURANTS RÄTSELHAFTE ZONEN 32
Michael Darling

INTERVIEW WITH SAM DURANT 56
INTERVIEW MIT SAM DURANT 66
Rita Kersting

COVER SONG 82
COVERSONG 94
Kevin Young

ACKNOWLEDGMENTS/DANK 110
Michael Darling and Rita Kersting

SELECTED EXHIBITION CHRONOLOGY 112
AUSSTELLUNGEN (AUSWAHL)

CHECKLIST OF THE EXHIBITIONS 115
ARBEITEN IN DEN AUSSTELLUNGEN

SELECTED BIBLIOGRAPHY 120
BIBLIOGRAPHIE (AUSWAHL)

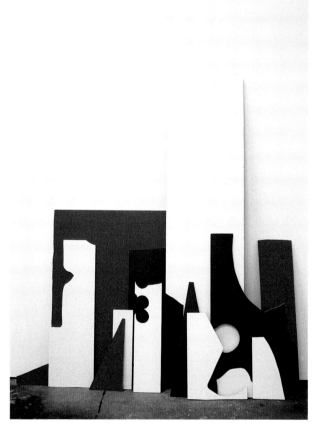

SCRAP RECYCLING PROJECT WITH AMERICAN INGENUITY, 1995, DETAIL
WOOD AND LAMINATE; DIMENSIONS VARIABLE
COURTESY OF THE ARTIST AND BLUM & POE, SANTA MONICA

FOREWORD

Sam Durant has often been described as an artist's artist. Indeed, his work commands tremendous respect among his Los Angeles peers. Though he has been making important work for well over a decade, he has remained relatively little-known outside of Los Angeles. Only recently has he begun to garner the kind of critical and curatorial attention he so richly deserves. Durant's exhibitions at The Museum of Contemporary Art, Los Angeles, and the Kunstverein für die Rheinlande und Westfalen, Düsseldorf, signal the momentum that is building around his work, and we are honored to be part of this exciting chapter in his career.

Durant's importance has been known to MOCA for quite some time, and I am proud to say that our permanent collection comprises many of his key works. He has also been featured in such MOCA exhibitions as "Power of Suggestion: Narrative and Notation in Contemporary Drawing"; "Just Past: The Contemporary in MOCA's Permanent Collection, 1975–96"; and "Elusive Paradise: Los Angeles Art from the Permanent Collection." Now Assistant Curator Michael Darling has brought MOCA's ongoing commitment to Durant's work to its next logical step—a monographic exhibition. Michael's acute attention to the issues and references surrounding the work, as well as his sensitive handling of the installation, make for a compelling and memorable show. Providing institutional support to Los Angeles-based artists before they achieve worldwide recognition is a role that MOCA takes pride in playing. Durant joins Amy Adler, Kevin Appel, Uta Barth, Jessica Bronson, Toba Khedoori, Liz Larner, Catherine Opie, and Jorge Pardo, whose works have been seen in galvanizing solo exhibitions here over the years.

Of course, none of this would be possible without the unwavering engagement of our Board of Trustees. Chair Robert Tuttle and President Gilbert B. Friesen have offered this project their consistent support. The exhibition was initiated during the tenure of former Chair Audrey M. Irmas, who consistently has demonstrated a strong commitment to younger artists and offered substantial financial support for this exhibition. I am also grateful to the MOCA Contemporaries, Janet Karatz Dreisen, and David Hockney for their exceptional contributions.

We are delighted to be collaborating with the Kunstverein für die Rheinlande und Westfalen on this publication, and I'd like to thank Director Rita Kersting for her insightful interview with Sam. Finally, I would like to thank Sam Durant for the intelligence and assiduousness he brought to the realization of this exhibition.

VORWORT

Sam Durant ist oft als »Künstler-Künstler« bezeichnet worden. Ohne jeden Zweifel verdient sein Werk den enormen Respekt, der ihm von seinen Kollegen entgegen gebracht wird. Obwohl er seit mehr als einem Jahrzehnt bedeutende Arbeiten geschaffen hat, ist er außerhalb von Los Angeles relativ unbekannt geblieben. Erst seit kurzem erfährt er die kritische und kuratorische Aufmerksamkeit, die er so reichlich verdient. Durants Ausstellungen im Museum of Contemporary Art in Los Angeles und im Kunstverein für die Rheinlande und Westfalen in Düsseldorf sind Zeichen für den Aufschwung, der sich um seine Arbeit bildet, und wir fühlen uns geehrt, an diesem aufregenden Kapitel seiner Karriere teilzuhaben.

Durants Bedeutung ist dem MOCA nicht entgangen, und ich bin stolz, sagen zu können, dass viele seiner Schlüsselwerke in unserer ständigen Sammlung zu finden sind. Seine Arbeiten sind ebenfalls in MOCA-Ausstellungen wie »Power of Suggestion: Narrative and Notation in Contemporary Drawing«; »Just Past: The Contemporary in MOCA's Permanent Collection, 1975–96« und »Elusive Paradise: Los Angeles Art from the Permanent Collection« gezeigt worden. Nun hat Assistant Curator Michael Darling den nächsten logischen Schritt in MOCAs Engagement gegenüber dem Werk Durants unternommen – eine monografische Ausstellung. Michaels scharfsinnige Aufmerksamkeit gegenüber den Themen und Referenzen, die die Arbeit umgeben, sowie seine einfühlende Handhabung beim Aufbau haben eine bewunderns- und erinnernswerte Ausstellung zustande gebracht. Künstlern aus Los Angeles institutionelle Unterstützung zu gewähren, bevor sie internationale Anerkennung erfahren, ist eine Rolle, die das MOCA mit Stolz übernommen hat. Durant gesellt sich zu Künstlern wie Amy Adler, Kevin Appel, Uta Barth, Jessica Bronson, Toba Khedoori, Liz Larner, Catherine Opie und Jorge Pardo, deren Werke hier über die Jahre hin in höchst stimulierenden Ausstellungen zu sehen waren.

Natürlich wäre dies nicht ohne das unerschütterliche Engagement unseres Board of Trustees möglich gewesen. Der Vorsitzende Robert Tuttle und Präsidentin Gilbert B. Friesen haben diesem Projekt ihre unbeirrbare Unterstützung zukommen lassen. Initiiert wurde die Ausstellung während der Amtszeit der früheren Vorsitzenden Audrey M. Irmas, die sich konsequent für jüngere Künstler stark engagiert und dieser Ausstellung wesentliche finanzielle Unterstützung gewährt hat. Auch den MOCA Contemporaries, Janet Karatz Dreisen und David Hockney bin ich für ihren außergewöhnlichen Beitrag aufrichtig dankbar.

Wir sind hocherfreut, an dieser Veröffentlichung mit dem Kunstverein für die Rheinlande und Westfalen zusammenzuarbeiten, und ich möchte der Direktorin Rita Kersting sowohl für ihr aufschlussreiches Interview mit Sam Durant als auch für ihren redaktionellen Einfluss bezüglich der deutschen Übersetzung danken. Vor allem möchte ich Sam Durant für die Einsicht und Beharrlichkeit danken, mit der er die Realisierung dieser Ausstellung möglich gemacht hat.

Übersetzung: Hans-Jürgen Schacht

JEREMY STRICK
DIRECTOR, THE MUSEUM OF CONTEMPORARY ART, LOS ANGELES

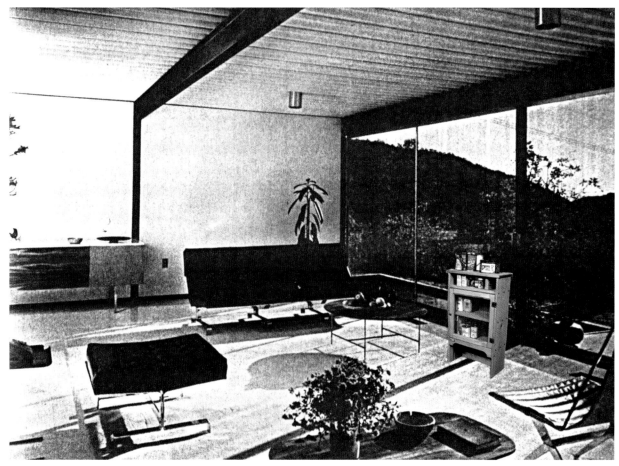

CABINETS, 1995, DETAIL

FOREWORD

Sam Durant's works address utopias and their failures. They cross past events to create relationships between art-historical, pop-cultural, and political phenomena that have come to define popular, particularly American, culture during the last thirty-five years. Durant's conceptually conceived, multimedia installations refer to specific guiding figures and ideas; artist Robert Smithson and his work on entropic processes, rock stars Mick Jagger and Neil Young, as well as Black Panther co-founder Huey Newton, are in different ways integrated into his work. The enormous enthusiasm with which Durant's work has been received in Germany thus far is surprising on first sight, given his preoccupation with specifically American issues. However, when considered in relation to Andy Warhol, Robert Rauschenberg, Jasper Johns, Dennis Hopper, or Mike Kelley, Durant extends Germany's fascination with American art.

The Kunstverein für die Rheinlande und Westfalen, Düsseldorf, is delighted to have the opportunity to organize the first institutional exhibition in Europe of this remarkable artist, and it is an honor to present this project in cooperation with The Museum of Contemporary Art, Los Angeles, which has supported Durant's work for some time. I would like to thank the artist for the extraordinary amount of time and energy he devoted to the exhibition. At the Kunstverein, in addition to important work from 1998 through 2002, Durant will show a special project inspired by Düsseldorf's rich art history and his travels and research focusing on one of the central figures in twentieth-century art, Joseph Beuys.

I would like to thank Rita Kersting, director of the Kunstverein für die Rheinlande und Westfalen, who has been following the work of Sam Durant and has organized the exhibition with great commitment. I am also very grateful to the Stiftung Kunst und Kultur des Landes Nordrhein-Westfalen for supporting this important project in Germany. In addition I would like to extend our warm thanks to MOCA and Director Jeremy Strick. Particular thanks go to MOCA Assistant Curator Michael Darling, whose insights and enthusiastic cooperation made this catalogue possible.

I wish the reader exciting hours perusing this publication, which provides a fundamental survey on Durant's work and contains a detailed and knowledgeable essay by Michael Darling, an enlightening interview between Rita Kersting and Sam Durant, as well as a poetic text by Kevin Young.

VORWORT

Die virtuosen Arbeiten von Sam Durant reflektieren Utopien und deren Scheitern; sie verschränken Ereignisse der jüngeren Geschichte und schaffen Zusammenhänge zwischen kunsthistorischen, popkulturellen und politischen Phänomenen, die in den vergangenen 35 Jahren die Entwicklung der vor allem amerikanischen Kultur prägten. Durants konzeptuell angelegte, multimediale Installationen rekurrieren auf spezielle Leitfiguren und -ideen, und so finden der Künstler Robert Smithson und seine Arbeit über entopische Prozesse, die Rock Stars Mick Jagger und Neil Young, sowie der Mitbegründer der Black Panther-Bewegung Huey Newton auf unterschiedliche Art Eingang in die Arbeit des Künstlers. Die enorme Faszination, mit der Sam Durants Arbeit in Deutschland bisher aufgenommen wurde, ist angesichts seiner Auseinandersetzung mit spezifisch amerikanischen Themen auf den ersten Blick erstaunlich, steht jedoch, wenn man an das Werk von Andy Warhol, Robert Rauschenberg, Jasper Johns, Dennis Hopper, oder Mike Kelley denkt, in einer langen Tradition.

Der Kunstverein für die Rheinlande und Westfalen, Düsseldorf, freut sich über die grandiose Gelegenheit, die erste große institutionelle Ausstellung dieses bedeutenden Künstlers in Europa zu organisieren, und es ehrt uns, das Projekt in Zusammenarbeit mit dem Museum of Contemporary Art in Los Angeles vorzustellen, das ebenfalls dem Werk des Künstlers seit langer Zeit verbunden ist. Ich möchte Sam Durant sehr herzlich für seinen außerordentlichen Einsatz für diese Ausstellung danken. Der Künstler zeigt im Kunstverein neben wichtigen Arbeiten aus den Jahren 1998–2002 ein spezielles, durch die reiche Düsseldorfer Kunstgeschichte und durch Reisen und Recherchen inspiriertes Projekt, das eine der zentralen Figuren in der Kunst des 20. Jahrhunderts fokussiert, Joseph Beuys.

Mein Dank geht an Rita Kersting, der Direktorin des Kunstvereins, die die Arbeit von Sam Durant seit langer Zeit verfolgt und die Ausstellung mit großem Engagement vorbereitet hat. Für die Unterstützung dieses wichtigen Projekts sind wir der Stiftung Kunst und Kultur des Landes Nordrhein-Westfalen sehr dankbar. Weiterhin möchte ich dem MOCA, vertreten durch den Direktor Jeremy Strick, und insbesondere dem Assistant Curator Michael Darling danken, ohne dessen inhaltlich orientierten, unbürokratischen Einsatz die fruchtbare Zusammenarbeit beim Katalog nicht möglich gewesen wäre.

Ich wünsche den Leserinnen und Lesern aufregende Stunden bei der Lektüre des Kataloges, der einen grundlegenden Überblick über das bisherige, reiche Werk Sam Durants gibt und neben einem ausführlichen, kenntnisreichen Aufsatz von Michael Darling, ein ergiebiges Interview zwischen Rita Kersting und Sam Durant sowie einen poetischen Text von Kevin Young enthält.

GEORG KULENKAMPFF
VORSITZENDER DES KUNSTVEREIN FÜR DIE RHEINLANDE UND WESTFALEN, DÜSSELDORF

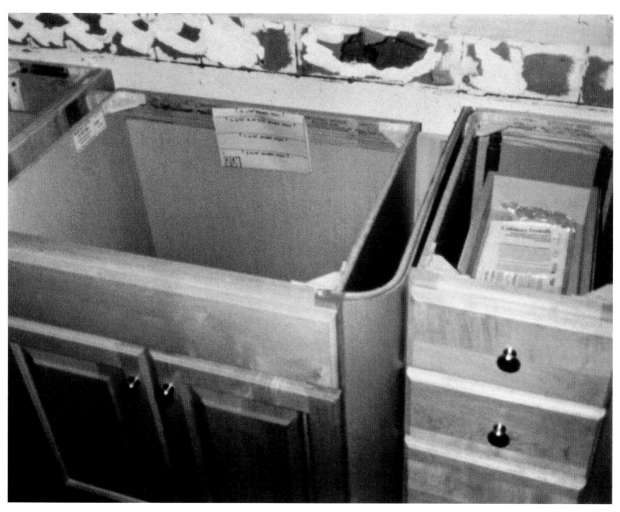

THE WAY THE WORLD MIGHT BECOME, 1995
C-PRINT; 16 x 20 INCHES
COURTESY OF THE ARTIST AND BLUM & POE, SANTA MONICA

SAM DURANT'S RIDDLING ZONES

MICHAEL DARLING

In the late 1960s, many cultural workers collectively initiated a shift from the accumulated characteristics and dicta of modernism to what grudgingly came to be known as post-modernism. Robert Venturi's *Complexity and Contradiction in Architecture* (1966) was an exemplary effort at breaking up monolithic notions of taste and propriety, proposing new, more inclusive vistas of criticism and practice. Such inclusiveness ushered in a new appreciation for the "messy vitality" of the everyday over abstract, machine-era purity, leading Venturi to rhetorically question "is not Main Street almost all right?"[1] and to posit flatfootedly "less is a bore."[2] His vision for an architecture after modernism likewise involved a greater level of referentiality and historical conti-nuity, where juxtapositions between styles and tastes would generate urban frisson and meaning. Instead of clamping down on absolutist "either-or" rules about architectural style, he encouraged a "both-and" approach.[3] Such an approach is helpful when looking at art and architecture from this period, as the break from modernism was neither sudden nor clean. Rather, this transition had been building for some time; it came from a variety of sources and continues to be felt to this day.

The "both-and" way of looking at the world has been vigor-ously pursued by Sam Durant in the fascinating body of work he has assembled over the past decade. Freely pulling a wide range of references into his art, he has built complex, highly discursive groups of objects. Judging from his mix of pre-ferred media (graphite-on-paper drawings, photocopy col-lages, sculpture, photography, video, sound, and installation) and the sources he draws from (rock-and-roll history, mini-mal/postminimal art, 1960s social activism, modern dance, Japanese garden design, mid-century modern design, self-help literature, and do-it-yourself home improvements), one could say with confidence that Durant, too, thinks "less is a bore." Everything including the kitchen sink has made it into his work at one point or another, but the effect is not one of mindless randomness or silly psychedelia. Rather, Durant's strategic collisions of disparate materials break down the bar-riers that box in certain concepts and histories, which then intermingle, interact, and often suggestively cohere with seemingly unrelated phenomena. Grappling with the com-plexities and contradictions of late twentieth-century culture is the artist's primary endeavor, and with such a vast field of inquiry, he is only beginning his ambitious undertaking. Nevertheless, the series of thematic installations he has com-pleted thus far has set him and his audience well on their way towards a more nuanced appreciation of certain momentous histories, keeping them alive and available in the present for further debate.

One of Durant's first attempts at historical revisionism was a site-specific installation at Bliss, an artist-run gallery in Pasadena, California. Titled "Pardon Our Appearance...," this 1992 exhibition was inspired by the Craftsman-style house that intermittently served as Bliss's gallery space. The germinative theme of the installation was home improve-ment, derived from historical and contemporary connotations of "Craftsman," which denotes both the utopian Ruskinians from the turn of the twentieth century who took root in Pasadena and the Sears brand of tools for weekend workers. From this diametric starting point, Durant in many ways sub-jected himself and the exhibition site to psychoanalysis: look-ing at remodeling as a form of therapy, examining his own day job as a carpenter against his identity as an artist, and explor-ing the extent of drug and alcohol use among modern-day construction workers. This freely associative methodology—which cuts across high and low cultural boundaries, flips back and forth between the historical and the contemporary, and incorporates a range of disciplines—yielded an installation of diverse materials and subjects that would set the tone for much of the artist's work to follow.

On the front lawn of the house, a ring of provocatively posi-tioned sawhorses suggested the lewd thoughts of beer- and testosterone-fueled construction workers. It was joined by a crude sign that aped those found at commercial establish-ments under renovation. Taking the form of a frothy beer mug with legs, the sign set the tone for the installation's aesthetic—low-tech Americana—and its preoccupations. Inside, more crudely fabricated objects sketched out inter-connected themes: jigsawed plywood silhouettes of psyche-delic mushrooms, bongs, pipes, and marijuana leaned against the walls; a pile of 1,000 used coffee cups spread outwards from a corner; snapshots of a do-it-yourselfer deep into his household tasks lined the mantel; and an impromptu cluster of a baseball hat, a tool belt, and a pair of well-worn boots served as a self-portrait. Perhaps the most direct diagram of the exhibition's discursive polarities was found on a framed sheet of yellow, lined paper where, in casual script, the artist mapped out a comparison between three virtues of modernism—clarity, unity, honesty—and three rules of

1. Robert Venturi, *Complexity and Contradiction in Architecture* (New York: The Museum of Modern Art, 1966), 102.

2. Ibid., 25.

3. Ibid., 23.

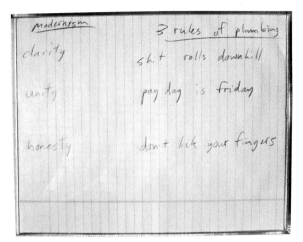

3 RULES OF PLUMBING, 1992
PENCIL ON PAPER; 8 1/2 x 11 INCHES
GABY AND WILHELM SCHÜRMANN, AACHEN, GERMANY

MIKE KELLEY
LOADING DOCK DRAWING, 1984, DETAILS
ACRYLIC ON PAPER; FOUR PANELS, 71 x 42 INCHES EACH
COLLECTION OF THE ARTIST

plumbing—"shit rolls downhill," "payday is Friday," and "don't lick your fingers." The rift Durant identified between the abstract ideals of modern architecture and the practical, if unrefined, guiding principles of a blue-collar trade is the territory where much of his art remains grounded: the area where fine art and everyday life rarely meet.

The exhibition, Durant's first solo effort, came at a time when the discourse about multiculturalism was at its apex and when institutional critique, feminism, and identity politics found their greatest traction within the art world and other cultural spheres.[4] Durant's work can certainly be seen as an outgrowth of those movements, as he too was preoccupied with the failure of the avant-garde to truly connect with the everyday. Much of the socially engaged art of this time became primarily occupied with sexual and racial identity, and while Durant's work invariably touched upon related issues, his investigations tended to have a broader focus. His work was more invested in engineering chance encounters between high art and popular culture, opting for "both-and" rather than "either-or." The look and feel of Durant's work at this time owed a lot to the work of Mike Kelley, who also brought working-class concerns into volatile proximity with modernist traditions.[5] One can think of Kelley's felt banners from the 1980s such as Let's Talk (1987), which poignantly blends middle-American religious decor (and guilt) with ersatz modern graphics, or his Loading Dock Drawings from 1984,

which recontextualize and re-present jokes from "worker's quarters" in a fine-art setting.[6] Durant saw the Loading Dock works when they were shown alongside works by John Miller at Metro Pictures in New York in 1985. This two-person show revolutionized Durant's conception of what art could be, and both artists, especially the scathingly political Miller, have proven to be highly influential figures.[7] Miller's scatological preoccupation and socio-political engagement have found their way into Durant's work in various ways over the years, and his strategic use of mirrors has also been taken up by the younger artist. Presciently, the Metro Pictures exhibition featured mirror works by Miller covered in brown acrylic, prefiguring a similar choice of medium by Durant beginning in the late 1990s. The landmark exhibition "Helter Skelter: L.A. Art in the 1990s" at The Museum of Contemporary Art, Los Angeles, during the same year as the Bliss show likewise featured an installation by Kelley. Mike Kelley's Proposal for the Decoration of an Island of Conference Rooms (with Copy Room) for an Advertising Agency Designed by Frank Gehry (1991) provocatively juxtaposed white-collar, work-related jokes with the elitist schemings of the advertising industry and the aesthetic slumming found in architect Frank Gehry's use of crude construction materials.

The associative, additive approach is also a hallmark of installations by Jason Rhoades, whose early work debuted

4. Technically, Durant's first solo exhibition outside of academia was at Richard Green Gallery in Santa Monica earlier in 1992. The exhibition was a reprise of his 1991 M.F.A. thesis exhibition at California Institute of the Arts. For this reason, the artist considers the Bliss exhibition to be his first fully formed, professional outing.

5. Durant later worked as a studio assistant for Kelley between 1994 and 1995.

6. Paul Schimmel, "A Full-Scale Model for a Dysfunctional Institutional Hierarchy," in Elizabeth Sussman, ed., Mike Kelley: Catholic Tastes (New York: Whitney Museum of American Art, 1993), 211.

7. Conversation with the author, 21 February 2002.

concurrently with Durant's. Rhoades's first mature work, *Jason the Mason and the Mason Dickson Linea* (1991), was executed while the artist was still a student at the University of California, Los Angeles, and his first non-academic gallery exhibition dates from 1992, when he presented *Montgomery Ward Clinique Clinic* in a group show at Los Angeles's Rosamund Felsen Gallery. Durant and Rhoades share a penchant for absurdist leaps of logic that result in bizarre pairings and complicated connections, with Durant's process leading into more social and political territory, while Rhoades's work involves itself with the mythology of the artist and artistic creation. This approach, too, has a precedence in the work of Kelley, whose ambitious and complex *Plato's Cave, Rothko's Chapel, Lincoln's Profile* (1985) sets up a chain reaction of divergent references and readings that explode in a firestorm of intertextuality. To find an artist working in Los Angeles who hasn't been affected by Kelley's overwhelmingly rich and challenging oeuvre is a daunting task; yet Durant has emerged as one of the most thoughtful inheritors of the older artist's mantle. He has succeeded in crafting a practice that is both visceral and cerebral while also equally attuned to the tantalizing limitations of language and history.

After the Bliss exhibition, Durant tackled other multifaceted themes inflected by peculiarly American issues in his multi-part, multimedia installations. The photographs and texts making up *Melancholic Consolation and Cynicism* (1993) grappled with, among other things, substance abuse and addiction, while the objects in *Library* (1994) mined the fecund terrain of the self-help industry. A 1995 exhibition at Blum & Poe in Santa Monica picked up where the Bliss show left off with another look at the connections between home-improvement projects, the roots of modernism, and the American psyche. In a quasi-ranting explanation of the impetus behind the installation, the artist wrote:

Regarding design theory (form following function) and its subsequent mutation and evolution, from Herman Miller to K-Mart (mirroring the dillution [sic] and distillation of an idea as it passes through production and into form). Repression as a repressed sub-text in open plan, modern architecture with exhibitionist in the window/voyuer [sic] hidden in the bushes. The boundry [sic] between inside and outside breaks down, entire walls of glass slide open, the bathroom, which can be viewed from anywhere inside or outside the house must be kept spotless/immaculate—all traces of activity wiped clean. The throne becomes a stage—the original creative act performed for all to see. Perhaps the proud artist is reading while engaged in his/her production, subconsciously fortifying the mind against what the body loses.[8]

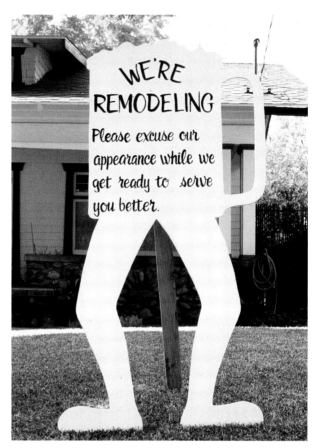

SIGN, 1992
ENAMEL ON WOOD; 72 x 40 x 50 INCHES
COURTESY OF THE ARTIST AND BLUM & POE, SANTA MONICA

As this text implies, the installation pulled the viewer in a number of directions, guided by the sometimes complementary, other times conflicting vectors of design criticism, scatological humor, class consciousness, and Freudian analysis. One entered the installation through a garden-variety aluminum-and-glass sliding door, germane to the outdoor-oriented suburban homes of the West but also a symbol of the domestication (and degradation) of the glass-walled modernist box. The clear box, reductivist apogee of architectural purity, was further analyzed in a wall-mounted sculpture made of Plexiglas that recalled a unit from a Donald Judd "stack" and Philip Johnson's 1949 glass house. Durant's version was stripped of all domestic accoutrements save a miniature ceramic toilet. A length of clear plastic tubing trailed from the toilet to the ground with nary a hint of human waste. Elsewhere, in a series of graphite drawings, toilets were rudely juxtaposed with Eames chairs, analogous emblems of modern design, while in color photographs the artist posed classic mid-century modern chairs in compromising positions. Documented with their feet in the air in such a way that any appraisal of their best features (sinuous

8. Unpublished statement by the artist, November 1995.

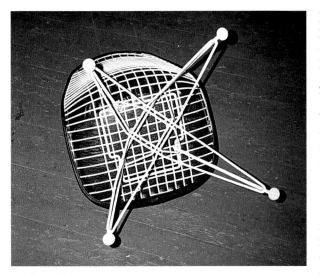

CHAIR #1, 1995

lines and elegant proportions) was denied, the positions also invited crass anthropomorphic readings, as if the chairs were primed for humiliation. This punk gesture, where the usually carefully art-directed chairs are theatrically flipped over and photographed in an artless, snapshot style, suggests a changing of the guard, a dethronement, or comeuppance at the hands of unappreciative philistines. The chair photographs hint at the simmering class conflict that turns up in much subsequent work and has become an important problem for the artist.

Another series of photographs from the Blum & Poe exhibition, including *The Way the World Could Be* and *The Way the World Might Become* (both 1995) showed kitchen-counter displays from home-improvement stores in the process of being repaired or replaced. These unaestheticized views reinsert the worker into the picture of domestic bliss, albeit by his absence rather than direct presence. About these images, Durant wrote: "The displays, when whole, function much the way models do—as stages for the projection of fantasies. During de-installation the seamlessness of the intended illusion is broken and through the photograph a new one is posited. These chaotic breaks, for me characterize the labor in production…. the act of 'remodeling' is about ordering chaotic materials into a finished product."[9] The "labor" in such "productions," however, is extremely complicated, for such cheap, mass-produced items shortcut custom craftsmanship, bringing consumer and laborer expectations to new lows.

Perhaps the most emblematic work from this exhibition is *Scrap Recycling Project with American Ingenuity* (1995), which represents another attempt at "ordering chaos." Here,

leftover wood in various shapes was resurfaced with colorful laminates and leaned against a wall in discrete clusters. Combining Matisse cutouts with dumpster diving, Duchamp's "Standard Stoppages" with Sister Corita Kent graphics and John McCracken planks, *Scrap Recycling* celebrates second chances on a variety of levels. The retro colors—mustard yellow, pumpkin orange, and cocoa brown, or red, white, and blue—testify to the never-ending cycles of fashion trends, while also pinpointing a certain mid-1970s moment when these hues were first *au courant*. This period also coincides with the artist's own adolescence, evoking the ambience "when discovering the nuances of repression and subterfuge in dealing with authority." The bright new exteriors also symbolize concurrent "jr. high attempts to resurface one's damaged identity,"[10] when new guises and forms of self-expression are sampled with manic fervor. (My own dizzying parade of adolescent personas—ranging from preppy to punk to mod to rockabilly—seems, in fuzzy retrospect, to have changed almost weekly.) How Durant managed to transport viewers like myself from bathrooms and the Bauhaus to teens in trench coats is a testament to his canny deployment of signifiers. The Blum & Poe exhibition firmly established how his deft orchestration of unlikely metaphors frequently leads to surprising places. Appropriately within the same show, Durant pinned a drawing above the sliding door that showed, as one exited the gallery, a toilet and a Judd-like Ikea shelf unit connected by a tangle of scribbled lines. Hinting at his process and the viewer involvement required, Durant included between the two images a phrase from the Ikea assembly manual, "Follow Me!"—a fitting entreaty for the faith required for one of his associative journeys.

Durant has made drawing an integral part of his artistic process, using it as a tool to explore ideas that often lead to more multimedia installations. From 1995 to 1997, he made numerous graphite-on-paper works that continued to forge unlikely connections across the spectrum of cultural production. Sometimes dissimilar objects were paired on a single sheet of paper as in *Bad Combination* (1995), where a John Chamberlain sculpture and a child's lamp are awkwardly juxtaposed, while the artist also tried his hand at larger diptychs such as *Organizational Model, Order, Entropy, Material* (1995), featuring a sketch of a scatter piece by postminimalist artist Robert Morris in one frame and a household plumbing diagram in the other. Durant explained the function of drawings within his practice by saying: "They are in no way resolved or offer any form of critique or closure. Their function is to offer space for associative interpretation, as much for me as the viewer. They reference what I was looking at, thinking about while formulating the work

9. Ibid.
10. Ibid.

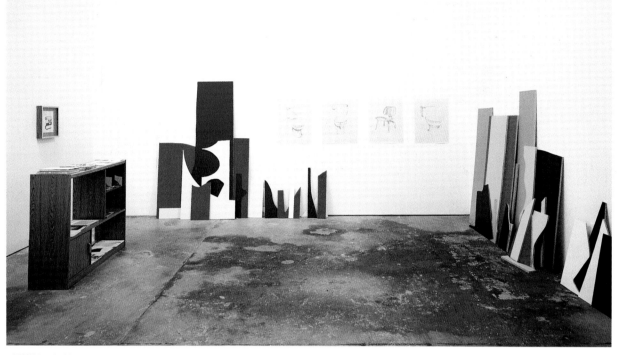

LEFT TO RIGHT: *EVOLUTION OF A PERFECT IDEA; SCRAP RECYCLING PROJECT WITH AMERICAN INGENUITY; SITTING, PROBLEM SOLVING, IDENTITY, I AM WHAT I SIT ON KOHLER WELLWORTH LITE, TOTO, VITROMEX, AND EAMES LCW CHAIR,* ALL 1995
INSTALLATION AT BLUM & POE, SANTA MONICA, 1995

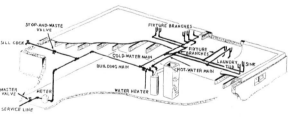

A TYPICAL WATER-SUPPLY SYSTEM FOR ONE BATHROOM AND A KITCHEN

ORGANIZATIONAL MODEL, ORDER, ENTROPY, MATERIAL, 1995
GRAPHITE ON PAPER; DIPTYCH, 28 $^1/_2$ x 22 $^1/_2$ INCHES EACH
COLLECTION MARIA AND TIM BLUM, LOS ANGELES

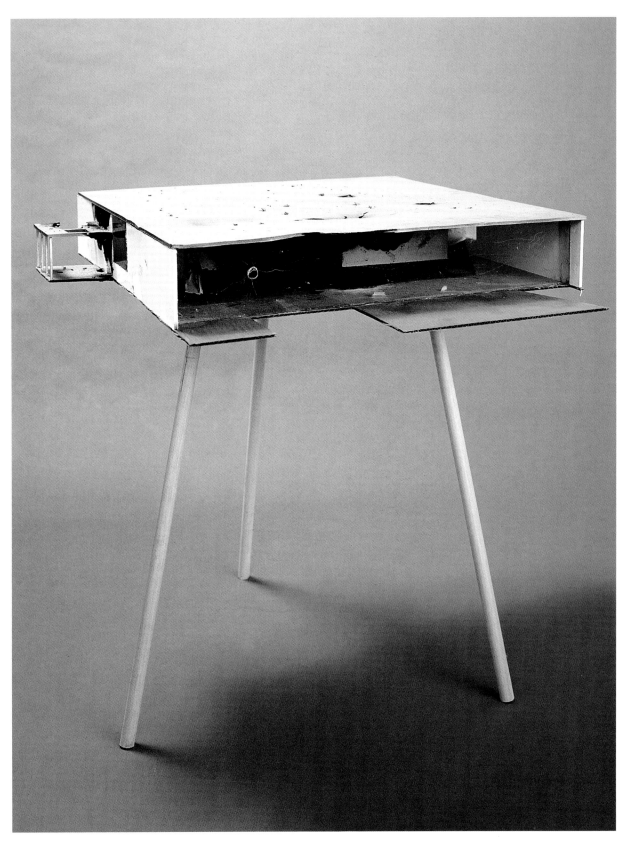

ABANDONED HOUSE #3, 1995

BEER BONG, 1995

for the show. Associations are made on many levels and needn't succeed on the level of—'Oh, I get it'—it's more about a slow burn, connections made perhaps days, weeks, months after viewing. They look like they should make sense, but don't."[11] The drawings also palpably underscore the highly referential nature of his work, documenting in a time-based manner his attention to and assimilation of a wide range of sources, from art-history books and old art magazines to furniture catalogues and do-it-yourself manuals. Each image is faithfully transferred by hand to its new context in a variety of styles, from rough-hewn and expressionistic to feathery and precise.

ABANDONED HOUSES

While the 1995 Blum & Poe exhibition in many ways involved bringing order to chaos, a show developed during the same period presented an exploration of the opposite: fomenting chaos in the realm of order. This installation, created for the now-defunct Roger Merians Gallery in New York, also took modern architecture as its starting point but maintained a stricter and less free-ranging focus on a particular theme. In six freestanding sculptures and dozens of small photocopy collages made between 1994 and 1996, Durant engineered the degradation of pristine modernist homes by the forces of bad behavior, bad taste, and bad construction. By far Durant's most well-known works to date, the sculptures are cheap recreations of the Case Study Houses, prototypical dwellings by leading modern architects created in Southern California under the sponsorship of *Arts & Architecture* magazine between 1945 and 1966. Impressionistic at best, Durant's models of these homes provide sketches of the shape and layout of the buildings, but the raw foam core, cardboard, plywood, and Plexiglas from which they are made make no effort to replicate textures, colors, or construction materials. Standing on wobbly bases made from bare wood dowels, the models are not only poorly built but subjected to all manner of mistreatment. Houses by Richard Neutra; Pierre Koenig; Killingsworth, Brady, and Smith; and others have been burned, riddled with holes, defaced with graffiti, and generally left to rot. *Abandoned House #2* (1995), although in an advanced state of disrepair, glows from within by the blue light of a miniature television. The accompanying sound alerts one to the fact that the TV is tuned to tawdry soap operas and scandalous talk shows like those of Sally Jesse Raphael or Jerry Springer, still another blow to the Neutra house's former glory.

But such "glory" is truly only a historical fabrication, perpetuated through stringently art-directed photographs and overbearing architects. What Durant accomplishes is akin to a reality check, pointing out that few owners of such homes can maintain these messianic standards. By putting into motion this kind of regression from abstract purity to messy humanity, Durant intended to invoke the concept of entropy, a phenomenon from the realm of physics appropriated by Robert Smithson in the 1960s as a way to look at art and landscape. As Smithson tells it, entropy is defined by the "Second Law of Thermodynamics, which extrapolates the range of entropy by telling us energy is more easily lost than obtained, and that in the ultimate future the whole universe will burn out and be transformed into an all-encompassing sameness."[12] Durant's houses seem to be pulled toward such

11. Ibid.

12. Robert Smithson, "Entropy and the New Monuments" (1966), in Nancy Holt, ed., *The Writings of Robert Smithson* (New York: New York University Press, 1979), 9.

a fate, with the unruly forces of nature and culture dragging them off their pedestals. Modern architecture's pretensions to perfection and ahistoricity make them game for such dethroning. Indeed Smithson said such "'cold glass boxes'… helped to foster the entropic mood" and gave rise to new models of urbanity like those proposed by Venturi.[13]

Durant explored this theme further in a series of raw, tossed-off collages made from photocopies of classic modern houses and marked by sudden ruptures of taste and class. In *Beer Bong* (1995), for instance, a grainy, black-and-white xerox of a Julius Shulman photograph of Koenig's Case Study House #22 (1959–60) unexpectedly features two biker-types in full color chugging beer by the pool. *Modern Moon* (1994) similarly appropriates an artfully composed interior image of an *echt* modern house, disrupted by a Hells Angel groupie flashing a bethonged, bare ass for the camera, while *Free Beer* (1995) captures a fictive moment before Koenig's Case Study House #21 (1958) is overtaken by keg-seeking Hessians. A great portion of the photography that has been passed down to us about this period and particular type of architecture is devoid of people, preferring to show the architecture in its mechanistic perfection, which is one reason why Durant's entropic images are so funny and shocking. Likewise, the decor of these vintage images is controlled to the finest detail, a characteristic that Durant also subverts in collages such as *Love Seat* (1994), *Yellow Lamp* (1995), and *Pie* (1995). The implied hygiene of modernism is also sent up by Durant in works like *Untitled* (1995), *Repression and Material* (1995), and *Kiddie's Room* (1994), where John Miller-like excremental overpainting introduces another variation on the *unheimlich* within the series. Scores of such collages were made between 1994 and 1996 and, together with the sculptures, represent Durant's first iterations on the subject of entropy. Durant's entropic scenarios from this point forward evoke de-evolutions of culture and society, where distinctions of class and taste come crashing down in a cathartic leveling, while Smithson's use of the term, although richly metaphoric, more often referred to states of nature and the built environment.

REPRESSION AND MATERIAL, 1995
COLLAGE ON PHOTOCOPY; 9 x 8 ½ INCHES
COLLECTION OF TOMIO KOYAMA, TOKYO

PARTIALLY BURIED WOODSHED

Smithson has come to be an important source of content for Durant, serving as an exemplar of the shift from modernism to postmodernism, a symbol of the end of the utopian dreams of futurists and hippies and the dawning of a dystopian perspective, and an amazingly gifted artist and writer whose work is ripe for close reading and rereading. Within Durant's work from 1998 to the present, Smithson has been invoked conceptually (especially concerning entropy), formally (in appropriated motifs and materials), and metaphorically (as a stand-in for late 1960s/early 70s radicalism), appearing first in a two-part sculptural work titled *Partially Buried 1960s/70s Dystopia Revealed (Mick Jagger at Altamont)* and *Partially Buried 1960s/70s Utopia Reflected (Wavy Gravy at Woodstock)* (both 1998). This work has proven to be an important progenitor of a lengthy examination of the era by Durant. It contains references to concerts at Woodstock and Altamont, Smithson's non-sites and his *Partially Buried Woodshed* (1970), scatology, death, mirroring, and archeology. It features two rectangular mirrors upon which are piled mounds of dirt in a direct nod to works such as Smithson's mirror displacements in *Incidents of Mirror-Travel in the Yucatan* (1968). Within each mound, the artist placed a speaker, one wired with a soundtrack of entertainer Wavy Gravy addressing the euphoric crowd at Woodstock, the other with Mick Jagger pleading for calm at the disastrous Altamont concert. As critic James Meyer has written, "Literalizing the cliché of Woodstock as utopia and Altamont as dystopia, the two tapes and identical mirrors suggest that the concerts were of a piece. Rather than an aberration or betrayal of '60s ideals, Altamont becomes the entropic fulfillment of that epoch's lofty expectations."[14] Again preferring the stimulating friction of "both-and," Durant evokes a dialectical chain of events that leads from the 1960s right to the present with contemporary viewers haunted by voices from history's grave, harbingers of another fall to come. Such implosions, the work implies, are always imminent, as recent events like the dot-com crash, September 11th, and the Enron scandal attest.

Durant's *Partially Buried 1960s/70s* pieces lead to a sustained engagement with Smithson's legendary *Partially Buried Woodshed*, an earthwork installed on the campus of Kent State University in Kent, Ohio. Months after the piece was completed, four student protesters were gunned down on the campus by National Guardsmen sent in to quell an antiwar demonstration, and the work thereafter came to memorialize the event. (In 1975 a portion of the monument was set on fire and half of it burned. The remaining structure was removed in 1984.) Kent State has come to

13. Ibid., 11.
14. James Meyer, "Impure Thoughts: The Art of Sam Durant," *Artforum* 38, no. 8 (April 2000): 115.

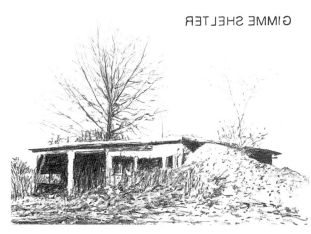

GIMME SHELTER

GIMME SHELTER IN REVERSE/WOODSHED, 1999
GRAPHITE ON PAPER; 22 x 30 INCHES
COLLECTION OF MICHAEL COOK

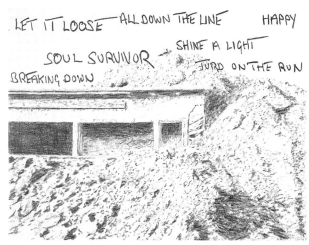

LET IT LOOSE/WOODSHED, 1998

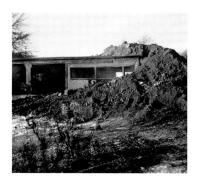

ROBERT SMITHSON
PARTIALLY BURIED WOODSHED, KENT, OHIO, JANUARY 1970
ESTATE OF ROBERT SMITHSON
COURTESY JAMES COHAN GALLERY, NEW YORK

epitomize the loss of American innocence ushered in by Vietnam, the Kennedy assassinations, and civil rights struggles; Smithson's work too represents a new cynicism and nihilism in contemporary art. The piece was created by piling dirt onto a utilitarian woodshed until the central support beam cracked, stopping at the crucial midway point of an entropic event. Durant has made two sculptures based on the woodshed, *Upside Down and Backwards, Completely Unburied* and *Reflected Upside Down and Backwards* (both 1999), in addition to a series of photographs and numerous drawings that explore myriad connections. The first sculpture is a scale model, utilizing materials more like the original than in his earlier Case Study models, which sits on the ground surrounded by six audio speakers. With the help of three CD players, the speakers transmit three songs playing concurrently: "Gimme Shelter" by The Rolling Stones, "Smells Like Teen Spirit" by Nirvana, and "Hey Hey, My My (Into the Black)" by Neil Young. As the songs are of different lengths and play continuously on auto-repeat, new coincidences between the lyrics are constantly created.

Returning to the subject again, as a DJ would with a remix, the second sculpture features a stack of two identical woodsheds, the one on top severely burned while the one on the bottom is untouched. Here, two CD players project acoustic versions of Nirvana's "All Apologies" and Neil Young's "My My, Hey Hey (Out of the Blue)" simultaneously. The repeating woodsheds function as objects of an obsession, or fiercely rejuvenative structures that sprout up anew after each setback, or perhaps more accurately, mirrored signifiers of a subject that continues to yield new information with each investigation. The related drawings bear this last interpretation and help to explain the musical components, as Durant has rendered the woodshed over and over again in labor-intensive, graphite drawings capturing different views and presenting it with a range of context-enhancing references. Providing graphic counterparts to the seemingly random soundtracks, the drawings connect the disparate entities and help define the terms of the artist's unconventional inquiry. In *Let It Loose/Woodshed* (1998), for instance, Durant shows a close-up of the Smithson sculpture overlaid with titles from The Rolling Stones album *Exile on Main Street* that suddenly become appropriately entropic and scatological: "Turd on the Run," "Stop Breaking Down," and "Let It Loose." In *It's Better to Burn Out Than Fade Away* (1998) he draws Smithson reclining in a chair next to Mick Jagger and Keith Richards in an alcohol-soaked recording session, captioning the pairing with the eponymous Neil Young lyric written backwards (as if in a mirror) at the bottom of the drawing. Neil Young memorialized the Kent State massacre in his song "Ohio," while the quoted lyric comes from his album *Rust Never Sleeps*, whose title is practically Smithsonian in its acknowledgment of the entropic

19

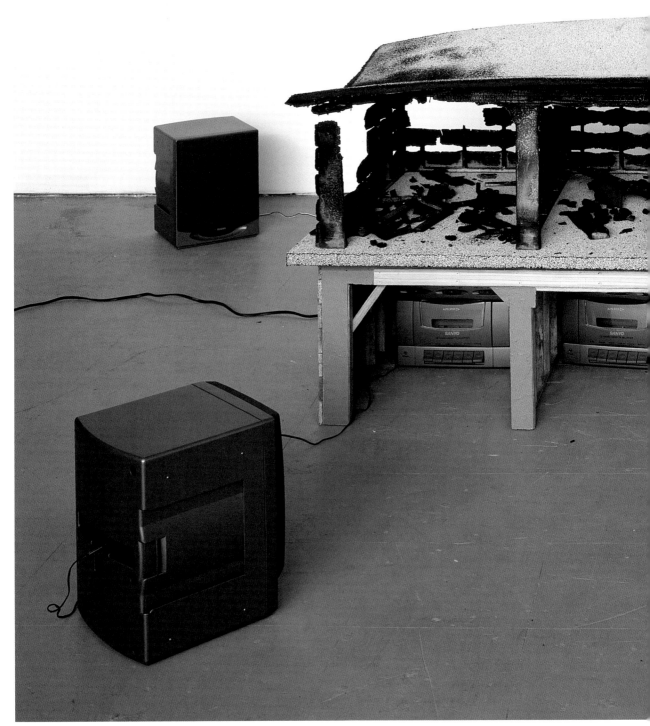

REFLECTED UPSIDE DOWN AND BACKWARDS, 1999

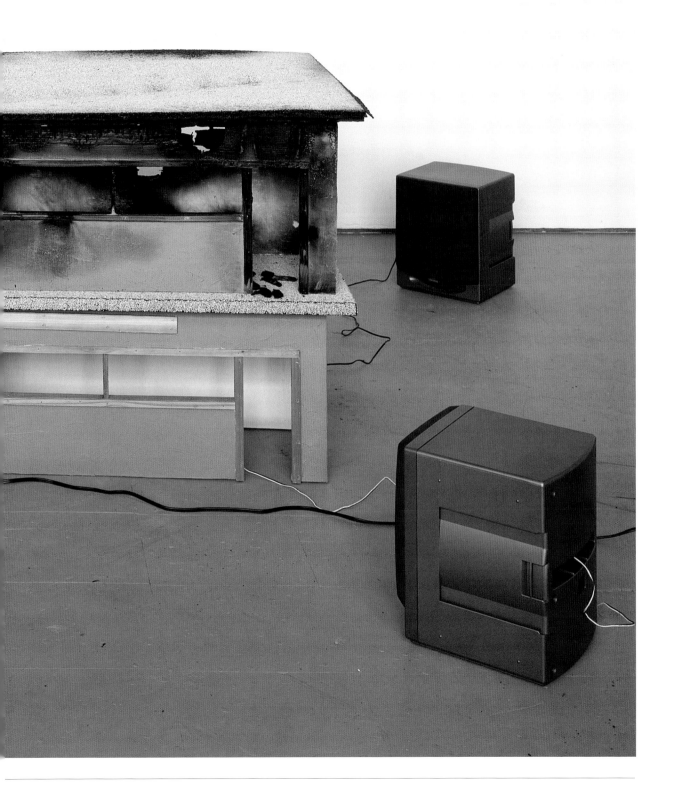

process.[15] *Into the Black/Rockstar* (1998) brings yet another reference to the equation, disjunctively portraying the late Nirvana frontman Kurt Cobain above a caption for Smithson's woodshed, which is nowhere to be seen in the drawing. As it turns out, Cobain included the phrase "It's better to burn out than to fade away" in his suicide note, and his tragic death, so common in the annals of rock and roll, can be compared to Smithson's own untimely death in a plane crash in 1973. All of these surprising coincidences are mapped out in still another drawing from the series, *Quaternary Field/Associative Diagram* (1998), appropriating a format famously used by art critic Rosalind Krauss in her 1978 essay "Sculpture in the Expanded Field" to address the new hybrid "postmodernist" sculpture (or "expanded field") cropping up between the years of 1968 and 1970.[16] Krauss singled out Smithson's *Partially Buried Woodshed* as an example of "site-construction," sitting at the top of the diamond, exactly where Durant puts him in his version. From there, Durant's diagram includes all of his key players (Cobain, Young, the Stones) and concepts (scatological structures, entropy, song lyric, pop star) but in the end it lacks the abstruse rigor of its model and remains rather hermetic to his own project. As a slacker repartee, a related drawing, *Rosalind Krauss* (1998), matches the critic's name in the same font as it appears on her book *Passages in Modern Sculpture* with a towering marijuana plant as if to say: "Here's an expanded field for you!" Durant's fascinating tangle of referents has the effect of joining past and present, art history and pop culture, in a way that makes all his

sources relevant once again, open to new discussion and consideration by the audience confronting his work in the here and now. The sculptures, drawings, and photos rewind and remix history (implied in the drawing *Counterclockwise* [1999], where time is turned back to revisit the woodshed), through reclaimed imagery, mirroring, and also through the conflation of song lyrics:

Tin soldiers and Nixon coming
We're finally on our own
This summer I hear the drumming
Four dead in Ohio
 Neil Young, "Ohio"

Oh, a storm is threat'ning
My very life today
If I don't get some shelter
Oh yeah, I'm gonna fade away
 The Rolling Stones, "Gimme Shelter"

Load up on guns
Bring your friends
It's fun to lose
 Nirvana, "Smells Like Teen Spirit"

In the sun
In the sun
I'm married
Buried
 Nirvana, "All Apologies"

And once you're gone,
You can't come back
When you're out of the blue
And into the black
 Neil Young, "Hey Hey, My My (Into the Black)"

This body of work accepts and seeks out complexity in order to create a fuller, more richly contextualized picture of history than one would find in specialized sources about any one of his given subjects, channeling the omnivorous mind of Smithson and the ideological battles of the late 1960s and early 70s through the words of Neil Young: "There's more to the picture/Than meets the eye/Hey hey, my my."

QUATERNARY FIELD/ASSOCIATIVE DIAGRAM, 1999
OFFSET PRINT, 17 x 22 INCHES
COURTESY OF THE ARTIST AND BLUM & POE, SANTA MONICA

15. Smithson wrote about rust as a metaphor to distinguish between modernist, machine-oriented ideals and the new entropic, postindustrial forms of expression emerging in the late 1960s: "Molded steel and cast aluminum are machine manufactured, and as a result they bear the stamp of technological ideology. Steel is a hard, tough metal, suggesting the permanence of technological values…. Yet, the more I think about steel itself…the more rust becomes the fundamental property of steel…. In the technological mind rust evokes a fear of disuse, inactivity, entropy, and ruin." Smithson, "A Sedimentation of the Mind: Earth Projects" (1968), in *The Writings of Robert Smithson*, 86.
16. Rosalind Krauss, "Sculpture in the Expanded Field" (1978), in *The Originality of the Avant-Garde and Other Modernist Myths* (Cambridge, Mass.: The MIT Press, 1985), 284–87.

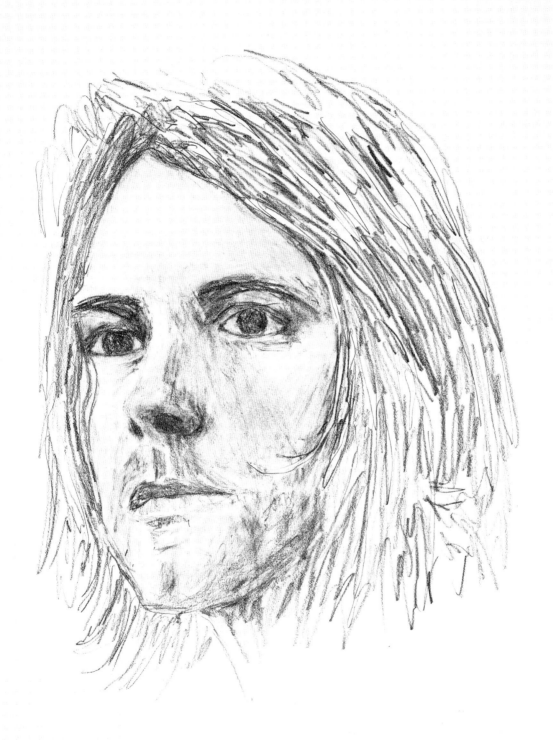

Robert Smithson, *Partially Buried Wood Shed—*
Kent State University, Ohio, 1970.

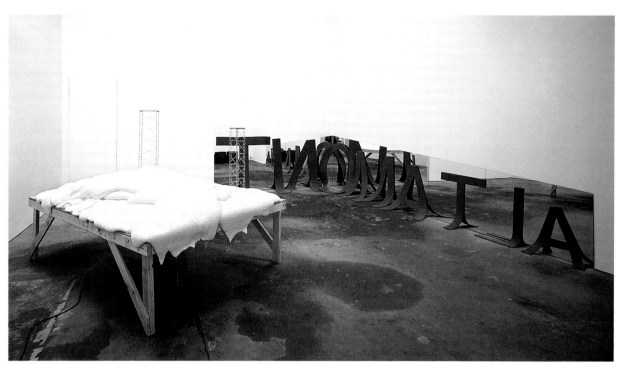

LEFT TO RIGHT: *PROPOSAL FOR MONUMENT AT ALTAMONT RACEWAY, TRACY, CA*; AND *ALTAMONT*, BOTH 1999
INSTALLATION AT BLUM & POE, SANTA MONICA, 1999

ROBERT SMITHSON
GLUE POUR, VANCOUVER, CANADA, DECEMBER 1969
ESTATE OF ROBERT SMITHSON
COURTESY JAMES COHAN GALLERY, NEW YORK

ALTAMONT

Finding a similarly rich source of associative material in the circumstances surrounding the ill-fated concert at Altamont Raceway in 1969, Durant devoted another extensive and multifaceted body of work to this watershed event. Sited in Tracy, California, Altamont was envisioned as a West Coast Woodstock, but the crowds and security staff (hired from the ranks of local Hells Angels gangs) surged out of control, resulting in the death of one gun-wielding concertgoer at the hands of a Hells Angel, two fatalities of fans run over in the parking lot, and another death caused by an acid-induced fall off an aqueduct.[17] Durant revisited the topic in a series of sculptures, drawings, and videos, applying his editorial skills in a fresh reexamination. The central sculptural work from this group, first shown at Blum & Poe in 1999, is *Proposal for Monument at Altamont Raceway, Tracy, CA* (1999). It consists of a wood plinth on top of which the artist let loose an effusive pour of beige polyurethane foam that vaguely resembles the dry, barren hills of Tracy. The mound of artificial material is perhaps more allusive of Smithson's oozing earthworks *Asphalt Rundown* and *Glue Pour* (both 1969), or Lynda Benglis's amorphous foam sculptures from the same period, such as *For Carl Andre* (1970). Placed within this abject landscape are two small-scale towers of scaffolding like those used to support audio equipment at large outdoor concerts. The repetitive, identical, industrial scaffold units recall the work of Smithson's and Benglis's contemporary Carl Andre, while also suggesting ominous surveillance towers. The combined effect creates a sense of desolation and ennui, which is amplified further by the loud soundtrack emanating from under the platform. "Brown Sugar," the song the Stones played shortly after the murder, is reversed and layered so that its racist and misogynist lyrics are thwarted and trapped in time just as the flowing landscape is frozen. Durant's designation of this work as a monument calls to mind Smithson's poetic reflection on the postindustrial landscape in his essay "Entropy and the New Monuments," where he practically describes the younger artist's project:

Instead of causing us to remember the past like the old monuments, the new monuments seem to cause us to forget the future. Instead of being made of natural materials, such as marble, granite, or other kinds of rock, the new monuments are made of artificial materials, plastic, chrome, and electric light. They are not built for the ages, but rather against the ages. They are involved in a systematic reduction of time down to fractions of seconds, rather than in representing the long spaces of centuries. Both past and future are placed into an objective present. This kind of time has little or no space; it is stationary and without movement, it is going nowhere, it is anti-Newtonian, as well as being instant, and is against the wheels of the time-clock.[18]

The frozen, unpopulated landscape and suffocating soundtrack of Durant's *Proposal for Monument at Altamont* exactly evokes the nihilistic scenario portrayed by Smithson, bringing forth the past but trapping it in the present without a clear path to the future. The mirrored twin towers and reversed music contribute further to this effect and set up a leitmotif of reflection that runs through the work. A related video, *Entropy in Reverse (Gimme Shelter Backwards)* (1999), performs a similar operation in which a documentary film about Altamont by the Maysles brothers is played in reverse on twin monitors, so that the events at the concert are continuously being undone, disallowing its resolution despite the horrible known outcome. Graphite-on-paper drawings help to extrapolate further connections between postminimalist sculpture, scatological metaphors, Altamont, and the shameful lyrics of "Brown Sugar." Deliriously running these references together and contributing further to the bleak atmosphere are pieces such as *Glue Horizon, Brown Sugar Rundown, Landscape/Shit Covered,* and *Taste Good/Mirrored* (all 1999) in a format not dissimilar from the earlier pieces dealing with *Partially Buried Woodshed.* Also exhibited with the *Proposal for Monument at Altamont* was a work titled *Altamont* (1999), which combines wall-mounted mirrors with gray drooping felt reminiscent of the work of Robert Morris to capture a related collapse of time, progress, and meaning. As a whole, the entire body of work is one of the artist's darkest evocations of entropy, and succeeds in memorializing in a reflective, anything-but-sentimental way, this epochal period of recent history.

sugar covered how come
you taste so good horizontal '69

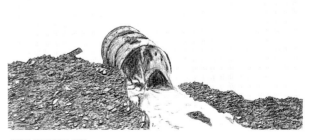

GLUE HORIZON, 1999

17. Christopher Miles, "Sam Durant: Going with the Flow," *art/text*, no. 63 (November 1998/January 1999): 48.

18. Smithson, "Entropy and the New Monuments," 10.

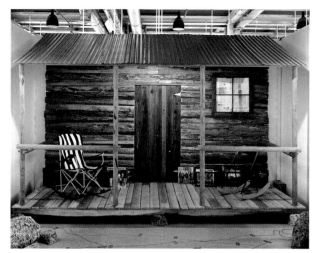

PROPOSAL FOR MONUMENT IN FRIENDSHIP PARK, JACKSONVILLE, FL, 2000

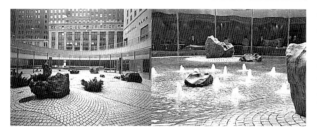

ISAMU NOGUCHI
SUNKEN GARDEN, CHASE MANHATTAN BANK PLAZA, NEW YORK, 1961–64
DIAMETER: 60 FEET
COURTESY JPMORGAN CHASE ARCHIVES, NEW YORK

FRIENDSHIP PARK WITH FLAGS, 2000

FRIENDSHIP PARK

The depressing thematics of Durant's work with Altamont led to a much more playful and obscure set of references in 2000 when he made a second *Proposal for Monument,* this time to commemorate the emergence of the musical genre of Southern rock in the early 1970s. Durant's close study of Neil Young in previous bodies of work turned up an indictment of the racist South in the song "Southern Man," furthering an interest in how popular music reflects political and social realities. The Southern rock band Lynyrd Skynyrd in turn penned the lyric "Old Neil put her down, but the Southern Man doesn't need him anyhow" in their classic barroom anthem "Sweet Home Alabama," a revealing repartee that points to the nagging racial tension between North and South. The resulting work, *Proposal for Monument in Friendship Park, Jacksonville, FL* (2000), is perhaps Durant's most wildly referential work to date, casting a wide and unfettered net that gathers together a bizarre, and ultimately revelatory, host of citations. While ostensibly not as indebted to Smithson as his two prior works, *Friendship Park* does partake of a post-structuralist, linguistic freedom that Smithson also favored, and its generative methods parallel ideas found in Smithson's important tract, "A Sedimentation of the Mind: Earth Projects":

The names of minerals and the minerals themselves do not differ from each other, because at the bottom of both the material and the print is the beginning of an abysmal number of fissures. Words and rocks contain a language that follows a syntax of splits and ruptures. Look at any word long enough and you will see it open up into a series of faults, into a terrain of particles each containing its own void. This discomforting language of fragmentation offers no easy gestalt solution; the certainties of didactic discourse are hurled into the erosion of the poetic principle.[19]

Durant, it appears, looked at the word "rock" long enough to find a system of cracks that led in innumerable directions, which in turn became the map for his *Friendship Park* piece. Southern rock led him to think of geological stones, and the public siting of his monument in a park led him to a close consideration of the master of public stone gardens, Isamu Noguchi. An artist with a serious modernist pedigree after apprenticing for Constantin Brancusi in the early 1900s, Noguchi was known for his essentialized forms, or what the artist himself (conveniently for Durant) described as an attempt "to transcend the physical and emerge into a new birth of an object. So that a rock becomes more than a rock."[20] Durant decided the look of his monument should take inspiration from the stereotypical back porch of a swamp shack, and as luck would have it, Noguchi riffed on just such a struc-

19. Smithson, "A Sedimentation of the Mind: Earth Projects," 87.
20. Isamu Noguchi, in an interview with Friedrich Teja Bach, 19 February 1975, in *Constantin Brancusi: Metamorphosen Plastischer Form* (Cologne: Dumont Buchverlag, 1987), 291.

ture in stage-set designs he made for choreographer Martha Graham's *Appalachian Spring* in 1944. Within this framework all kinds of provocative antimonies developed between high and low, East and West, past and present, natural and artificial, ideal and real. Fascinating contestations of identity and issues of hybridity also arose from the human-scaled installation and a characteristic profusion of works on paper.

The installation of *Friendship Park* presents the façade of a Southern-style shack of stacked-log wall construction, replete with a corrugated tin roof, a newspaper-covered window, and an ample porch that nicely accommodates rocking chairs, crates of records, and turntables. The chairs are white-trash pastiches of modernist rocking chairs like those conceived by Charles and Ray Eames in the 1950s, but also useful antidotes to the non-functional, minimalist rocker that Noguchi devised for *Appalachian Spring*. Durant adapts low-rent folding chairs by adding curved runners to the bottom of their legs. The records are a selection of Southern rock classics that viewers are invited to play on the two turntables, one of which is altered to play the albums backwards. If the monument actually were to be installed in Jacksonville, Durant's porch would serve as a site for impromptu jam sessions with aspiring musicians. Parks were breeding grounds for the future stars of Southern rock during the late 1960s, where Sunday afternoon concerts fostered musicians that later played in bands such as the Allman Brothers Band, Lynyrd Skynyrd, Blackfoot, 38 Special, Grinderswitch, and Wet Willie.[21]

In *Friendship Park*, the sound of the records is amplified through speakers placed in fiberglass rocks and a trash can. (It seems implied that the speakers could also transmit live music if real bands were to play on Durant's stage.) The artificial rocks and pebble-veneered trash can are laid out in a figure-eight pattern, implying the timeless concept of infinity and also aping Japanese Zen rock gardens such as the famous Ryoanji Temple Garden in Kyoto. Noguchi famously brought Japanese rock gardens to bear on Western public spaces, and his thinking about these spaces was inflected by Eastern philosophy and modernist notions of abstraction. Writing about his *Sunken Garden* for the Chase Manhattan Bank Plaza in New York (1961–64), where real rocks sit within a sculpted, stylized landscape set below ground-level and occasionally enhanced by water, Noguchi remarked: "I have noticed that when one visits the plaza on a quiet but somewhat windy Sunday, the great building emits an eerie music, and I can see that looking down into the garden with its water flowing will be like looking into a turbulent seascape from which immobile rocks take off for outer space."[22] If pulled from this context and applied to

Durant's rock-and-roll garden, Noguchi's misty, space-age observation could just as easily describe seas of scantily clad stoners swaying to guitar solos and embarking on a different sort of interplanetary flight. Durant's public park supplants the contemplative with the raucous, and exchanges symbols of sublime nature (gigantic exotic rocks) for markers of contemporary, functional, public space (trash containers).

Many other ironic coincidences are put into play in related works, including comparisons between the work of minimalist sculptor and architect Tony Smith and the Southern vernacular construction found in works on paper such as *Backporch Combination*, *Friendship Park Vocabulary*, and *Parson's House with Cabin* (all 2000). The latter juxtaposes a rugged home Smith designed for New York art dealer Betty Parsons with a backwoods building. The rocks in Noguchi's Japanese gardens also were installed so as to connect with the earth and the "primordial mass," a concept that becomes comically apt in drawings such as *Major Connections*, *Akari and Rock Pile*, and *Friendship Park–Primordial Mass* (all 2000), when one considers the swampy substrate associated with Florida.

Related works also extend to a series of colorful posters in the style of rock concert promotionals that further mix and match references from the artist's assorted sources, with new posters appearing with each showing of the work. A spin-off installation, *Southern Rock Garden Beginningless/Endless Primordial Connection to a Floating World with Consciousness of Sheer Invisible Mass* (sound with Takeshi Kagami) (2000), was shown at Tomio Koyama Gallery in Tokyo, where both the Southern rock references and the bastardized, rowdy rock garden were doubly exotic. While it is entertaining and rewarding to track the myriad associations in this work and others like it, Durant's pieces ultimately evade exhaustive analysis as each is too broad, too suffused with multiple meanings to definitively pin down. While for some the lack of a unified gestalt may be disappointing, for those viewers interested in a more complicated, lengthy, and sustained discursiveness, Durant's inclusionary scenarios never fail to reward.

PARSON'S HOUSE WITH CABIN, 2000

21. From an unpublished statement by the artist, 2000.
22. Noguchi, "New Stone Gardens," *Art in America* 52, no. 3 (June 1964): 89.

UPSIDE DOWN: PASTORAL SCENE

In his latest endeavor, Durant has returned to the generous oeuvre of Smithson to revisit yet another chapter in the tumultuous history of the 1960s and 70s. Beginning with an exhibition at Galleria Emi Fontana in Milan in 2001 and developed further for an ambitious new installation as part of his exhibition at MOCA in 2002, the artist appropriated Smithson's motif of the upside-down tree to explore the fractious and ongoing struggle for civil rights among African Americans. Smithson realized three such sculptures before his death in 1973, including one made on a Florida beach with the assistance of Robert Rauschenberg. The trees suggest an entirely unnatural condition, evidence of human intervention, and even a kind of sadistic violence, and yet they also embody a new perspective, a new order, and a second chance at life for the fallen objects to take root again. Smithson recognized the duality of the gesture when writing about the version he made in the Yucatan jungles of Mexico:

Are they totems of rootlessness that relate to one another? Do they mark a dizzy path from one doubtful point to another?… Perhaps they are dislocated "North and South poles" marking peripheral places, polar regions of the mind fixed in mundane matter—poles that have slipped from the geographical moorings of the world's axis. Central points that evade being central. Are they dead roots that haplessly hang off inverted trunks in a vast "no man's land" that drifts toward vacancy? In the riddling zones, nothing is for sure.[23]

Durant has placed his stumps—each unique and made from painted fiberglass with organic roots grafted onto them that range and writhe several feet from the floor plane—on large mirrors so that the trunk is doubled and reflected into the unmeasurable void of the mirror. Like Smithson's trees, Durant's sculptures have "slipped from the geographical moorings" of the world as well as conventional meaning, dragged from one context into the "riddling zones" where so much of his work operates. At Emi Fontana, a single tree was accompanied by large graphite drawings that built the components of this new context. A portrait of Bobby Seale, co-founder with Huey Newton of the activist Black Panther party in 1966, shared space with a drawing of a stack of books written by fellow Panther Eldridge Cleaver called *Heap of Language (Soul on Ice)* (2001)—a title partially borrowed from a work by Smithson. A drawing of one of Smithson's upside-down trees, *A Garbage Dump Doesn't Need to Grow Trees to Reach the Heavens, the Fumes Rise and Rise* (2001), was paired with a backwards rendition of the philosophical family tree that appears on the cover of black intellectual Cornel West's book *The American Evasion of Philosophy: A Geneology of Pragmatism* (1989). Titled *Standing on Our Head* (2001), it

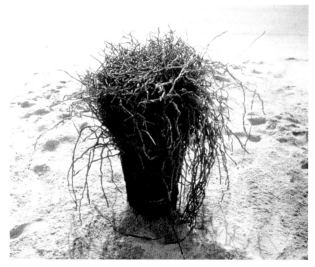

ROBERT SMITHSON
SECOND UPSIDE-DOWN TREE, CAPTIVA ISLAND, FLORIDA, 1969
ESTATE OF ROBERT SMITHSON
COURTESY JAMES COHAN GALLERY, NEW YORK

was joined by another drawing of a tree, *Standing Upside Down* (2001), this time featuring an upside-down album cover by the Southern hip-hop group Goodie Mob titled *Still Standing*. Suddenly Smithson's trees had become intertwined with the painful history of the American South, where trees were the symbols of lynchings, and by extension to the militant activities of 1960s black activists like Cleaver, Seale, and Newton and more recent theorizations on race by West. The examination of Southern culture initiated by the *Friendship Park* project invariably led to race as rockers like those in Lynyrd Skynyrd often enthusiastically partied under the banner of the Confederacy, itself a minefield of socio-cultural issues.

As one has come to expect from Durant, however, there is no simple polarity being charted. Rather, he orchestrates conflicting and individually charged referents to provoke a wider consideration of his chosen subject. In addition to an illuminated lightbox with a text taken from a 1960s protest sign, the exhibition also included a double portrait that is perhaps the most complex work of all. Titled *Inversion, Proposal for the Five Dollar Bill (Huey Newton, Founder of the Black Panther Party for Self-Defense)* (2001), it is a vertically oriented diptych showing the mercurial Huey Newton above an inverted portrait of Abraham Lincoln, mimicking the effect of the tree sculpture on its mirror. Is Lincoln the root of the Black Panthers, or are the two men reflections of a common, unseen object? Newton was one of the most visible figures of the black power movement and Lincoln has been celebrated for leading the United States through the Civil War and away from institutionalized slavery; yet both figures embody numerous contradictions and are contentious figures within

23. Smithson, "Incidents of Mirror-Travel in the Yucatan" (1968), in *The Writings of Robert Smithson*, 101.

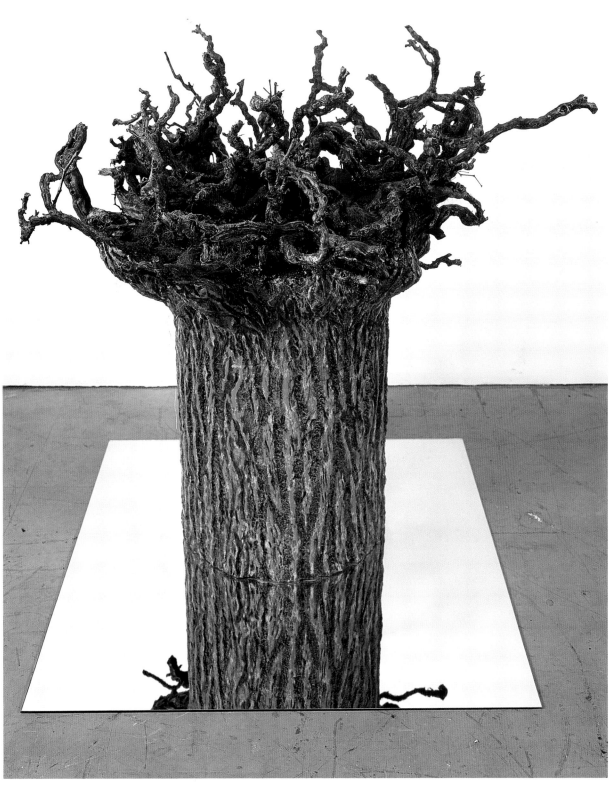

UPSIDE DOWN: PASTORAL SCENE, 2002, DETAIL

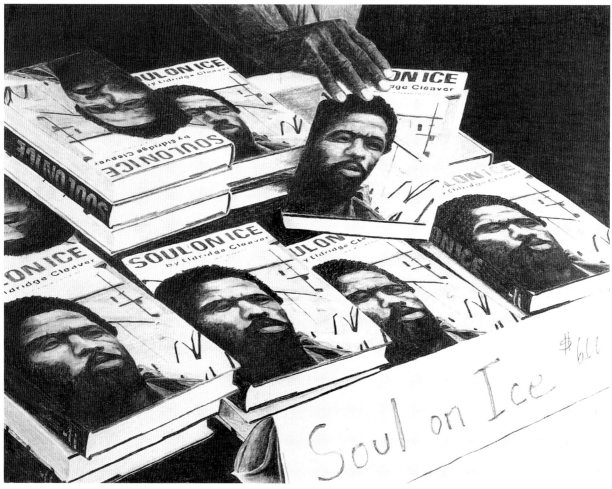

HEAP OF LANGUAGE (SOUL ON ICE), 2001

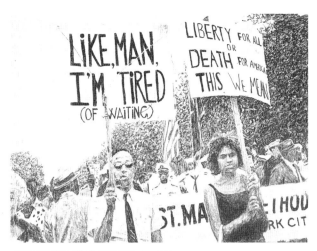

CIVIL RIGHTS MARCH, WASH. DC, 1963, 2002

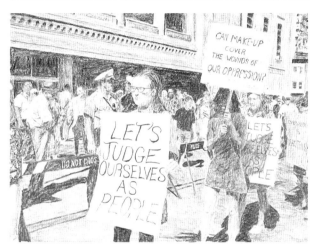

MISS AMERICA PAGEANT, ATLANTIC CITY, 1968, 2002

WASH. DC, 1968, 2002

the annals of American civil rights. Newton held a Ph.D. but was a long-time drug addict, twice charged with murder, and spent considerable time in jail, but was also held up as a martyr to his cause, which itself was complicated by good intentions marred by a predilection for violence. Lincoln in turn has been immortalized by his Gettysburg Address, but also promoted for many years the idea of sending freed slaves "to Liberia—to their own native land," a concept that has been likened to ethnic cleansing.[24] Durant's conflation of these two figures within the installation activates over 100 years of history and delivers it to the present, where struggles for equality continue to be fought.

The work debuting at MOCA ramps up the referentiality of the Emi Fontana installation by adding musical accompaniment, as the artist has done so effectively before. In this presentation, Durant installs twelve unique tree stumps on mirrors to create a virtual forest of otherworldly trees wired to a computer-controlled soundtrack. Haunting, reflective, and politically charged songs such as Billie Holliday's "Strange Fruit," John Lee Hooker's "Blues for Abraham Lincoln," and Public Enemy's "Fear of a Black Planet" alternate from tree to tree throughout the installation and add still more discursive content to the quizzical objects. These musical trees make for a powerful exhumation of history, where a wild diversity of representational modes (sculpture, installation, jazz, blues, punk, opera, funk, reggae, classical, and rap) and an inclusive historical perspective encourages a fresh, careful consideration of a dark and still unresolved chapter in American life. The mirrors of course symbolize such a reflection, but they also create an ambiguous space— a "non-site," in Smithson's parlance—where reality can be questioned and illusions challenged. As elements in Durant's multifaceted inquiry, the mirrors also serve as surprisingly neutral repositories in which his disparate references can freely commingle. Smithson's extensive use of mirrors led him to characterize them in terms quite fitting to Durant's project: "The mirror itself is not subject to duration, because it is an ongoing abstraction that is always available and timeless. The reflections, on the other hand, are fleeting instances that evade measure."[25] Durant, too, seeks to free his subjects from duration so that they resonate throughout time, setting off complex reverberations that envelop audiences in the present. In the riddling zones of his installations, Durant never privileges one answer. He steers away from "either-or" propositions, preferring instead compound reflections that allow us to ruminate the wide web of circumstances that leads to, and ultimately away from, the here and now.

24. Abraham Lincoln, as cited in Eric Foner, "The Education of Abraham Lincoln," *The New York Times Book Review*, 10 February 2002, 11.
25. Smithson, "Incidents of Mirror-Travel in the Yucatan," 96.

SAM DURANTS RÄTSELHAFTE ZONEN

MICHAEL DARLING

In den späten 1960er Jahren initiierte eine Vielzahl von »Kulturarbeitern« gemeinsam einen Wandel, der die angesammelten Merkmale und Maxime des Modernismus hinter sich liess und zu dem führte, was man widerwillig als Postmoderne bezeichnete. Robert Venturis *Complexity and Contradiction in Architecture* (1966) war ein beispielhafter Versuch, die monolithischen Vorstellungen von Geschmack und Schicklichkeit aufzulösen. Er schlug einen neuen, umfassenderen Weg für Kritik und Praxis vor. Diese umfassende Sicht verkündete Aufgeschlossenheit gegenüber der sogenannten »unsauberen Vitalität« des alltäglichen im Gegensatz zur abstrakten Reinheit des Maschinenzeitalters. Sie führte Venturi zu der rhetorischen Frage »ist Massenkultur nicht fast akzeptabel?« (»is not Main Street almost all right?«)[1], und er postulierte entschieden »weniger ist langweilig« (»less is a bore«).[2] Seine Vorstellung von einer Architektur nach dem Modernismus beinhaltete ein größeres Maß an Referenzialität und historischer Kontinuität, um durch Nebeneinanderstellung von Stil und Geschmack urbane Lebhaftigkeit und Bedeutung zu gewinnen. Anstatt gegen absolutistische »entwederoder« Regeln architektonischen Stils vorzugehen, befürwortete er einen »beidesund« Ansatz.[3] Solch eine Haltung ist hilfreich, wenn man die Architektur dieser Zeit betrachtet, da der Bruch mit dem Modernismus weder plötzlich noch klar vonstatten ging. Im Gegenteil, dieser Übergang brauchte einige Zeit, vollzog sich aufgrund einer Reihe unterschiedlicher Beweggründe und ist heute noch spürbar.

Der »beides-und« Weg, die Welt zu sehen, ist von Sam Durant energisch verfolgt worden und zeigt sich in den faszinierenden Arbeiten, die er im Laufe des vergangenen Jahrzehnts hervorgebracht hat. Zwanglos nimmt er ein weites Feld von Bezügen in seine Kunst auf und hat auf diese Weise komplexe, höchst diskursive Gruppen von Objekten erstellt. Wenn man die Vielfalt seiner bevorzugten Medien (Bleistiftzeichnungen, Fotokopie-Collagen, Skulptur, Fotografie, Video, Sound und Installation) sowie die Quellen seiner Anregungen berücksichtigt (die Geschichte des Rock & Roll, minimal-/postminimalistische Kunst, Sozialaktivismus der 1960er Jahre, moderner Tanz, Japanische-Garten-Gestaltung, modernes Design aus der Mitte des 20. Jahrhunderts, Selbsthilfe-Literatur, und do-it-yourself Eigentumsmodernisierung), kann man mit Überzeugung behaupten, dass auch Durant der Meinung ist »weniger ist langweilig«. Es gibt nichts, was nicht zu dem einen oder anderen Zeitpunkt einen Weg in seine Arbeiten gefunden hätte und trotzdem sind die Ergebnisse nie gedankenlose Zufälligkeiten oder alberne Psychedelia. Im Gegenteil, Durants strategische Widersprüche unvereinbarer Materialen überwinden die Barrieren, die bestimmte Konzepte und geschichtliche Fakten eingrenzen, und vermischen sich, wirken aufeinander und regen oft Zusammenhänge scheinbar beziehungsloser Phänomene an. Das Ringen mit den Komplexitäten und Widersprüchen der Kultur des späten zwanzigsten Jahrhunderts ist des Künstlers wichtigstes Bestreben. Bedenkt man das gewaltige Feld seiner Recherchen, wird klar, dass er erst am Anfang seiner ambitiösen Aufgabe steht. Nichtsdestotrotz haben die bislang vollendeten Serien thematischer Installationen ihn und sein Publikum zweifellos auf einen Weg gebracht, der Feinfühligkeit für die Bedeutung kulturbedingter Geschichtsversionen hervorruft und sie auf diese Weise lebendig und für weitere Auseinandersetzungen gegenwärtig und verfügbar hält.

Einer der ersten Versuche Durants, sich mit historischem Revisionismus auseinanderzusetzen, war eine ortspezifische Installation in der von Künstlern organisierten Galerie Bliss in Pasadena. Diese 1992 realisierte Ausstellung mit dem Titel »Pardon Our Appearance…«,

1. Robert Venturi, *Complexity and Contradiction in Architecture*, New York: The Museum of Modern Art, 1966, S. 102
2. Ebd., S. 25
3. Ebd., S. 23

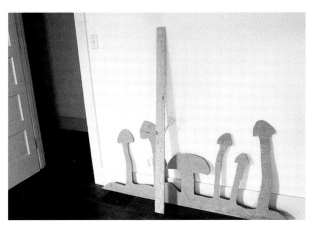

war von dem »Craftsman-Style« Haus angeregt worden, das periodisch als Bliss Galerie genutzt wurde. Das entwicklungsfähige Thema der Installation war Eigenheimmodernisierung und leitete sich von der sowohl historischen als auch zeitgenössischen Bedeutung von »Craftsman« ab: Von den ruskinschen Utopisten, die sich um 1900 in Pasadena angesiedelt hatten, und von den Sears-Markenwerkzeugen für Wochenendarbeiter. Ausgehend von diesen Gegenpolen setzte Durant auf verschiedene Weise sich selbst und den Ausstellungsort psychoanalytischen Betrachtungen aus. Er sah Renovierung als eine Form der Therapie, untersuchte seinen Beruf als Zimmermann im Verhältnis zu seiner Identität als Künstler und erkundete den weit verbreiteten Genuss von Drogen und Alkohol heutiger Bauarbeiter. Diese Methode freier Assoziation – sie überschneidet obere und untere kulturelle Grenzen, springt zwischen Historischem und Zeitgenössischem hin und her und verbindet eine Reihe von Disziplinen – führte zu einer Installation unterschiedlicher Materialien und Themen, die für viele der folgenden Arbeiten des Künstlers den Ton vorgeben sollte.

Auf dem Rasen vor dem Haus suggeriert ein Kreis von provokativ arrangierten Sägeböcken lüsterne Gedanken von bier- und testosterongetriebenen Bauarbeitern. Dazu ein grobschlächtiges Schild, das jene nachäfft, die bei kommerziellen Gebäuden die Renovierung anzeigen. In der Form eines schäumenden Bierkruges mit Beinen bestimmt es den Ton für die Ästhetik der Installation, Low-Tech Amerika und die damit verbundenen Voreingenommenheiten. Im Haus selbst skizzieren weitere dieser grobschlächtig fabrizierten Objekte miteinander verbundene Themen: Gesägte Sperrholzsilhouetten psychedelischer Pilze, Bongs, Pfeifen und Marihuana waren gegen die Wand gelehnt; ein Haufen von tausend gebrauchten Kaffeebechern breitete sich aus einer Ecke in den Raum aus; Schnappschüsse eines in seine Aufgabe vertieften Heimwerkers umrahmen die Kamineinfassung; eine Stegreif-Komposition, bestehend aus einer Baseballkappe, einem Werkzeuggürtel, und einem Paar abgetragener Stiefel dient als Selbstporträt. Die vielleicht bezeichnendste grafische Darstellung der diskursiven Polaritäten dieser Ausstellung fand sich in einem gerahmten gelben, linierten Papierblatt, auf dem der Künstler in zwangloser Handschrift einen Vergleich der drei Tugenden des Modernismus – Klarheit, Einheit, Ehrlichkeit – und den drei Regeln der Klempnerei ausführt: »Scheiße fließt bergab«, »Freitag ist Zahltag« und »Finger nicht in den Mund stecken«. Die Kluft, die Durant zwischen den abstrakten Idealen der modernen Architektur und den praktischen, wenn auch unkultivierten, leitenden Prinzipien der Arbeiterberufe aufzeigt, ist das Gebiet, dem ein Großteil seiner Kunst verwurzelt bleibt – der Raum, in dem die schönen Künste und das tägliche Leben sich selten treffen.

Diese Ausstellung, Durants erste Einzelausstellung, kam zu einem Zeitpunkt als der multikulturelle Diskurs auf seinem Höhepunkt war, als Institutionskritik, Feminismus und die Identitätsdebatten in der Kunstwelt und anderen Bereichen des kulturellen Lebens in vollem Schwung waren.[4] Durants Arbeiten können sicherlich als ein Ergebnis dieser Bewegungen gesehen werden, denn auch er war voreingenommen gegenüber der Unfähigkeit der Avantgarde, eine wirkliche Verbindung zum alltäglichen Leben herzustellen. Ein Großteil der sozial engagierten Kunst dieser Zeit beschäftigte sich vornehmlich mit sexueller und Rassenidentität, doch obgleich in Durants Arbeiten ähnliche Probleme kontinuierlich eine Rolle spielen, hatten seine Untersuchungen in der Regel einen breiteren Fokus. Seine Arbeit war meist so angelegt, zufällige Begegnungen zwischen hoher Kunst und populärer Kultur zu konstruieren, wobei er sich für das »beides-und« anstelle des »entweder-oder« entschied. Erscheinung und Wirkung von Durants Arbeit dieser Zeit verdanken viel dem Einfluss der Arbeiten Mike Kelleys. Auch er brachte die Anliegen der Arbeiterklasse in die vergängliche Nähe der modernen Tradition.[5] Man denke an Kelleys Filzbanner der 1980er Jahre, z.B. *Let's Talk* (1987), in denen sich religiöses, mittelamerikanisches Dekor (und Schuldbewusstsein) beißend mit billigen Kopien moderner Grafik mischt, oder seine Loading Dock Drawings aus dem Jahre 1984, die Witze aus Arbeitervierteln mit neuem Kontext, im Rahmen der schönen Künste präsentieren.[6] Durant sah die *Loading Dock* Arbeiten 1985 in einer Ausstellung der Metro Pictures Galerie, New York, zusammen mit den Arbeiten John Millers. Diese Zwei-Mann Ausstellung revolutionierte Durants Vorstellung von den Möglichkeiten der Kunst, und beide Künstler, insbesondere der ätzend politische Miller, erwiesen sich als höchst einflussreiche Persönlichkeiten für Durant.[7] Millers Auseinandersetzung mit Skatologie und sein soziopolitisches Engagement haben im Laufe der Jahre auf vielfältige Weise ihren Weg in die Arbeiten Durants gefunden. Auch Millers strategische Anwendung von Spiegeln ist von dem jüngeren Durant aufgenommen worden. Die Metro Pictures Ausstellung zeigte mit braunem Acryl überzogene Spiegelarbeiten von Miller, die eine ähnliche Materialwahl von Durant Ende der 1990er Jahre vorwegnahmen. Die »Helter Skelter: L.A. Art in the 1990s«-Ausstellung im Museum of Contemporary Art in Los Angeles – ein Meilenstein – wurde im gleichen Jahr wie die Bliss-Ausstellung gezeigt und präsentierte eine ähnliche Installation von Kelley. *Mike Kelley's Proposal for the Decoration*

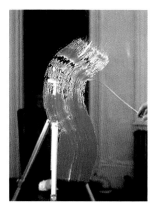

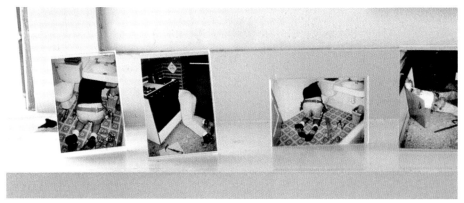

JOHN MILLER
REAL THING #2, 1986
ACRYLIC AND MIRROR; 18 x 14 INCHES
COURTESY OF THE ARTIST AND METRO PICTURES

HEADLESS WORKER, 1992
FOUR C-PRINTS IN PLEXIGLAS FRAMES; 3 x 5 INCHES EACH
COURTESY OF THE ARTIST AND BLUM & POE, SANTA MONICA

4. Technisch gesehen fand Durants erst Soloausstellung außerhalb des akademischen Betriebes Anfang 1992 in der Richard Green Galerie in Santa Monica statt. Die Ausstellung war jedoch in etwa eine Wiederholung seiner M.F.A. Thesis-Ausstellung am California Institute of the Arts im Jahre 1991. Aus diesem Grund betrachtet der Künstler die Ausstellung in der Bliss Galerie als sein erstes professionell konzipiertes Auftreten.

5. Durant arbeitete in den Jahren 1994 und 1995 als Studioassistent für Kelley.

6. Paul Schimmel, »A Full-Scale Model for a Dysfunctional Institutional Hierarchy«, in: Elizabeth Sussman, ed., *Mike Kelley: Catholic Tastes*, New York, Whitney Museum of American Art, 1993, S. 211

7. Gespräch mit dem Autor, 21. Februar 2002

EMPTY #4, 1993
C-PRINT; 20 x 30 INCHES
COURTESY OF THE ARTIST AND BLUM & POE, SANTA MONICA

of an Island of Conference Rooms (with Copy Room) for an Advertising Agency Designed by Frank Gehry (1991) zeigte eine provokative Mischung aus Büro-Witzen, elitären Ränken der Werbeindustrie und der primitiven Ästhetik, die sich bei dem Architekten Frank Gehry und seiner Verwendung grobschlächtiger Baumaterialien findet.

Durants assoziierender, additiver Ansatz ist auch ein Merkmal der Installationen von Jason Rhoades, dessen frühe Arbeiten erstmals zur gleichen Zeit mit denen Durants gezeigt wurden. Rhoades erste ausgereifte Arbeit, *Jason the Mason and the Mason Dickson Linea* (1991), realisierte der Künstler, als er noch an der University of California, Los Angeles studierte. Seine erste Ausstellung in einer Galerie außerhalb des akademischen Betriebes fand 1992 statt, als er *Montgomery Ward Clinique Clinic* im Rahmen einer Gruppenausstellung der Rosamund Felsen Galerie in Los Angeles präsentierte. Durant und Rhoades teilen eine Vorliebe für absurde, alogische Sprünge, die zu bizarren Paarungen und komplizierten Verbindungen führen. Während Durants Vorgehen eher in soziale und politische Gebiete führte, beschäftigte sich Rhoades in seinen Arbeiten mit der Mythologie des Künstlers und des künstlerischen Schaffens. Auch dieser Ansatz war schon in den Arbeiten Mike Kelleys aufgetaucht, dessen ehrgeiziges und komplexes *Plato's Cave, Rothko's Chapel, Lincoln's Profile* (1985) eine Kettenreaktion divergierender Bezüge und Deutungen auslöst, die in einem Feuersturm interagierender Themen explodieren. In Los Angeles einen Künstler zu finden, der nicht von Kelleys überwältigendem und herausforderndem Werk beeinflusst ist, mag eine entmutigende Aufgabe sein. Dennoch, Durant hat sich als einer der reflektiertesten Erben im Hinblick auf die vom älteren Künstler geschaffenen Voraussetzungen entwickelt. Er hat mit Erfolg eine Praxis entwickelt, die sowohl instinktiv als auch gedanklich herausfordernd ist und die ebenfalls den quälenden Grenzen der Sprache und Geschichte gerecht wird.

Nach der Bliss-Ausstellung nahm Durant weitere vielschichtige, von spezifisch amerikanischen Problemen angeregte Themen in Angriff, die er in mehrteiligen, Multi-Media Installationen ausführte. Die Fotografien und Texte in *Melancholic Consolation and Cynicism* (1993) greifen Drogenmissbrauch und Sucht auf, während die Objekte von *Library* (1994) im schöpferischen Terrain der Selbsthilfeindustrie graben. Eine Ausstellung in der Blum & Poe Galerie in Santa Monica 1995 führte fort, was er in der Bliss-Ausstellung begonnen hatte, ein zweiter Blick auf die Beziehungen zwischen Eigenheimmodernisierung, den Wurzeln des Modernismus, und der amerikanischen Psyche. In einer mehr oder weniger schwülstigen Erklärung der Beweggründe für die Installation schrieb der Künstler:

Bezogen auf Designtheorie (Form folgt Funktion) und die darauf folgende Mutation und Evolution, von Herman Miller bis zum K-Mart (Verwässerung und Destillation einer Idee

reflektieren, wie sie durch die Produktion geht und Form annimmt). Unterdrückung als unterdrückter Sub-Text im offenen Grundriss moderner Architektur mit Exhibitionisten im Fenster/Voyeur versteckt in den Büschen. Die Grenze zwischen Innen und Außen fällt, ganze Wände aus Glas werden aufgeschoben, das Badezimmer, das man von jedem Standpunkt, ob drinnen oder draußen, sehen kann, muss fleckenlos/rein gehalten werden – alle Spuren von Aktivität weggewischt. Der Thron wird zur Bühne – der ursprünglich kreative Akt allen vorgeführt. Vielleicht liest der stolze Künstler, während er in seine Produktion vertieft ist, unterschwellig den Geist stärkend gegen das, was den Körper verlässt.[8]

Wie der Text verdeutlicht, zog die Installation den Betrachter in verschiedene Richtungen. Er wird geleitet von mal sich ergänzenden, mal widersprüchlichen Aspekten: Der Designkritik, skatologischem Humor, Klassenbewusstsein, und Freudscher Analyse. Man betrat die Installation durch eine Garten-Schiebetür aus Aluminium und Glas typisch für diese nach Außen orientierten Vorstadthäuser des Westens, aber auch Symbol für die Domestizierung (und Degradierung) des modernistischen Glaskastens. Diese Clear Box, der reduktive Höhepunkt architektonischer Reinheit, wurde überdies durch eine an die Wand montierte Skulptur aus Plexiglas analysiert, die sowohl an ein Element von Donald Judds Stacks als auch an Philip Johnsons Glashaus von 1949 erinnerte. Abgesehen von einer keramischen Miniaturtoilette fehlte in Durants Version jegliche häusliche Ausstattung. Ein Stück transparente Rohrleitung aus Plastik, ohne auch nur eine Spur von Exkrementen, verlief von der Toilette zum Boden. An anderer Stelle, in einer Serie von Bleistiftzeichnungen, sah man eine Toilette provokativ neben Stühlen von Eames, verwandte Symbole modernen Designs, während der Künstler auf Farbfotografien klassische Stühle der Moderne der Mitte des Jahrhunderts in kompromittierenden Stellungen zeigte. Mit den Stuhlbeinen in der Luft sind sie auf eine Art dargestellt, die eine Würdigung ihrer besten Eigenschaften (schwungvolle Linien und elegante Proportionen) verweigerte. Die Positionierung lud zu krassen anthropomorphen Deutungen ein. Der Eindruck drängt sich auf, die Stühle seien geradezu auf Demütigungen vorbereitet. Diese Punk-Geste, normalerweise kunstvoll arrangierte Stühle theatralisch umzustülpen und in geschmackloser Schnappschussmanier zu fotografieren, suggeriert eine Wachablösung, eine Entthronung oder verdiente Strafe durch einen ignoranten Spießbürger. Die Fotografien der Stühle deuten auf einen schwelenden Klassenkonflikt, der sich in vielen folgenden Arbeiten wiederfindet und ein wichtiges Thema für den Künstler geworden ist.

8. Unveröffentlichtes Statement des Künstlers, November 1995

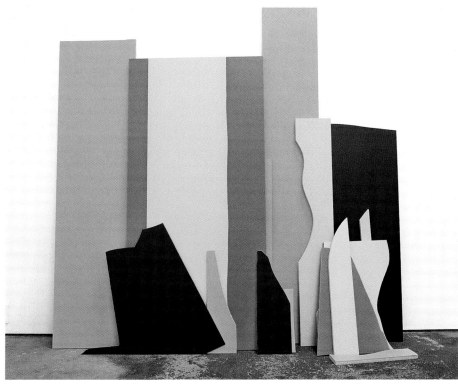

SCRAP RECYCLING PROJECT WITH AMERICAN INGENUITY, 1995, DETAIL
WOOD AND LAMINATE; DIMENSIONS VARIABLE
COURTESY OF BLUM & POE, SANTA MONICA

Eine andere Serie von Fotografien der Blum & Poe Ausstellung, mit u.a. *The Way the World Could Be* und *The Way the World Might Become* (beide 1995), zeigt Auslagen von Küchentheken in Heimwerker-Läden, die gerade repariert, bzw. ersetzt werden. Diese gewollt unästhetischen Ansichten platzieren den Arbeiter zurück in das Bild häuslichen Glücks, wenn auch eher durch seine Abwesenheit als durch tatsächliche Präsenz. Durant schrieb über diese Bilder: »Die Auslagen, vorausgesetzt sie sind vollständig, fungieren sehr ähnlich wie Modelle – als Bühne für die Projektionen der Phantasie. Während der Deinstallation wird die Nahtlosigkeit der beabsichtigten Illusionen unterbrochen und eine neue wird durch die Fotografie postuliert. Für mich charakterisieren diese chaotischen Brüche die Arbeit der Produktion.... beim Akt des ›Modernisierens‹ geht es darum, chaotische Materialien zum fertigen Produkt zu fügen«.[9] Die »Arbeit« solcher »Produktionen« ist jedoch höchst kompliziert, denn solch billige Massenprodukte verzichten auf handwerkliches Können und reduzieren die Erwartungen von Konsumenten und Arbeitern auf neue Tiefen.

Die Arbeit *Scrap Recycling Project with American Ingenuity* (1995) hat vielleicht die weitreichendste symbolische Bedeutung in dieser Ausstellung. Sie repräsentiert einen weiteren Versuch, »Chaos zu kanalisieren«. Hier wurde Abfallholz unterschiedlicher Formen mit farbenfreudigem Laminat beschichtet und in einzelnen Gruppen gegen die Wand gelehnt. Durch die Kombination von Matisse-Scherenschnitten mit Sperrmüllcontainer-Abfall, von Duchamps »Standard Stoppages« mit Sister Corita Kent-Graphiken und John McCracken-Planken zelebriert *Scrap Recycling* auf einer Vielzahl von Ebenen die sogenannten zweiten Chancen. Retrofarben – Senfgelb, Kürbisorange oder Rot, Weiß und Blau – sind Zeugnis der unendlichen Zyklen der Modetrends, während sie gleichzeitig einen bestimmten Moment Mitte der 1970er Jahre festlegen, in dem diese Farbtöne erstmals au courant waren.

9. Ebd.

BAD COMBINATION, 1995
GRAPHITE ON PAPER; 9 x 12 INCHES
PRIVATE COLLECTION

Diese Periode fällt mit der Jugend des Künstlers zusammen und beschwört das Ambiente herauf, »in dem die Nuancen von Repression und List entdeckt wurden, die für den Umgang mit Autorität gebraucht werden«. Die leuchtend neue Umgebung symbolisiert auch die »während der ersten High-School-Jahre, verletzte Identität zu erneuern«,[10] wenn neue Aufmachungen und Formen des persönlichen Ausdrucks in manischer Leidenschaft ausprobiert werden. (Meine eigene schwindelerregende Parade von Rollen – vom Musterschüler zum Punk, zum Mod, zum Rockabilly – scheint sich in verschwommenem Rückblick fast wöchentlich verändert zu haben.) Wie Durant es schaffte, Betrachter wie mich von Badezimmern und dem Bauhaus zu Teenagern in Trenchcoats zu transportieren, ist ein Beweis für seine äußerst geschickte Anwendung von Signifikanten. Die Blum & Poe-Ausstellung etablierte mit Nachdruck, wie seine geschickte Orchestrierung häufig zu überraschenden Ergebnissen führt. So schien es nur angemessen, dass Durant eine Zeichnung über die Schiebetür des Ausgangs geheftet hatte, die eine Toilette und eine an Judd erinnernde Regaleinheit von Ikea zeigte, verbunden durch ein Gewirr von hingekritzelten Zeilen. Auf seinen Arbeitsprozess und das geforderte Engagement des Betrachters anspielend, fügte Durant eine Wendung aus einer Ikea Montage-Anweisung zwischen die beiden Motive – »Follow Me!« – ein nicht unpassendes, dringliches Flehen, das das erforderliche Vertrauen für einen seiner assoziativen Ausflüge zum Ausdruck bringt.

Für Durant ist das Zeichnen ein integraler Teil seines künstlerischen Schaffens, ein Instrument, Ideen zu erkunden, die häufig zu weiteren multimedialen Installationen führen. Zwischen 1995 und 1997 schuf er eine Vielzahl von Bleistiftzeichnungen, die ungewöhnliche Verbindungen aus dem ganzen Spektrum kultureller Produktion zusammenführten. Manchmal waren ganz unterschiedliche Objekte auf einem einzelnen Blatt gepaart, z.B. in *Bad Combination* (1995), auf dem eine Skulptur John Chamberlains in merkwürdiger Beziehung zu einer Kinderzimmerlampe steht. Dann wieder versuchte sich der Künstler an größeren Diptychen wie *Organizational Model, Order, Entropy, Material* (1995), das eine Skizze eines »Scatter Piece« des Postminimalisten Robert Morris in einem und ein Diagramm der Haushaltswasserversorgung in einem zweiten Rahmen zeigte. Durant erklärt die Funktion der Zeichnungen in seiner Arbeit so: »Sie sind auf keinen Fall Lösungen, noch stellen sie irgendeine Form von Kritik oder Abschluss dar. Ihre Funktion ist schlicht, Raum für assoziative Interpretationen zu schaffen, sowohl für mich als auch für den Betrachter. Sie beziehen sich darauf, was ich gesehen, worüber ich nachgedacht habe, während ich das Konzept für eine Installation formulierte. Assoziationen vollziehen sich auf vielen Ebenen. Sie müssen nicht auf der ›Aha‹-Ebene erfolgen. Es geht vielmehr um einen stetigen Prozess, um Verbindungen, die vielleicht Tage, Wochen, oder Monate nach dem Besuch der

10. Ebd.

Ausstellung gemacht werden. Sie sehen aus als sollten sie einen Sinn ergeben, doch das tun sie nicht«.[11] Die Zeichnungen unterstreichen offensichtlich die höchst beziehungsreiche Natur seiner Werke. Sie dokumentieren auf zeitintensive Weise seine Aufmerksamkeit für und die Assimilation von weiten Spektren von Quellen, angefangen von Kunstgeschichts-büchern und alten Kunstmagazinen bis hin zu Möbelkatalogen und Selbsthilfe-Handbüchern. Jedes Image ist gewissenhaft von Hand in seinen neuen Kontext übertragen und zwar in einer Reihe stilistischer Variationen – von grobschlächtig und expressionistisch bis zu federleicht und präzise.

ABANDONED HOUSES

Während es 1995 in der Ausstellung bei Blum & Poe vornehmlich darum ging, Chaos zu kanalisieren, zeigte eine weitere, in der gleichen Zeit entwickelte Ausstellung die Erforschung des Gegenteils: Chaos im Bereich der Ordnung zu stiften. Diese Ausstellung, die für die ehemalige Roger Merians Galerie in New York entwickelt wurde, nahm ebenfalls die moderne Architektur zum Ausgangspunkt, war aber weniger weitläufig angelegt, son-dern konzentrierte sich wesentlich strikter auf ein bestimmtes Thema. Mit sechs freistehen-den Skulpturen und Dutzenden von kleinen Fotokopie-Collagen aus den Jahren 1994 bis 1996 zielte Durant auf eine Degradierung erhabener moderner Häuser, indem er sie dem Druck schlechten Benehmens, schlechten Geschmacks und fehlerhafter Bauweise aussetzte. Bei diesen bis heute wohl bekanntesten Arbeiten Durants handelt es sich um billige, schäbige Nachbildungen der Case Study-Häuser, Musterhäuser führender moderner Architekten, die unter der Patenschaft des Magazins *Arts & Architecture* zwischen 1945 und 1966 in Südkalifornien gebaut wurden. Bestenfalls als impressionistisch zu bezeichnen, liefern Durants Modelle dieser Häuser zwar Skizzen zu Form und Gestaltung der Gebäude, doch machen die verwendeten Materialien, roher Schaumstoff, Pappe, Sperrholz, und Plexiglas, deutlich, dass es sich nicht um einen ernsthaften Versuch handelt, Struktur, Farben oder Baumaterialien der Originale zu reproduzieren. Die Modelle, die auf wackligen Fundamenten aus unbearbeiteten Holzpflöcken stehen, sind nicht nur schlecht gebaut, son-dern waren allen möglichen Misshandlungen ausgesetzt. Häuser von Richard Neutra, Pierre

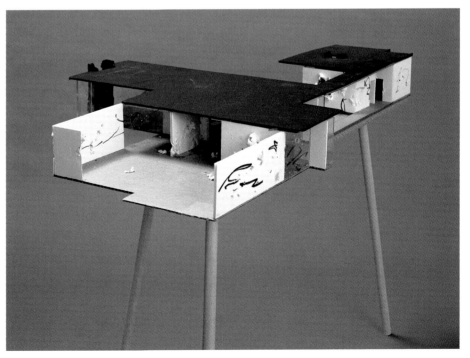

ABANDONED HOUSE #4, 1995

11. Ebd.

Koenig, Killingsworth, Brady, Smith und anderen waren teilweise verbrannt, durchlöchert, mit Graffiti beschmiert und einfach dem Verfall überlassen worden. *Abandoned House # 2* (1995), obwohl im fortgeschrittenen Stadium der Baufälligkeit, glüht von innen heraus durch das blaue Licht eines Miniaturfernsehers. Der zum Licht gehörige Sound macht darauf aufmerksam, dass das TV auf geschmacklose Soap Operas und skandalöse Talkshows wie die von Sally Jesse Raphael oder Jerry Springer geschaltet ist. Ein zusätzlicher Schlag gegen den einstigen Ruhm des Hauses von Neutra.

Andererseits ist dieser »Ruhm«, der durch strenge, kunstvoll arrangierte Fotografien ebenso wie durch anmaßende Architekten beständig beschworen wird, nicht mehr als historische Fabrikation. Durant holt den Betrachter auf den Boden der Tatsachen zurück. Es gelingt ihm zu verdeutlichen, dass nur wenige Eigentümer solcher Häuser ihren messianischen Standards gerecht werden können. Die Absicht hinter dieser manipulierten Regression von abstrakter Reinheit zu »unsauberer Menschlichkeit« liegt darin, das Konzept der Entropie auf den Plan zu rufen. Dieses Phänomen aus dem Bereich der Physik wurde von Robert Smithson in den 1960er Jahren als Methode angewandt, Kunst und Landschaft zu betrachten. Laut Smithson wird Entropie durch den »Zweiten Hauptsatz der Thermodynamik« definiert, der das Ausmaß der Entropie extrapoliert, insofern er besagt, dass Energie leichter verloren geht als gewonnen wird und dass in ferner Zukunft das gesamte Universum ausgebrannt sein wird und nur allumfassende Gleichheit bleibt«.[12] Auch Durants Häuser scheinen diesem Schicksal angesichts der unbändigen Naturgewalten und Kulturzwänge, die sie von ihren Sockeln zerren, entgegenzusehen. Der prätentiöse Anspruch moderner Architektur auf Perfektion und Geschichtslosigkeit macht sie anfällig für diese Entthronung. Smithson führt aus, dass solche »kalten Glaskästen die entropische Tendenz begünstigten« und neue Modelle von Urbanität, wie die von Venturi vorgeschlagenen, hervorbrachten.[13]

Durant vertiefte dieses Thema mit einer Serie von grob hingeworfenen Collagen aus Fotokopien klassisch moderner Häuser, die von abrupten Geschmacks- und Klassenbrüchen gekennzeichnet sind. *Beer Bong* (1995), eine körnige Schwarzweiß-Kopie einer Julius Shulman-Fotografie des Koenig Case Study House # 22 (1959–60), zeigt überraschend zwei Motorrad-Typen in Farbe, die ihr Bier am Pool herunterschütten. Ähnlich in *Modern Moon* (1994), in dem ein kunstvoll entworfener Innenraum eines echt modernen Hauses von einem Hells Angels-Groupie gestört wird, die ihren mit einem Lederstring bekleideten nackten Arsch in die Kamera hält, während *Free Beer* (1995) den fiktiven Augenblick vor einem Überfall des Koenig Case Study House # 21 (1958) durch eine Horde von Rohlingen festhält, die nach Bierfässern suchen. In einem großen Teil der Fotografien, die uns aus

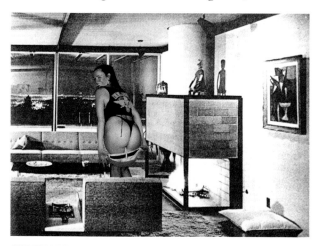

MODERN MOON, 1994

12. Robert Smithson, »Entropie und Neue Monumente«, 1966, in: *Robert Smithson, Gesammelte Schriften*, Kunsthalle Wien, 2000, S. 28
13. Ebd., S. 29

dieser Zeit und der dafür typischen Architektur überliefert wurden, sind keine Menschen abgebildet. Man zog es vor, die mechanische Perfektion der Architektur zu zeigen, einer der Gründe dafür, dass Durants entropische Bilder so witzig und schockierend sind. Selbstverständlich ist das Dekor dieser klassischen Bilder bis ins kleinste Detail kontrolliert, ein Umstand, dem Durant in Collagen wie *Love Seat* (1994), *Yellow Lamp* (1995) und *Pie* (1995) entgegenwirkt. Die implizierte Hygiene des Modernismus wird von Durant in den Arbeiten *Untitled* (1995), *Repression and Material* (1995) und *Kiddie's Room* (1994) auf die Spitze getrieben. Im Rahmen dieser Serie wird mit John Miller-ähnlichen, exkrementellen Übermalungen eine andere Version des Unheimlichen vorgestellt. Dutzende solcher Collagen wurden zwischen 1994 und 1996 produziert. Sie repräsentieren, zusammen mit den Skulpturen, die ersten Recherchen und Äußerungen zum Thema Entropie. Durants entropische Szenarien stellen von nun an die Rückentwicklung von Kultur und Gesellschaft dar. Dabei lösen sich Unterschiede von Klassen und Geschmack im kathartischen kleinsten Nenner auf, während Smithsons Gebrauch des Ausdrucks, so anschaulich er auch ist, sich meist auf den Naturzustand und die konstruierte Umwelt bezieht.

PARTIALLY BURIED WOODSHED

Smithson ist zu einer wichtigen inhaltlichen Quelle für Durant geworden – als Beispiel für den Übergang vom Modernismus zur Postmoderne, als Symbol für das Ende utopischer Träume der Futuristen und Hippies und für die heraufdämmernde dystopische Perspektive. Darüber hinaus ist er ein begnadeter Künstler und Schriftsteller, dessen Werk einer genau(er)en Untersuchung würdig ist. In Durants Arbeiten der Jahre 1998 bis zum heutigen Tag sieht man diesen Bezug. Er beruft sich sowohl konzeptuell (besonders im Hinblick auf Entropie), formell (durch entsprechende Motive und Materialien) als auch metaphorisch (stellvertretend für den Radikalismus der späten 1960er und frühen 1970er Jahre) auf Smithson. Ein erster Beweis findet sich in einer zweiteiligen bildhauerischen Arbeit mit dem Titel *Partially Buried 1960s/70s Dystopia Revealed (Mick Jagger at Altamont)* und *Partially Buried 1960s/70s Utopia Reflected (Wavy Gravy at Woodstock)* (beide 1998). Diese Arbeit Durants stellte sich als wichtiger Vorläufer einer ausgedehnten Untersuchung dieser Epoche heraus. Sie beinhaltet Hinweise auf die Konzerte in Woodstock und Altamont, Smithsons Nonsites und sein *Partially Buried Woodshed* (1970), Skatologie, den Tod, Spiegelungen und Archäologie. Zwei rechteckige Spiegel, auf denen große Erdhügel aufgehäuft sind, stellen einen unverblümten Wink in Richtung Smithon und seine »Spiegel-Versetzungen« *Incidents of Mirror-Travel in the Yucatan* (1968) dar. In den Erdhügeln platzierte Durant je einen Lautsprecher. Einer gab die Ansprache des Entertainers Wavy Gravy vor der enthusiastischen Menge in Woodstock wieder, der andere Mick Jaggers Beschwichtigungsversuche während des katastrophalen Konzerts in Altamont. Der Kritiker James Meyer schrieb, »betrachtet man die Klischees von Woodstock als Utopie und Altamont als Dystopie nüchtern, legen die Tapes und identischen Spiegel nahe, dass die Konzerte Teile eines Ganzen waren. So gesehen steht Altamont weder für Verirrung noch Verrat der Ideale der 60er Jahre, sondern wird zur entropischen Erfüllung der extatischen Erwartungen dieser Epoche«.[14] Wiederum auf die stimulierende Spannung des »beides-und« zurückgreifend, löst Durant eine dialektische Kettenreaktion aus, die von den 1960ern geradewegs in die Gegenwart führt, in der der heutige Betrachter von Stimmen aus dem Grab der Geschichte heimgesucht wird, den Vorboten eines weiteren künftigen Niedergangs. Solche Implosionen, die die Arbeit impliziert, sind ständig vorhandene Bedrohungen, wie Ereignisse aus jüngster Vergangenheit, z.B. der Dot-Com-Absturz, der 11. September, und der Enron-Skandal belegen.

Durants *Partially Buried 1960s/70s*-Arbeiten führen zu einer ausgedehnten Auseinandersetzung mit Smithsons legendärem Werk *Partially Buried Woodshed*, einer auf dem Campus der Kent State University in Kent, Ohio, installierten Erdarbeit. Wenige Monate nach der

14. James Meyer, »Impure Thoughts: The Art of Sam Durant«, *Artforum* 38, Nr. 8, April 2000, S. 115

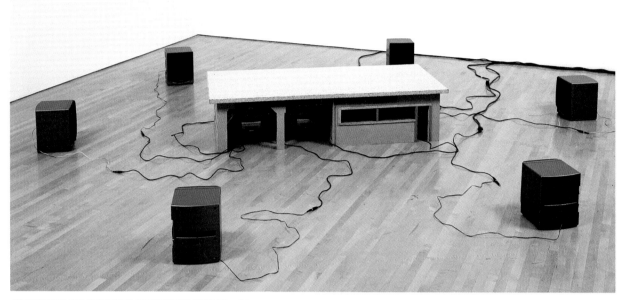

UPSIDE DOWN AND BACKWARDS, COMPLETELY UNBURIED, 1999

Fertigstellung dieser Installation wurden auf dem Campus vier protestierende Studenten von Männern der Nationalen Garde erschossen, die eingesetzt worden waren, um eine Anti-Kriegs-Demonstration aufzulösen. Nach diesem Vorfall wurde die Installation zu einer Gedenkstätte. (1975 wurde ein Teil dieses Monuments in Brand gesteckt und eine Hälfte brannte nieder. Die verbleibende Konstruktion wurde 1984 entfernt). Kent State verkörpert noch heute den Verlust der amerikanischen Unschuld, der durch den Krieg in Vietnam, die Ermordung Kennedys und die Auseinandersetzungen um Civil Rights eingeleitet wurde; Smithsons Werk repräsentiert einen neuen Zynismus und Nihilismus in der zeitgenössischen Kunst. Die Installation wurde geschaffen, indem solange Erde auf den zweckdienlichen Holzschuppen gehäuft wurde bis der tragende Stützbalken brach und auf halbem Wege dieses entropischen Ereignisses zur Ruhe kam. Durant schuf zwei Skulpturen, die auf dem Holzschuppen basierten, *Upside Down and Backwards, Completely Unburied* und *Reflected Upside Down and Backwards* (beide 1999). Hinzu kamen eine Serie von Fotografien und zahlreiche Zeichnungen, die eine Vielzahl von Verbindungen erkunden. Die erste Skulptur ist ein maßstabgetreues Modell, das von sechs Lautsprechern umgeben auf dem Boden steht. Durant verwertet hier Materialien, die stärker als in seinen früheren Case Study Modellen dem Original entsprachen. Mit Hilfe von drei CD-Spielern bringen die Lautsprecher gleichzeitig drei Songs zu Gehör: »Gimme Shelter« der Rolling Stones, »Smells Like Teen Spirit« von Nirvana und »Hey Hey, My My (Into the Black)« von Neil Young. Da die Songs unterschiedlich lang sind und mit Hilfe des Auto-Repeat kontinuierlich spielen, ergeben sich ständig neue Zufälle durch die Liedtexte.

Zum Thema zurückkehrend, wie ein DJ mit einem Re-mix, zeigt die zweite Skulptur zwei aufeinandergestapelte, identische Holzschuppen, der obere stark verbrannt während der untere unversehrt ist. In diesem Fall senden zwei CD-Spieler gleichzeitig akustische Versionen von Nirvanas »All Apologies« und Neil Youngs »My My, Hey Hey (Out of the Blue)«. Die duplizierten Holzschuppen fungieren als Objekte einer Obsession, bzw. als sich fanatisch verjüngende Gebilde, die nach jedem Rückschlag erneut sprießen, oder auch, und vielleicht zutreffender, als reflektierte Merkmale eines Themas, das bei jeder Untersuchung neue Informationen bereithält. Die dazugehörigen Zeichnungen bestätigen die letztere der Interpretationen und machen die musikalischen Komponenten verständlich. Wieder und

It's better to burn out than fade away

wieder interpretiert Durant den Holzschuppen durch arbeitsintensive Bleistiftzeichnungen, hält unterschiedliche Ansichten fest und präsentiert sie mit umfangreichen Hinweisen auf den Kontext. Die Zeichnungen sind grafische Gegenstücke der scheinbar zufälligen Soundtracks. Sie verbinden die disparaten Felder und helfen, die Ausgangspunkte der unkonventionellen Untersuchung des Künstlers zu klären. Mit *Let It Loose/Woodshed* (1998) zum Beispiel, zeigt Durant eine Nahaufnahme der Skulptur von Smithson versehen mit Titeln des Rolling Stones-Albums *Exile on Main Street*, die plötzlich ganz passend entropisch und skatologisch anmuten: »Turd on the Run«, »Stop Breaking Down« und »Let It Loose«. In *It's Better to Burn Out Than Fade Away* (1998) zeichnet er Smithson, wie dieser sich während einer alkoholgetränkten Recording Session neben Mick Jagger und Keith Richards in einen Stuhl zurücklehnt und beschriftet die Paarung mit der titelgebenden Zeile von Neil Young, die er rückwärts in Spiegelschrift unten auf die Zeichnung schreibt. Neil Young erinnerte in seinem Song »Ohio« an das Kent State Massaker, die zitierte Zeile stammt jedoch von seinem Album *Rust Never Sleeps*, einem Titel, der als Ausdruck der Anerkennung des entropischen Prozesses praktisch von Smithson selbst sein könnte.[15] *Into the Black/Rockstar*

15. Smithson schrieb über Rost als Metapher, um zwischen modernistischen, maschinenorientierten Idealen und der neuen Entropie zu unterscheiden, die in den späten 1960ern mit ihren nachindustriellen Ausdrucksformen auftauchte: »Gussstahl und geformtes Aluminium zeichnen sich im Sinne der Technologie-Ideologie dadurch aus, dass sie maschinell hergestellt werden. Stahl ist ein hartes, widerstandsfähiges Material, das die Dauerhaftigkeit technologischer Werte suggeriert. Doch je länger ich über Stahl als solchen nachdenke, desto mehr wird Rost die fundamentale Eigenschaft des Stahls. Im technologischen Bewusstsein weckt Rost die Furcht vor Stillstand, Untätigkeit, Entropie, und Verfall«. Smithson, »Eine Sedimentierung des Bewusstseins: Erdprojekte«, 1968, in: *Robert Smithson, Gesammelte Schriften*, Kunsthalle Wien, 2000, S. 134

(1998) bringt noch eine weitere Referenz in die Gleichung. Hier porträtiert Durant den verstorbenen Sänger der Rockgruppe Nirvana, Kurt Cobain, beziehungslos über dem Titel für Smithsons Holzschuppen gezeichnet, der wiederum auf der Zeichnung nicht zu sehen ist. Wie man weiß, stand das Motto »It's better to burn out than to fade away« in dem von Cobain hinterlassenen Selbstmordbrief. Sein tragischer Tod, so gewöhnlich er auch in den Annalen des Rock & Roll erscheint, kann mit Smithsons eigenem, vorzeitigen Tod bei einem Flugzeugabsturz im Jahre 1973 verglichen werden. Alle diese überraschenden Zufälle sind in einer anderen Zeichnung dieser Serie ausgearbeitet, *Quaternary Field/Associative Diagram* (1998), dessen Format aus dem berühmten Essay »Sculpture in the Expanded Field« der Kunstkritikerin Rosalind Krauss übernommen wurde. In diesem Essay schreibt Krauss über die neuen hybriden »postmodernen« Skulpturen (oder »expanded field«), die in den Jahren von 1968 bis 1970 überall auftauchten.[16] Krauss hebt Smithsons *Partially Buried Woodshed* als ein Beispiel für »Site-Construction« hervor, ganz oben auf dem Diamanten eines von ihr erstellten Diagramms, genau dahin, wo Durant ihn in seiner Version platziert. Davon ausgehend bezieht Durants Diagramm all seine Schlüsselfiguren (Cobain, Young, die Rolling Stones) und Konzepte ein (skatologische Strukturen, Entropie, Liedtext, Popstar), aber letztendlich fehlt ihm die tiefgründige Schärfe des Vorbildes und es bleibt recht hermetisch im Hinblick auf sein eigenes Projekt. Als schlagfertige Antwort auf eine solche Kritik kann die Zeichnung *Rosalind Krauss* (1998) gesehen werden, in der ihr Name in dem Schriftzug erscheint, der auf ihrem Buch *Passages in Modern Sculpture* verwendet wurde und mit einer alles überragenden Marihuanapflanze kombiniert wird, ganz nach dem Motto: »Hier ist dein erweitertes Feld!« (»Here's an expanded field for you!«). Durants faszinierende Verstrickungen von Beziehungen bringen Vergangenheit und Gegenwart, Kunstgeschichte und Popkultur auf eine Weise zusammen, die seinen Quellen zu neuer Bedeutung verhelfen. Das mit Durants Arbeiten konfrontierte Publikum wird eingeladen, diese für neue Diskussionen offenen Quellen im Hier und Heute zu erwägen und auf's Neue zu diskutieren. Die Skulpturen, Zeichnungen und Fotos spulen Geschichte zurück und mischen sie neu auf (wie durch die Zeichnung *Counterclockwise* (1999) angedeutet, in der die Zeit zurückgedreht wird, um den Holzschuppen wieder zu besuchen). Dies geschieht sowohl durch neu genutzte, wiedergewonnene Bilder, durch Spiegelungen als auch durch die Verschmelzung von Liedtexten:

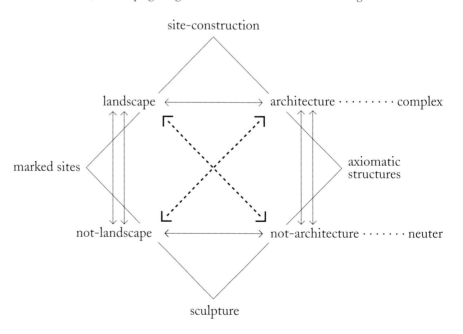

DIAGRAM FROM ROSALIND KRAUSS'S "SCULPTURE IN THE EXPANDED FIELD," 1978

16. Rosalind Krauss, »Sculpture in the Expanded Field«, 1978, in: *The Originality of the Avant-Garde and Other Modernist Myths*, Cambridge, Mass., The MIT Press, 1985, S. 284–87

Tin soldiers and Nixon coming
We're finally on our own
This summer I hear the drumming
Four dead in Ohio
 —*Neil Young, »Ohio«*

Oh, a storm is threat'ning
My very life today
If I don't get some shelter
Oh yeah, I'm gonna fade away
 —*The Rolling Stones, »Gimme Shelter«*

Load up on guns
Bring your friends
It's fun to lose
 —*Nirvana, »Smells Like Teen Spirit«*

In the sun
In the sun
I'm married
Buried
 —*Nirvana, »All Apologies«*

And once you're gone,
You can't come back
When you're out of the blue
And into the black
 —*Neil Young, »Hey Hey, My My (Into the Black)«*

Sein Werk akzeptiert und sucht Komplexität, um ein dichteres, mit reicherem Kontext versehenes Bild der Geschichte zu schaffen. Ein Bild, das über die spezialisierten Quellen zu den einzelnen einbezogenen Themen hinausreicht und gleichzeitig den alles verschlingenden Geist Smithsons sowie die ideologischen Schlachten der späten 1960er und frühen 1970er Jahre durch die Worte Neil Youngs repräsentiert: »There's more to the picture/Than meets the eye/Hey hey, my my«.

ALTAMONT
Ähnlich reiche Quellen assoziativen Materials fand Durant in den Begleitumständen des unglücklichen Konzerts auf der Rennstrecke von Altamont im Jahre 1969. Durant widmete diesem folgenreichen Ereignis ein weiteres ausführliches und vielschichtiges Werk. Altamont, im kalifornischen Tracy gelegen, hatte man sich als das Woodstock der Westküste vorgestellt, doch geriet die Menge und das Sicherheitspersonal (rekrutiert aus den Reihen der örtlichen Hells Angels-Banden) außer Kontrolle. Das Ergebnis war der Tod eines revolverschwingenden Besuchers durch die Hells Angels, zwei tödliche Unfälle von Fans, die auf dem Parkplatz überfahren wurden, und ein weiterer Toter, der unter LSD-Einfluß von einem Aquadukt gefallen war.[17] Durant beleuchtete das Thema noch einmal mit einer Serie von Skulpturen, Zeichnungen und Videos. Dabei führten seine redigierenden Fähigkeiten zu neuen Ergebnissen. Die zentrale skulpturale Arbeit dieser Gruppe, erstmals bei Blum & Poe im Jahre 1999 ausgestellt, ist *Proposal for Monument at Altamont Raceway, Tracy, CA* (1999). Sie bestand aus einer hölzernen Sockelplatte, auf die der Künstler einen sich ausbreitenden Fluss von beigem Polyurethan-Schaum ergoss, der vage an die trockenen, öden Hügel von Tracy erinnerte. Noch eher deutet dieser Hügel künstlichen Materials

17. Christopher Miles, »Sam Durant: Going with the Flow«, *art/text*, Nr. 63, November 1998/Januar 1999, S. 48

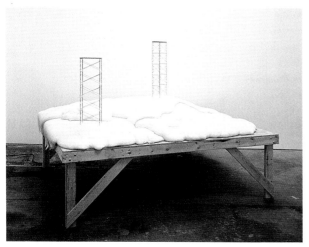

PROPOSAL FOR MONUMENT AT ALTAMONT RACEWAY, TRACY, CA, 1999

TASTE GOOD/MIRRORED, 1999

jedoch auf Smithsons aussickernde Erdarbeiten *Asphalt Rundown* und *Glue Pour* (beide 1969) oder Lynda Benglis' formlose Schaumskulpturen derselben Zeit wie zum Beispiel *For Carl Andre* (1970). In diese entmutigende Landschaft sind zwei kleine Gerüsttürme gestellt, ähnlich jenen, die man für den Aufbau der Soundausrüstung bei großen Open-Air-Konzerten sieht. Die beiden sich wiederholenden, identischen industriellen Gerüsteinheiten erinnern an Arbeiten von Smithsons und Benglis' Kollegen Carl Andre und suggerieren gleichzeitig drohende Überwachungstürme. Dieser kombinierte Effekt erzeugt ein Gefühl von Trostlosigkeit und Langeweile, das durch einen lauten Soundtrack weiter verstärkt wird, der von einem Gerät unter der Plattform ausgestrahlt wird. Gespielt wird der Song »Brown Sugar« von den Rolling Stones, und zwar rückwärts und überlagert, sodass der Bedeutung des rassistischen und frauenfeindlichen Textes entgegengewirkt und er so in der Zeit gefangen wird, ähnlich wie auch die fließende Landschaft erstarrt. Durants Bezeichnung dieser Arbeit als Monument ruft Smithsons Essay »Entropie und Neue Monumente« in Erinnerung, der sich durch poetische Reflektionen über die post-industrielle Landschaft auszeichnet und praktisch das Projekt des jüngeren Künstlers beschreibt:

Während uns die alten Monumente an die Vergangenheit erinnern, lassen uns die neuen Monumente eher die Zukunft vergessen. Sie sind nicht aus natürlichen Materialien wie Marmor, Granit oder anderen Gesteinen gemacht, sondern aus künstlichen Materialien: Plastik, Chrom, elektrisches Licht. Sie sind nicht für alle Zeiten gemacht, sondern eher gegen die Zeiten. Statt der Darstellung jahrhundertelanger Zeiträume betreiben sie eine systematische Reduktion der Zeit bis auf Bruchteile von Sekunden. Vergangenheit und Zukunft werden beide in einer objektiven Gegenwart platziert. Diese Art von Zeit hat wenigen oder gar keinen Raum, sie ist stationär und bewegungslos, sie geht nirgendwo hin, sie ist eine un-newtonsche Zeit und sie besteht im Augenblick, und sie ist gegen die Räderwerke der Zeit-Uhr.[18]

Die erstarrte, unbevölkerte Landschaft sowie der erstickende Würgegriff des Soundtracks von Durants *Proposal for Monument at Altamont* weckt genau das von Smithson geschilderte nihilistische Szenarium. Es bringt die Vergangenheit hervor, fängt sie jedoch in der Gegenwart, ohne einen klaren Weg in die Zukunft zu weisen. Die spiegelgleichen Türme und die rückläufige Musik verstärken diesen Effekt und bestimmen das Leitmotiv dieser Arbeit. Ein hierauf bezogenes Video, *Entropy in Reverse (Gimme Shelter Backwards)* (1999), erzielt eine ähnliche Wirkung. Der Dokumentarfilm der Brüder Maysles läuft rückwärts auf Twin-Monitoren. Auf diese Weise werden die Ereignisse während des Konzerts kontinuierlich aufgehoben und verweigern so, trotz des bekannten, schrecklichen Ausgangs, die

18. Smithson, »Entropie und Neue Monumente«, in: s.o., S. 28

Auflösung. Bleistiftzeichnungen extrapolieren die Verbindungen von post-minimalistischer Skulptur, skatologischen Metaphern, Altamont und dem beschämenden Text von »Brown Sugar«, dem Song, der von den Stones kurz nach der Ermordung des Fans durch die Hells Angels gespielt wurde. In einer den früheren Arbeiten, die *Partially Buried Woodshed* behandeln, nicht unähnlichen Weise führen *Glue Horizon, Brown Sugar Rundown, Landscape/Shit Covered* und *Taste Good/Mirrored* (alle 1999) diese Beziehungen in rasendem Stil zusammen und tragen so ebenfalls zur finsteren Atmosphäre bei. Zusammen mit *Proposal for Monument* wurde eine Arbeit mit dem Titel *Altamont* (1999) ausgestellt, die an die Wand montierte Spiegel und grauen, schlaff herabhängenden Filz kombiniert und, an die Arbeiten des Post-Minimalisten Robert Morris erinnernd, den Einbruch von Zeit, Fortschritt und Bedeutung einfängt. Als Ganzes gesehen stellt dieses Werk Durants eine seiner dunkelsten Beschwörungen der Entropie dar und bewirkt in seiner reflektierten, völlig unsentimentalen Art, diese epochale Periode jüngster Vergangenheit in der Erinnerung wachzuhalten.

FRIENDSHIP PARK

Die deprimierenden Themen, die Durants Arbeiten zu Altamont innewohnen, führen im Jahre 2000 zu einer weitaus verspielteren und obskuren Sammlung von Referenzen. Durant schuf ein zweites *Proposal for Monument*, dieses Mal, um dem Auftreten des sogenannten Southern Rock, eines musikalischen Genres der frühen 1970er Jahre, zu gedenken. Durants intensive Beschäftigung mit Neil Young in früheren Werken förderte in dessen Song »Southern Man« eine Anklage des rassistischen Südens zutage und vertiefte Durants Interesse an der Interpretation politischer und sozialer Realitäten in populärer Musik. Lynyrd Skynyrd wiederum, eine Rockband aus dem amerikanischen Süden, schrieb in ihrer klassischen Kneipenhymne »Sweet Home Alabama« die Zeile »Old Neil put her down, but the Southern Man doesn't need him anyhow«, eine enthüllende Antwort auf die nagenden rassistischen Spannungen zwischen dem Norden und Süden. Die daraus resultierende Arbeit, *Proposal for Monument in Friendship Park, Jacksonville, FL* (2000), stellt Durants bislang wohl ungestümste Verstrickung von Beziehungen dar. Hier wirft er ein weites und befreiendes Netz, in dem sich eine Menge bizarrer und grundlegend enthüllender Zitate sammeln. Scheinbar weniger Smithson verpflichtet als seine zwei vorhergehenden Arbeiten teilt *Friendship Park* dennoch die von Smithson bevorzugte post-strukturalistische, linguistische Freiheit. Auch die produktiven Methoden verlaufen parallel zu den Ideen, die man in Smithsons wichtigem Traktat »Eine Sedimentierung des Bewusstseins: Erdprojekte« findet:

Die Namen von Mineralien und die Mineralien selbst unterscheiden sich nicht voneinander, denn was den Buchstaben wie der Materie zugrunde liegt, ist der Anfang einer abgründigen Zahl von Rissen, Wörtern und Steinen, die eine Sprache enthalten, die einer Syntax von Spalten und Brüchen folgt. Wenn man ein beliebiges Wort lang genug anschaut, sieht man, wie es in einer Serie von Verwerfungen aufbricht, sich in ein Terrain von Partikeln verwandelt, die alle ihre eigene Leere enthalten. Diese beunruhigende Sprache der Fragmentierung erlaubt keine einfache gestalthafte Lösung; die Gewissheiten des didaktischen Diskurses werden in die Erosion des poetischen Prinzips hinabgestürzt.[19]

Durant, so scheint es, hat sich das Wort »Felsen« lange genug angesehen, um ein System von Rissen zu finden, das in unzählige Richtungen führte und dann wiederum zur Grundlage für sein *Friendship Park* wurde. Southern Rock brachte ihn dazu, über geologische Steine nachzudenken und sein für einen öffentlichen Park konzipiertes Monument führte wiederum dazu, Isamu Noguchi, den Meister der öffentlichen Steingärten näher in Betracht zu ziehen. Als Künstler mit seriösem »Stammbaum« – er war Anfang des 20. Jahrhunderts bei Constantin Brancusi in die Lehre gegangen – war Noguchi dafür bekannt, Formen auf das Wesentliche zu bringen. Er selbst beschrieb (äußerst bequem für Durant) seinen Versuch, »das Physische zu transzendieren und zu einer Neugeburt des Objektes zu kommen: dass ein

19. Smithson, »Eine Sedimentierung des Bewusstseins: Erdprojekte«, 1968, in: s.o., S. 136

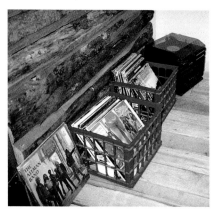
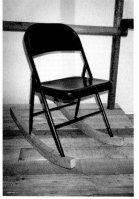
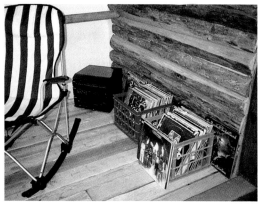

PROPOSAL FOR MONUMENT IN FRIENDSHIP PARK, JACKSONVILLE, FL, 2000, DETAILS

Stück Felsen mehr wird als nur ein Felsen«.[20] Durant beschloss, dass das Image seines Monuments von der typischen Veranda einer Sumpfhütte inspiriert sein sollte, und wie das Glück es wollte, arbeitete auch Noguchi gerade an genau so einem Bühnenbild, das er im Auftrag der Choreographin Martha Graham für ihr Stück *Appalachian Spring* herstellte. Innerhalb dieses Rahmens erschienen alle möglichen provokativen Widersprüche zwischen oben und unten, Osten und Westen, Vergangenheit und Gegenwart, natürlich und künstlich, ideal und real. Faszinierende Dispute zur Frage von Identität sowie Aspekte der Vermischung werden von der naturgetreuen Installation und einer für Durant charakteristischen Fülle von Arbeiten auf Papier aufgeworfen.

Die Installation *Friendship Park* präsentiert die Fassade einer für den Süden typischen Hütte, eine Wandkonstruktion aus übereinandergestapelten Balken, versehen mit einem Wellblechdach, einem mit Zeitungen abgedeckten Fenster und einer geräumigen Veranda, auf der ohne Schwierigkeiten Schaukelstühle, Kisten mit Langspielplatten, und Schallplattenspieler Platz finden. Die Schaukelstühle sind ein White-Trash-Mischmasch moderner Entwürfe wie die von Charles und Ray Eames aus den 1950er Jahren, aber auch geeignete Gegenmittel zu dem unfunktionalen, minimalistischen Schaukelstuhl, den Noguchi für Martha Grahams *Appalachian Spring* im Jahre 1944 entwarf. Durants Stühle sind den Klappstühlen billiger Mietshäuser angepasst; an den Füßen ist eine gebogene Laufschiene befestigt. Die Sammlung der Langspielplatten besteht aus Southern Rock-Klassikern, die der Betrachter auf den beiden Plattenspielern ablaufen lassen kann. Einer der beiden ist manipuliert und spielt die Alben rückwärts. Wäre dieses Monument in der Tat in Jacksonville installiert, würde die Veranda als Ort für Jam-Sessions aufstrebender Musiker dienen. In den späten 1960ern war der Park eine Brutstätte zukünftiger Stars des Southern Rock. Die Konzerte an Sonntagnachmittagen brachten Musiker hervor, die später in Bands wie der Allman Brothers Band, Lynyrd Skynyrd, Blackfoot, 38 Special, Grinderswitch und Wet Willie spielten.[21]

Der Sound der Platten wird in *Friendship Park* durch in Fiberglas-Felsen und einem Mülleimer platzierten Lautsprechern verstärkt. (Es scheint impliziert, dass die Lautsprecher auch Livemusik übertragen könnten, sollten wirkliche Bands auf Durants Bühne spielen wollen.) Die künstlichen Felsen und mit Kieseln furnierten Mülleimer sind in Form der Zahl Acht ausgelegt, um so das zeitlose Konzept Unendlichkeit anzudeuten und obendrein die Felsengärten des japanischen Zens nachzuäffen, z.B. des berühmten Gartens des Ryoanji Tempels in Kyoto. Bekanntermaßen war es Noguchi, durch den japanische Steingärten für öffentliche Plätze der westlichen Welt Bedeutung erlangten. Seine auf diese Räume

20. Isamu Noguchi, in einem Interview mit Friedrich Teja Bach, 19. Februar 1975; in: *Constantin Brancusi: Metamorphosen plastischer Form*, Köln, 1987, S. 291

21. Aus einem unveröffentlichten Statement des Künstlers, 2000

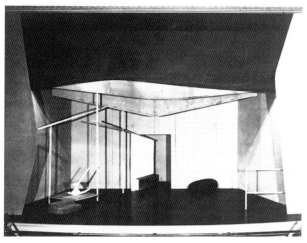

ISAMU NOGUCHI'S SET FOR *APPALACHIAN SPRING*, 1944 *FRIENDSHIP PARK STAGE SETS*, 2000

bezogenen Überlegungen waren sowohl von östlicher Philosophie als auch von modernistischen Vorstellungen von Abstraktion beeinflusst. Über seinen *Sunken Garden* für die Chase Manhattan Bank Plaza in New York (1961–64), in dem natürliche Felsen in eine geformte, stilisierte Landschaft eingebettet sind, die unterhalb der Bodenoberfläche angelegt und gelegentlich durch fließendes Wasser zur Geltung gebracht wird, erklärt Noguchi: »Mir ist aufgefallen, dass dieses großartige Gebäude bei Besuchen an ruhigen, einigermaßen windigen Sonntagen unheimliche Musik von sich gibt, und ich kann mir vorstellen, dass der Blick hinunter in den Garten mit dem fließenden Wasser wie ein Blick in eine turbulente Seelandschaft anmutet, aus der diese immobilen Felsen in das Universum abheben«.[22] Aus diesem Kontext genommen und auf Durants Rock & Roll-Garten angewendet, könnten Noguchis nebelhafte, Weltraumzeitalter-Betrachtungen genausogut Meere dürftig bekleideter Kiffer beschreiben, die sich zu Gitarrensolos wiegen und mit einem andersgearteten interplanetaren Flug entschweben. In Durants öffentlichem Park wird das Nachdenkliche vom Rüden verdrängt und Symbole der sublimen Natur (gigantische exotische Felsen) werden gegen Merkmale zeitgenössischer, funktionaler öffentlicher Orte (Mülleimer) ausgetauscht.

Viele andere ironische Zufälle kommen in den dazugehörigen Arbeiten ins Spiel, unter anderem Vergleiche von der Arbeit des minimalistischen Bildhauers und Architekten Tony Smith mit südstaatlichen Dialekt-Konstruktionen, die man in Arbeiten auf Papier wie *Backporch Combination*, *Friendship Park Vocabulary* und *Parson's House with Cabin* (alle 2000) findet. Die letztere stellt ein knorriges von Smith für die New Yorker Kunsthändlerin Betty Parsons entworfenes Haus neben ein hinterwäldlerisches Gebäude. Die Felsen in Noguchis japanischen Gärten waren so installiert als sollten sie sich mit Erde und »Urmasse« verbinden. Ein Konzept, das in Zeichnungen wie *Major Connections*, *Akari and Rock Pile*, und *Friendship Park–Primordial Mass* (alle 2000) auf komische Weise zutrifft, bedenkt man die mit Florida assoziierte sumpfige Substanz.

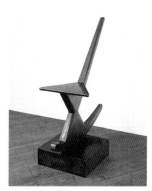

ISAMU NOGUCHI
*ROCKING CHAIR FROM
APPALACHIAN SPRING*, 1944
BRONZE; 40 ³/₄ x 33 ¹/₂ x 15 ³/₄ INCHES
COURTESY OF THE ISAMU
NOGUCHI FOUNDATION, INC.

Auch eine Serie farbenfreudiger Poster im Stil der Rockkonzertwerbung ist auf diese Arbeit bezogen. Sie setzen das Mischen und Paaren der verschiedenartigen Quellen des Künstlers fort. Mit jeder neuen Enthüllung der Arbeit wird ein neues Poster gezeigt. Eine von dieser Arbeit abgeleitete Installation, *Southern Rock Garden Beginningless/Endless Primordial Connection to a Floating World with Consciousness of Sheer Invisible Mass* (Sound: Takeshi Kagami) (2000), wurde in der Tomio Koyama Galerie in Tokio gezeigt. Hier waren sowohl die Hinweise auf Southern Rock als auch die bastardisierten, rüpelhaften Steingärten in beson-

22. Noguchi, »New Stone Gardens«, *Art in America* 52, Nr. 3, Juni 1964, S. 89

derem Maße exotisch. So unterhaltsam und lohnend es ist, den unzähligen Assoziationen dieser und anderer Arbeiten Durants zu folgen, entzieht sich sein Werk letztendlich einer erschöpfenden Analyse. Eine jede seiner Arbeiten ist zu weitläufig, zu sehr mit mannigfaltigen Bedeutungen überzogen, um abschließend definiert werden zu können. Für manch einen mag das Fehlen einer einheitlichen Gestalt enttäuschend sein, doch für Betrachter, die an einer komplizierteren, ausführlichen und nachhaltigen Diskursivität interessiert sind, sind Durants beeindruckende, alles umfassende Szenarien immer der Mühe wert.

UPSIDE DOWN: PASTORAL SCENE

Seine neuesten Unternehmungen führen Durant wiederum zu Smithsons umfangreichem Werk zurück, um ein weiteres Kapitel der stürmischen Geschichte der 1960er und 70er Jahre zu ergründen. Beginnend mit einer Ausstellung in der Mailänder Galerie Emi Fontana im Jahre 2001 und weiterentwickelt für eine ehrgeizige, neue Installation im Rahmen seiner Ausstellung im Museum of Contemporary Art, Los Angeles im Jahre 2002, verwendet der Künstler Smithsons Motiv des umgestülpten Baumes, um die anhaltenden und explosiven Auseinandersetzungen um die Civil Rights (der afroamerikanischen Bevölkerung) zu erforschen. Smithson vollendete drei solcher Skulpturen vor seinem Tod im Jahre 1973, darunter eine, die er mit Robert Rauschenbergs Hilfe auf einem Strand in Florida schuf. Die Bäume deuten einen völlig unnatürlichen Zustand an, ein Beweis menschlichen Eingreifens und darüber hinaus sogar eine Art sadistischer Gewalt, und gleichzeitig verkörpern sie auch eine neue Perspektive und Ordnung, eine zweite Lebenschance für die umgefallenen Objekte, eine Chance, wieder Wurzeln zu schlagen. Smithson erkannte die Dualität dieser Geste als er über die im Dschungel des mexikanischen Yucatans geschaffene Version schrieb:

Sind sie Totems des Unverwurzeltseins, die in Beziehung zueinander stehen? Bezeichnen sie einen verschlungenen Weg von einem zweifelhaften Punkt zum nächsten? Vielleicht sind sie dislozierte »Nord- und Südpole«, die periphere Orte markieren, Polargebiete des Bewusstseins, die in gewöhnlicher Materie fixiert sind – Pole, die sich aus ihrer geografischen Verankerung der Erdachse gelöst haben. Mittelpunkte, die die Mitte verlassen haben. Sind sie tote Wurzeln, die verloren an umgekehrten Baumstämmen hängen, in einem weiten »Niemandsland«, das in die Leere treibt? In diesen rätselhaften Zonen ist nichts sicher.[23]

Durant platziert seine Baumstümpfe – jeder einzigartig, geformt aus bemaltem Fiberglas mit organischen, aufgepfropften Wurzeln, die sich ca. einen Meter über dem Boden winden – auf große Spiegel. Auf diese Weise wird der Stamm verdoppelt und in die unermessliche Leere des Spiegels reflektiert. Wie Smithsons Bäume so sind auch Durants Skulpturen »gelöst aus ihrer geografischen Verankerung« der Welt genau wie die konventionelle Bedeutung, die aus dem Kontext in jene »rätselhaften Zonen« gezerrt wird, in denen so viele von Durants Arbeiten operieren. Bei Emi Fontana wurde einem einzelnen Baum eine große Bleistiftzeichnung beigefügt, auf der die Bestandteile dieses neuen Kontextes ausgeführt wurden. Ein Porträt von Bobby Seale, neben Huey Newton Mitbegründer der Black Panther-Partei im Jahre 1966, teilte den Platz mit einer Zeichnung eines Stapels von Büchern, die von Eldridge Cleaver, einem Gefährten aus der Zeit der Panther, geschrieben waren. Der Titel, *Heap of Language (Soul on Ice)* (2001), war zum Teil einer Arbeit von Smithson entlehnt. Eine Zeichnung eines der umgestülpten Bäume Smithsons, *A Garbage Dump Doesn't Need to Grow Trees to Reach the Heavens, the Fumes Rise and Rise* (2001), war gepaart mit einer umgekehrten Wiedergabe des philosophischen Stammbaums, der auf dem Cover des Buches *The American Evasion of Philosophy: A Geneology of Pragmatism* (1989) des schwarzen Intellektuellen Cornel West abgebildet ist. Neben dieser Zeichnung mit dem Titel *Standing on Our Head* (2001) hängt eine weitere Zeichnung eines Baumes *Standing Upside Down* (2001), diesmal mit einem auf den Kopf gestellten Album-Cover der Southern

23. Smithson, »Begebenheiten auf einer Spiegel-Reise in Yucatan«, 1968, in: *Robert Smithson, Gesammelte Schriften*, Kunsthalle Wien, 2000, S. 151

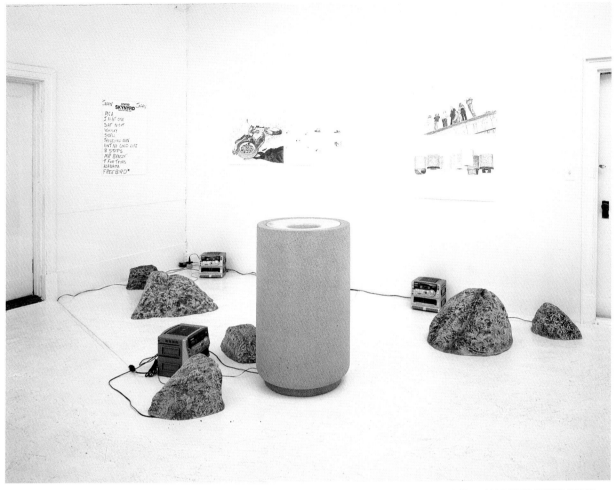

SOUTHERN ROCK GARDEN BEGINNINGLESS/ENDLESS PRIMORDIAL CONNECTION TO A FLOATING WORLD WITH CONSCIOUSNESS OF SHEER INVISIBLE MASS (SOUND BY TAKESHI KAGAMI), INSTALLATION AT TOMIO KOYAMA GALLERY, TOKYO, 2000

Hip-Hop-Band Goodie Mob mit dem Titel *Still Standing*. Plötzlich waren Smithsons Bäume mit der schmerzlichen Geschichte des amerikanischen Südens und den neueren rassentheoretischen Ausführungen von West verflochten. Im Süden war der Baum ein Symbol für Lynchjustiz und in weiterem Sinne ein Symbol für militante Aktionen schwarzer Aktivisten in den 1960er Jahren wie Cleaver, Seale und Newton. Die mit dem Projekt *Friendship Park* initiierte Untersuchung der südstaatlichen Kultur führte unweigerlich zu Rasse als Thema, zumal Rocker wie die von Lynyrd Skynyrd nicht selten, unter der Flagge der Konföderation auf enthusiastischen Parties zu sehen waren. Das allein ist ein Minenfeld sozio-kultureller Probleme.

Wie von Durant nicht anders zu erwarten, liefert er nicht einfach vorgezeichnete Polaritäten. Im Gegenteil, er orchestriert widersprüchliche und individuell aufgeladene Beziehungen, um eine umfassendere Erwägung seines gewählten Themas zu provozieren. Abgesehen von einer illuminierten Lichtbox mit dem Text eines Protestschildes aus dem Jahre 1960, zeigt er in dieser Ausstellung mit einem Doppelporträt eine Arbeit, die vielleicht alle anderen an Komplexität übertrifft. *Inversion, Proposal for the Five Dollar Bill (Huey Newton, Founder of the Black Panther Party for Self-Defense)* (2001) ist ein vertikal orientiertes Diptychon mit dem launischen Huey Newton über einem umgekehrten Porträt von Abraham Lincoln, den Effekt der Baumskulptur auf dem Spiegel nachahmend. Ist bei Lincoln der Ursprung der Black Panther zu suchen oder sind die beiden Männer Reflektionen eines gewöhnlichen,

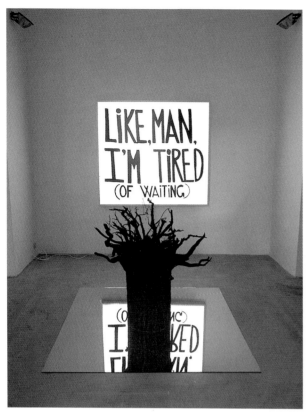

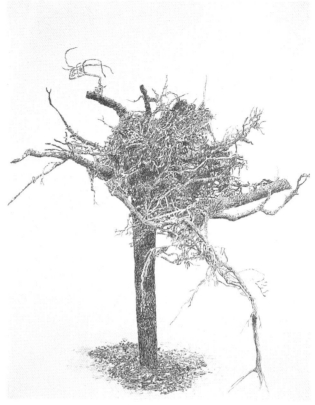

LIKE, MAN, I'M TIRED OF WAITING AND *TANGLED, CHAOTIC, DISCONTINUOUS…,*
BOTH 2001; INSTALLATION AT GALLERIA EMI FONTANA, MILAN, 2001

A GARBAGE DUMP DOESN'T NEED TO GROW TREES TO REACH THE HEAVENS,
THE FUMES RISE AND RISE, 2001

noch nicht erkennbaren Objekts? Newton war einer der sichtbarsten Persönlichkeiten der Black-Power-Bewegung und Lincoln wurde gefeiert, weil er die Vereinigten Staaten mit Erfolg durch den Bürgerkrieg und aus der institutionalisierten Sklaverei führte; dennoch verkörpern beide eine Reihe von Widersprüchen und stellen umstrittene Figuren in den Annalen der amerikanischen Civil-Rights dar. Newton hatte sich habilitiert, war aber lange drogenabhängig, zweimal wegen Mordes angeklagt und hatte eine nicht unerhebliche Zeit im Gefängnis gesessen. Man hob ihn auch als Märtyrer der Bewegung aufs Schild, ein durch den Widerspruch von guten Absichten und seiner Vorliebe für Gewalt kompliziertes Unterfangen. Lincoln hingegen war durch seine berühmte »Gettysburg Address« unsterblich geworden, unterstützte allerdings für viele Jahre die Idee, die befreiten Sklaven »nach Liberia, in ihr eigenes Heimatland« zu schicken. Ein Konzept, das man mit ethnischer Reinigung verglichen hat.[24] Durants Installation bewirkt eine Verschmelzung der beiden Persönlichkeiten, aktiviert mehr als 100 Jahre Geschichte und befördert sie ins Heute, in dem die Kämpfe um Chancengleichheit ohne Unterbrechung fortgeführt werden.

Die im MOCA erstmals ausgestellte Arbeit führt die Beziehungsfülle der bei Emi Fontana gezeigten Installation durch Hinzufügung begleitender Musik auf eine neue Ebene, wie der Künstler das schon in früheren Arbeiten erfolgreich tat. In dieser Präsentation installiert Durant zwölf verschiedene Baumstümpfe auf Spiegeln, eine Art Nachbildung eines virtuellen Waldes einer anderen Welt. Die Baumstümpfe sind mit einem durch Computer kontrollierten Soundtrack verdrahtet. Quälende, reflektierte und politisch geladene Songs wie Billie Hollidays »Strange Fruit«, John Lee Hookers »Blues for Abraham Lincoln« und Public Enemys »Fear of a Black Planet« wechseln von Baum zu Baum der Installation und bereichern den diskursiven Gehalt der seltsamen Objekte. Im Tandem mit den Zeichnungen

24. Abraham Lincoln, zitiert aus Eric Froner, »The Education of Abraham Lincoln«, *The New York Times Book Review*, 10. Februar 2002, S. 11

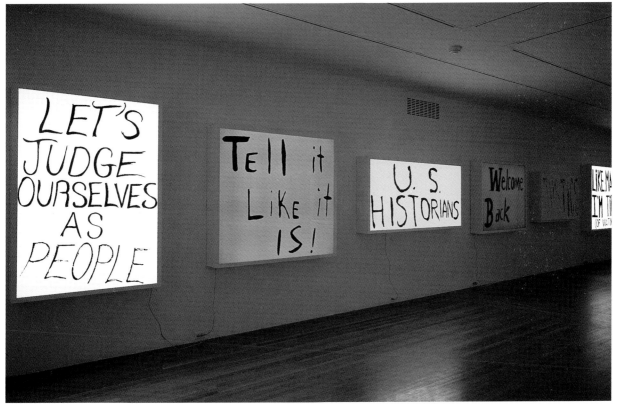

"7 SIGNS": REMOVED, CROPPED, ENLARGED AND ILLUMINATED (PLUS INDEX)"
INSTALLATION AT WADSWORTH ATHENEUM MUSEUM OF ART, HARTFORD, CONNECTICUT, 2002

streben diese musikalischen Bäume nach einer kraftvollen Exhumierung von Geschichte; eine ungestüme Vielfalt präsentierter Formen (Skulptur, Zeichnung, Literatur, Philosophie, Jazz, Blues, Punk, Oper, Funk, Reggae, Klassik, und Rap) sowie die umfassende historische Perspektive ermutigen zu neuen, frischen, vorsichtigen Überlegungen über ein dunkles und noch ungelöstes Kapitel des amerikanischen Lebens. Natürlich symbolisieren die Spiegel solch eine Reflektion, schaffen jedoch gleichzeitig einen ambivalenten Raum – eine »Nonsite«, um Smithsons Ausdrucksweise zu gebrauchen – in dem Realität hinterfragt und Illusionen herausgefordert werden. Die Spiegel dienen in Durants vielschichtiger Untersuchung auch als überraschend neutrale Ruheräume, in denen ungleiche Bezugnahmen sich zwanglos vermischen. Smithsons ausführlicher Gebrauch von Spiegeln führte ihn zu einer Charakterisierung, die durchaus angebracht für Durants Projekt erscheint: »Der Spiegel unterliegt nicht der Zeitdauer. Er ist eine fortwährende Abstraktion, die immer verfügbar und zeitlos ist. Spiegelungen dagegen sind flüchtige Momente, die sich jeder Messung entziehen«.[25] Auch Durant sucht seine Subjekte von Dauerhaftigkeit zu befreien, sodass sie durch alle Zeiten widerhallen und komplexe Echos ermöglichen, die das Publikum in die Gegenwart hüllen. In seinen rätselhaften Zonen begünstigt er nie nur eine Antwort und hält sich von »entweder-oder«-Vorschlägen fern. Er zieht hingegen facettenreiche Reflektionen vor, die uns erlauben, ein weites Netz von Gegebenheiten zu überdenken, führt uns so in das Hier und Heute und letztendlich darüber hinaus.

Übersetzung: Hans-Jürgen Schacht

25. Smithson, »Begebenheiten auf einer Spiegel-Reise in Yucatan«, 1968, in: s.o., S. 146

CHAIR #2, 1995

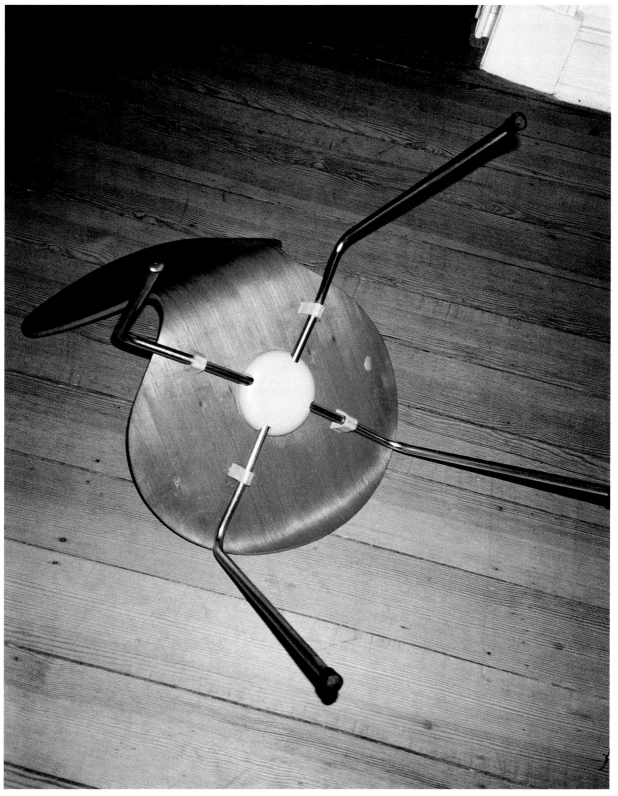

CHAIR #4, 1995

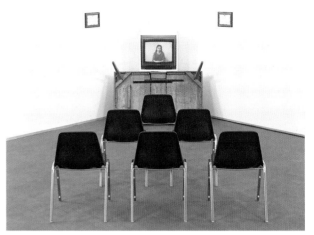

ADRIAN PIPER
CORNERED, 1988
VIDEO INSTALLATION WITH BIRTH CERTIFICATES, VIDEO, MONITOR,
TABLE, AND CHAIRS; DIMENSIONS VARIABLE
COLLECTION MUSEUM OF CONTEMPORARY ART, CHICAGO; BERNICE
AND KENNETH NEWBERGER FUND

KNOWN ASSOCIATE, 1995

INTERVIEW WITH SAM DURANT

RITA KERSTING

Rita Kersting: In your work you reflect on and juxtapose social, political, and cultural situations from the last thirty or so years. Your own socialization took place in a time very different from today. From a contemporary vantage point, it is tempting to assume that life in the 1960s was more clear-cut: black or white, left or right.

Sam Durant: The world was certainly different thirty-five years ago. But although the responses were different then, many of the issues are still the same today. I would even say that certain social and political conditions are much worse now than they were in the late 60s. Despite this the discourse around the issue of race has really changed, even from ten years ago. For example, Thelma Golden's recent show "Freestyle" is very interesting to me in this regard. For the first time an exhibition of African-American artists was put together as a group show of interesting and relevant work by artists who just happen to be African-American, not as a thematic exhibition organized around the artists' common identity. She has opened up territory to really change the nature of the dialogue with this idea of a "post-black" or "post-identity" art world. Of course this is very controversial and problematic, but that's probably why I'm so interested in it.

I saw Adrian Piper's piece *Cornered* (1988) two years ago and it blew my mind. Although it is a confrontational, accusatory piece, her tone and manner are just so bitingly funny that I found myself alternating between laughing and having goose bumps. Her thesis that nobody is really white, that there is no such thing as pure whiteness, and that everybody's got some "color" is so obviously true. Race is a social construction; there are no biological differences between us. Of course the real challenge she makes in *Cornered* is for us so-called "white folks" to start objecting to other white folks when they display racist attitudes. *Cornered* completely changed what I thought art could do. It was beyond aesthetic experience. The work effected a real change in the way I view the world. I think it is amazing that an artwork can do that. I realized that art could be much more powerful than I had previously imagined. This work reinforced for me the notion that art should be something significant.

In Gordon Matta-Clark's "anarchitectural" interventions, there is in his disruption of tectonic structure a metaphorical, liberating force that breaks with convention. By splitting houses, destroying windows, and throwing stones he wanted to combine the world of order and the world of change. He presented his virulent ideas by making artificial interventions on the fringes of everyday life. Does his work have an effect on your work? I am especially thinking about your series of Abandoned Houses.

There is a relationship between my work and Gordon Matta-Clark's. I know his work pretty well, and I admire it tremendously. I think the fact that I was a carpenter affected the way I saw his work. A lot of the things he did in his work I did as part of my job, like sawing houses in half and jacking up buildings or making holes in walls. His influence is definitely there in the Abandoned Houses. There was a show here at MOCA on the Case Study Houses in 1989. It happened around a time when a lot of people, myself included, were becoming interested in mid-century design and architecture. It not only spurred my interest in the design, but also in its philosophical underpinnings and the attendant economic, social, and political factors. At the time of the show there wasn't the fetishization of mid-century architecture that we have now. Many of the people who lived in the Case Study Houses didn't think of them as important architecture; they were just houses. The owners remodeled with no thought of architectural integrity: they added curtains, laid carpet, tore out kitchens, and all of that. The idea that the architecture would change the way the occupants lived was completely obliterated by how people wanted to live, by the traditional notion of a home. My models are poorly built, vandalized, and fucked up. This is meant as an allegory for the damage done to architecture simply by occupying it.

Transforming a theoretical utopia into a livable reality with carpets and curtains means ruining it?

Exactly. Human presence is the problem.

The human is very present in your collages. When I visited the reconstructed Barcelona Pavilion by Mies van der Rohe, I felt that my presence was too much, that I immediately disturbed the perfection of the straight lines, the beauty of the building, with my body and my movement. This nearly unbearable experience comes to mind when I see your collages.

I am interested in the notion of repression. I wondered if something gets repressed when form is reduced to total functionality. The collages became a way to manifest an absurd and nasty critique of the more strident aspects of mid-century design. I saw the pasting in of white-trash partiers and decorative furniture as the return of the repressed. This came about through a psychological interpretation of the architecture.

In your Woodsheds Poster *(1999), you paste images of Robert Smithson's* Partially Buried Woodshed *(1970) together with and on advertisements of woodshed kits that are "simple and ready to assemble," and "virtually maintenance free." These tragic-comic juxtapositions remind me of the repetitive aesthetic and mass-*

BURIED WOODSHED, 1999
OFFSET PRINT; 22 x 17 INCHES
COURTESY OF THE ARTIST AND BLUM & POE, SANTA MONICA

They form a human equivalent, doing what the dirt did but also referring to the figures of Smithson and Allison Krause, who was killed during the incident at Kent State.

The general, abstract notion of entropy or dystopia that Smithson was addressing with Partially Buried Woodshed *marked the beginning of a process of destruction that occurred on that site.*

My reading of the shed is presumptive, allegorical, and maybe not at all what Smithson had in mind. I read it as a grave site and a foreshadowing of both the student killings and Smithson's own death. It was on some level in tune with what was going on politically at the time. He wanted to set up a situation where entropy was in process. A few months later, the National Guard killed four students during a protest at Kent State, where *Woodshed* was built. As the work became an underground monument to that event it came to represent another kind of entropy: political entropy. Looking back now you realize he was very astute politically. His text "Art and the Political Whirlpool or the Politics of Disgust" (1970) is just fantastic. He cites Georges Bataille, which was really important for me as it confirmed my reading of much of Smithson's work as having a scatological impulse.

I made a piece called *Partially Buried 1960s/70s Utopia Reflected* and *Partially Buried 1960s/70s Dystopia Revealed* (1998), which was an illustration of Smithson's famous black-and-white sandbox analogy.[1] It was one of the first sculptures that I made dealing directly with his ideas, and I used his concept of entropy to make a political analogy with the work. A soundtrack of a very positive, "everything is beautiful" kind of stage announcement at the Woodstock concert emanates from one of the dirt piles. From the other pile you hear Mick Jagger at the Altamont concert pleading for the fighting to stop. One dirt pile signifies the white sand, the other the black sand. As the voices from the audio tracks mix together the viewer gets the effect of the sand getting mixed. The Altamont concert signaled the end of the utopian aspect of hippie culture and also foreshadowed the political alienation that began in the 70s—brought on by events like the Watergate scandal; the secret bombing of Cambodia; the FBI's destruction of the Black Panthers and other community organizations; and the cumulative effect of the Kennedy, Malcolm X, and Martin Luther King assassinations.

In your work the decisions about form, scale, material, and appearance seem to be influenced by public and private aesthetics as well as by historical sculptural practices. Still, the combinations of rather

production that Dan Graham focused on in his Homes for America *in 1966. The sheds you collaged have names like "Baltimore Shed" or "Yorktown Shed," as if they carry certain regional identities. Yet they are portable—a form of ubiquitous architecture. Displacement can produce new meaning or it can erase all meaning. It is central to your work. Can you describe your interest in displacement?*

I don't remember the exact circumstances leading to that poster. I think I was interested in producing a dead end. The relationship between *Partially Buried Woodshed* and the garden shed is in name only. I set up a false dialectic; it doesn't work or it negates itself. I think those garden sheds are a kind of negation. *Partially Buried Woodshed* certainly was, or at least the dumping of the dirt was. The idea of negation as a form of displacement is really interesting; I hadn't thought about that. In the photograph *What's the Opposite of Entropy?* (1999), displacement happens both formally and conceptually. There are two human models, a man and woman, draped over a scale model of the shed that Smithson used. The models are formally arranged to match the way the dirt was piled on and around the woodshed.

1. "Picture in your mind's eye the sand box divided in half with black sand on one side and white sand on the other. We take a child and have him run hundreds of times clockwise in the box until the sand gets mixed and begins to turn grey; after that we have him run anti-clockwise, but the result will not be a restoration of the original division but a greater degree of greyness and an increase of entropy." Smithson, "A Tour of the Monuments of Passaic, New Jersey" (1967), in *The Writings of Robert Smithson*, ed. Nancy Holt (New York: New York University Press, 1979), 56–57.

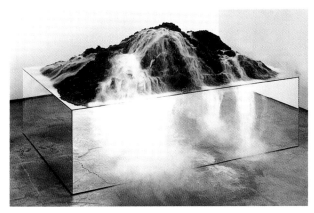

WHAT'S UNDERNEATH MUST BE RELEASED AND EXAMINED TO BE UNDERSTOOD, 1998

abstract elements, readymade-looking parts, hyperreal simulations of natural elements, and invented forms are very peculiar. Sometimes they seem like stills or props from different films or settings put together. Each element inherits a history and a future.

I am always looking for materials, objects, and phenomena that have both specific meaning and connotative or associative meaning. The Rolling Stones are an example of this. I am using them to represent a variety of things: the Altamont concert, the appropriation of African-American culture, scatological impulses, drugs, and death.

A lot of your installations are accompanied by a series of drawings that feature the "back story" of the works: they do not explain but offer hints. Recently the drawings have gotten more specific; they are nearly poster-like announcements showing portraits rather than rocks or dirt lumps.

The drawings started out ten years ago as a way to work out the connections between different things. They were basically traditional working drawings. Over the years they have evolved or maybe devolved into a kind of index for each project. I often do a series of what I call "exhibition drawings" which explain different elements within each body of work. One of the things I like about them is that they can function quite well outside the context of the installation that they were made for. They become like posters that refer back to their source, both in terms of content and their place in the original installation. Perhaps that is an example of the displacement effect that you mentioned earlier.

In your most recent work Southern Tree, Tree of Knowledge, Dead Tree *(2001), the mirror, as material, is more prominent than ever before.*

I started using mirrors for two reasons. One: Everybody I was interested in was using mirrors thirty years ago—Dan Graham, Joan Jonas, Robert Smithson, Robert Morris, Bruce

Nauman, etc. They were one of the most ubiquitous materials of the late 60s. Mirrors were something that everybody could use; they were not territorial. And since they were not specific to one artist or one artwork, I felt I could use them in my work to refer to a whole situation. Two: They have such symbolic power. They function as signifiers of the mental act of reflection as well as the physical. There are seemingly endless sets of references that you have access to with mirrors.

The mirror has a long tradition as a reflexive medium in art history. It has been used to explore image and afterimage, original and projection. You have used mirrors in your installations since 1998 in different ways, including using video as an ongoing mirror. They reflect images from a place other than the one they occupy. This is I think a metaphorical description of what you do in your work, in a way.

I would agree with all of that. My work displaces ideas that do not occupy the same space as the mirror. Basically it reinforces the idea that the work refers to things outside of itself. Maybe most importantly it refers to the mental act of reflection, the idea of examination and distance. It also is a device for doubling, which points toward multiple perspectives. In relation to the subject matter of particular works, I hope that this doubling serves to problematize history. If there are multiple interpretations of events the viewer can't construct a monolithic reading.

The mirror is a medium connected to theatricality, which is a historically loaded term as defined by Michael Fried in his dubious but essential critique of minimalism. Theatricality, however, is very important for a lot of contemporary works of art. The idea of extension from autonomy to interaction plays an important role. Not only the use of mirrors, but also your light sign with the inscription: "Like, Man, I'm Tired (of Waiting)" reminds me of Fried's analysis in "Art and Objecthood" of the relationship between the work of art and the beholder: "Inasmuch as literalist work depends on the beholder, is incomplete without him, it has been waiting for him."

"Art and Objecthood" is really important to much of my work and also to my ideas about the nature of art. Fried was so wrong in "Art and Objecthood." When you pick apart his argument there is nothing there; it's indefensible. But if you turn his criticisms around, sort of reverse them or use them against themselves, they offer fantastic theories on how art can function. Douglas Crimp did this with the essay "Pictures" in talking about artists like Sherrie Levine and Richard Prince. The notions of theatricality and temporality, of a work that is "between" the categories of art, are just great concepts. Good art of course does more than just express its formal components. Also my work is between the arts, as Fried would say, so I have had to think about defending that position.

The spectator plays an important role in your work. You integrate the viewer as a reflected projection in many pieces with mirrors—a central figure, almost like a motif analyzing, contemplating, combining, and laughing. But he or she is also put in the position of a repoussoir *figure, one who enters the scene and stands in for the artist's perspective, gazing into and within the setting.*

It is very important for the viewers to understand that they are active in their engagement with the work. Self-consciousness and reflection are part of the interpretative process.

Robert Smithson says: "I am for an art that takes into account the direct effect of the elements as they exist from day to day apart from representation." Smithson believed things flatten out and fade in the museum; it is a void, a tomb. Yet your work is always realized with the white cube in mind.

Yes.

You are not questioning it, as opposed to Smithson, whose starting point was to problematize the museum. But the works you show in museums are very much about outside; some are even models that could be executed outside.

I'm not so interested in engaging in a dialogue with the white cube or the museum. There are so many artists who do that really well, and I'm happy to leave that project to them. *Proposal for Monument at Altamont Raceway, Tracy, CA* (1999) is an example of the second part of your question. The model is an artwork and also an architectural model of a real proposal. I just fell into making models when I started the Abandoned Houses. When I made the first one I didn't think I would even show it. A friend saw it and convinced me it could be a worthwhile project. I started thinking about monuments after the Abandoned Houses. A monument commemorates something, it makes you remember a death, a tragedy, a big victory—it writes history. The *Partially Buried Woodshed* was already an unofficial monument to the killings at Kent State. My models just made that clear while pointing to the larger cosmology of death and destruction by using music. Neil Young is easy to reference because of his song "Ohio" and his connection to Kurt Cobain, which came about when Cobain quoted a Neil Young lyric in his suicide note. Altamont is also obviously a very problematic historical moment. I guess I am drawn to these traumatic events.

On the model you can't see any loudspeakers. It appears as pure construction, without any of the recognizable functional elements of the real Altamont site. It reminds me of the utopian tower by Vladimir Tatlin.

The monument for the Third International.

Could you imagine the large-scale execution of this or other works?

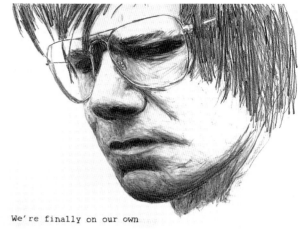

We're finally on our own

WE'RE FINALLY, 1998

I am currently trying to actually build the Altamont monument near the raceway. Unfortunately land isn't as cheap now as it was back in 1970.

Your work operates on the presumption that the audience is familiar with your references. Would you agree?

Yes and no. I think that in the last four or five years, the things I am working with are easily understandable. The pop music, art, and architecture I refer to are fairly well known. My references may not be the most popular, but they are definitely not esoteric.

They are very much about American culture.

Oh yeah, that's for sure. It's all about American culture and history. I think most viewers can access the work on a superficial level because I use things like The Rolling Stones and Neil Young. They are internationally famous; everyone knows them and knows what they are. I am not using esoteric, avant-garde music. On that level the work is very accessible. But to follow all the references in the work, I would agree, you need some knowledge. Certainly I don't expect the viewer to know all the things I am referring to, but the more popular, recognizable things allow a first access. Anyone can look at something and enjoy it on an aesthetic level. But if you are making something that has more than just aesthetic value—something that refers to something outside of itself—you run into the problem of the viewer's level of knowledge. Every work of art can be read on different levels and that is very important. I have been criticized for making work that is too difficult to understand but I don't agree with that. I think my work is actually quite easy to interpret. There is a lot of information and the content may not always be what viewers are used to dealing with in artworks. However, I think some viewers project their expectations onto artworks instead of directly addressing what is actually in front of them.

There is no other artist I know who works as intensely with such a specific period of time as you do. Freud believed that one must have control over one's past. Basically the only solution for a successful present is to be conscious about central experiences in the past. Do you see your artistic practice related to this message, albeit in a collective way?

Perhaps on a collective level, yes, but not on a personal level.

Some titles of your work allude to Freud, like Reflected Upside Down and Backwards (1999) and, even more, What's Underneath Must Be Released and Examined to Be Understood (1998).

Exactly. The title, *What's Underneath Must Be Released and Examined to Be Understood*, refers to a psychoanalytical model. It sets up a framework for interpreting the work. A title like *Reflected Upside Down and Backwards* is meant to problematize the subject of the piece and also the subjectivity of the viewer. It is also the way the lens in your eye works. Physiologically the world is first perceived upside down and backward. Then it's turned right side up and forward in your brain.

Reflecting upon history serves the present. Herbert Marcuse, whose ideas were influential to both the hippies and civil-rights activists, believed that life can only be lived in the present. What does the here and now mean to you?

The idea is that history is continuous. Malcolm X said that history is the most important thing to understand. You can't understand the conditions of the present until you know the causes of those conditions. There is a hypothesis that says that the experience of time as continuously moving forward is totally arbitrary. Actually there is nothing that we know that prevents time from moving backward. An interesting side note to this is that the law of entropy was thought to be the cause of time moving forward, due to the fact that all matter irrevocably degrades. This has since been proven wrong. There is nothing preventing the reverse from happening.

You are quoted in an article by James Meyer as saying "experience was sharper" and "things mattered more" in the 60s. Regarding your distance and investigative attitude towards this historic period, I am surprised by the sense of longing conveyed in these statements. It seems that for you the 60s represent a more "real" reality than today.

I was wrong about that. I was trying to figure out why I was interested in this period of time and I hadn't thought thoroughly enough about it. Although it has come back to haunt me, being quoted in print saying those things really helped. It forced me to get a better grasp on how my work functions.

What we know about that time has been mediated through films, music, and writing. You didn't experience Robert Smithson; your knowledge of him has come secondhand through different sources, some which have helped cast him as a mythic figure.

I like Smithson precisely because he is a mythic figure. His death is part of a continuum of all the tragic deaths of pop stars and celebrities. This is one of the ways in which he has been mythicized. It's also one of the ways he is linked to Cobain in my mind. I hope that by linking up these variously related people and events the mythicization becomes clear and some sort of perspective can be gained.

The reception of your work in Europe has been very strong. Astonishingly so, particularly because you deal specifically with American topics.

Political dissent in the 1960s wasn't limited to the United States. Revolutions were being staged around the world. In addition to the well-known events in Europe there were the African liberation movements, as well as uprisings and struggles in Central America, Asia, Korea, Cyprus, the Middle East, and Palestine, to name a few. Tariq Ali and Susan Watkins's book *1968: Marching in the Streets* shows the global nature of liberation struggles from that period.

These struggles were largely the result of societies striving toward the fulfillment of a utopian vision. Is the term "utopia" applicable to art?

I suppose so. When I was younger I had a big disappointment with what we call "Institutional Critique." I felt it had failed to bring about any real change and that the institutions it critiqued had simply co-opted it. Therefore for me it was valueless, a failure. Now I don't think this is true; change is not always measurable in that way. Things change in small ways over a very long time before they change in a big way. It is really important to keep the small changes happening. The struggle is continuous.

Do you do any site-specific work?

Not usually. I realized *Partially Buried 1960s/70s Utopia Reflected* and *Partially Buried 1960s/70s Dystopia Revealed* in a different way in Zurich. In an outdoor courtyard, I dug a hole about fifteen feet in diameter and six or eight feet deep. I piled dirt next to the hole and placed a speaker in the hole and another in the pile of dirt. I used the same soundtrack as *Partially Buried 1960s/70s Utopia/Dystopia*.

You did a special project for the MAK Center for Art and Architecture at the Schindler House in Los Angeles last year. And now you are working on a project related to Joseph Beuys for the Kunstverein in Düsseldorf.

Sometimes interests coincide with places. *Artforum* had asked me to write a text on R. M. Schindler for them. I ended up writing on his church in South Central L.A. Shortly after that the MAK Center invited me to participate in their show "In Between: Art and Architecture," so I was able to address the issues I raised in the *Artforum* text through the work in that show, which was really great. Your invitation to do a show at the Kunstverein in Düsseldorf coincided with my interest in Beuys. I am very interested in his relationship to the Düsseldorf Academy of Art and his office for the Organization for Direct Democracy Through Referendum. The physical work itself is less interesting to me than the myths surrounding him and his ideas, philosophies, theories of education, and engagement in politics. Smithson and Beuys were both in the "Prospect 69" show organized by the Kunsthalle. So the opportunity to do a show there is really perfect.

For "Prospect 69," Beuys did Plastic Foot Elastic Foot *(1969), a two-part piece with the title as text on the floor and two big felt sheets hanging from the wall. Smithson executed a mirror displacement outside. Both works show a lot of features that are present in your work as well, for example the materials, the dichotomous nature of the work, and the way the installations are built. And like you, both artists leave one-point perspective behind, collecting materials like spiders in the web, but without explicitly showing the materials themselves. The works are more figure, less message. Would you agree with this regarding your work?*

Yes, in the more recent work there is less direct critique and more of a kind of overall problematizing of the subject matter. The viewer can arrive at the critique by different paths; there isn't always a clearly delineated route. But I wouldn't say the work is open-ended, because its parameters are clearly defined and each project has specific meaning.

Can you give an example?

Southern Tree, Tree of Knowledge, Dead Tree grew out of *Proposal for Monument in Friendship Park, Jacksonville, FL* (2000). In Southern rock music the issue of race swirls around just under the surface. So it was something that I was really aware of in doing the *Friendship Park* project, and I wanted to deal with it in the next series of works. Billie Holiday's song "Strange Fruit" is the key to the whole thing. This song just totally changes the way you look at a tree. After you hear it the tree just flashes straight to lynching and slavery. I also wanted to bring in references to genealogy, family, philosophy, and all the symbolic meanings of the tree. This is being floated through the direct quotation of Smithson's Upside-Down Trees. The Goodie Mob, a hip-hop group from Atlanta, made a record called *Still Standing* featuring a tree on the cover, and this just fit right into

my cosmology. Cornel West's *The American Evasion of Philosophy*, with its cover illustration of a tree with names of philosophers like fruit on the branches, moved it in another direction. The project just kind of built itself as one reference led to another. It's funny because I didn't want the project itself to operate like the tree model but more like a field. It should be horizontal, kind of spreading out in a non-hierarchical way. And formally the piece is not vertical, but a field of upside-down tree stumps with a musical score swirling around in the field.

And there is a stage element…

It is very theatrical. Formally my sculptures tend to be somewhere between models, props, and sculptures, particularly with the *Friendship Park* piece, which is literally a stage. A big part of coming to that form was discovering Isamu Noguchi's stage sets for Martha Graham's dances. The elements are props in one sense. In another sense the installation is a fully functional monument and also an interactive sculpture. In *Southern Tree, Tree of Knowledge, Dead Tree* the stage effect is less obvious but just as important.

Will the project for the Kunstverein in Düsseldorf function similarly?

I think so. I am thinking about the new project functioning like the monument proposals by placing heavily mythicized and interrelated elements together in a field. I am really interested in setting up a situation that can incorporate several aspects of Beuys's life and work. I am sure the piece will examine things like his position at the Düsseldorf Academy of Art, some of the socio-political performances, and the myths he created about himself. I can imagine referring to the felt and fat materials, especially *Plastic Foot–Elastic Foot* from the "Prospect" show. I might also integrate some of the work Smithson did in Germany, like *Mirror Displacement on a Compost Heap* (1969), *Dead Tree* (1969), and the Oberhausen slag pieces (1968). It's really important that the new piece represents the roles of myth and ritual in Beuys's life and work and sets up a critical perspective on them. There is so much that's repressed in his practice, and I want to unearth some of that and take a look at it. Something interesting always comes out of repression.

Los Angeles, 8 February 2002

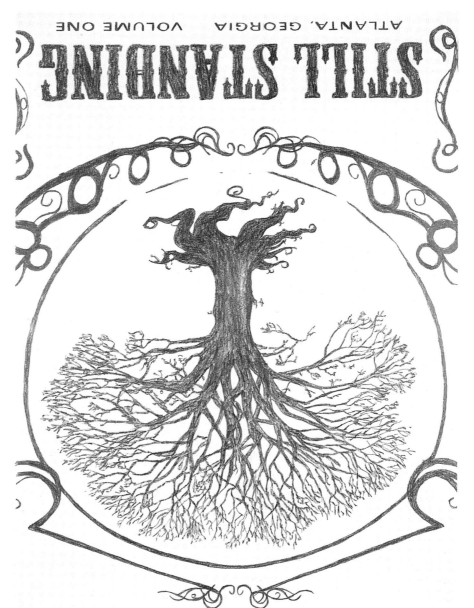

STILL STANDING

VOLUME ONE

ATLANTA, GEORGIA

GEORGIA

STANDING UPSIDE DOWN, 2001

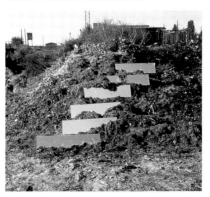

ROBERT SMITHSON
MIRROR DISPLACEMENT ON A COMPOST HEAP, DÜSSELDORF, OCTOBER 1969
ESTATE OF ROBERT SMITHSON
COURTESY JAMES COHAN GALLERY, NEW YORK

PATH TO INFINITY (DUANE'S HARLEY AND ROCK GARDEN), 2000
GRAPHITE ON PAPER; DIPTYCH, 22 x 30 INCHES EACH
COURTESY OF BLUM & POE, SANTA MONICA

INTERVIEW MIT SAM DURANT

RITA KERSTING

Rita Kersting: In deinen Arbeiten reflektierst und konfrontierst du soziale, politische und kulturelle Situationen der vergangenen dreißig Jahre. Deine eigene Sozialisation vollzog sich in einer Zeit, die völlig anders war, als die heutige. Von unserem Standpunkt aus gesehen, ist man versucht anzunehmen, dass das Leben in den 1960ern klarer umrissen war: Schwarz oder Weiß, Links oder Rechts.

Sam Durant: Die Welt war vor 35 Jahren sicherlich eine andere. Doch obwohl die Antworten damals anders ausfielen, sind viele der Probleme heute noch die gleichen. Ich würde sogar so weit gehen, zu behaupten, dass es um bestimmte soziale und politische Zustände heute weitaus schlechter bestellt ist als in den späten 60er Jahren. Ungeachtet dessen hat sich der Diskurs um die auf Rasse bezogenen Fragen wirklich verändert, selbst wenn man nur zehn Jahre zurückgeht. In dieser Hinsicht ist zum Beispiel die von Thelma Golden kürzlich gezeigte Ausstellung »Freestyle« sehr interessant für mich. Zum ersten Mal wurde eine Ausstellung afro-amerikanischer Künstler zusammengestellt, die nicht von der gemeinsamen Identität des Künstlers ausging, sondern schlicht eine Gruppenausstellung interessanter und bedeutender Arbeiten von Künstlern darstellte, die nun einmal Afro-Amerikaner waren. Sie hat eine Möglichkeit eröffnet, die das Wesen des Dialoges um die Idee einer »Post-Schwarzen« oder »Post-Identität«-Kunstwelt wirklich verändert. Natürlich ist das sehr umstritten und problematisch, doch das ist wahrscheinlich auch der Grund für mein Interesse.

Ich habe vor zwei Jahren Adrian Pipers Stück *Cornered* (1988) gesehen, und es hat mich vom Stuhl gerissen. Ihr Ton und die Art und Weise ist so beißend lustig – obwohl es ein so konfrontierendes, anklagendes Stück ist –, dass ich zwischen Lachen und Gänsehaut hin- und hergezogen wurde. Ihre These, dass niemand wirklich weiß ist, dass es so etwas wie pures Weißsein nicht gibt und jeder ein wenig »Farbe« in sich hat, ist so offensichtlich wahr. Rasse ist eine soziale Konstruktion; es gibt keine biologischen Unterschiede unter uns. Die eigentlich von ihr in *Cornered* aufgeworfene Herausforderung für uns sogenannte Weiße ist aber, dass wir anfangen sollen, zu protestieren wenn andere Weiße rassistische Haltungen an den Tag legen. *Cornered* hat mein Denken bezüglich der Möglichkeiten der Kunst völlig verändert. Es war weit mehr als eine ästhetische Erfahrung. Die Arbeiten bewirkten in mir einen wirklichen Wandel, die Welt zu sehen. Ich denke, es ist erstaunlich, dass ein Kunstwerk das tun kann. Mir ist klar geworden, dass Kunst sehr viel mächtiger sein kann als ich es mir bislang vorgestellt hatte. Diese Arbeit hat in mir die Ansicht verstärkt, dass Kunst »bedeutend« sein sollte.

In Gordon Matta-Clarks »un-architektonischen« Eingriffen kann man von einer Zerrüttung tektonischer Strukturen sprechen, die eine metaphorische, befreiende Kraft auslöst, die mit Konventionen bricht. Indem er Häuser spaltet, Fenster zerstört und Steine wirft, versucht er die Welt der Ordnung mit der Welt der Veränderung zu kombinieren. Er präsentiert seine bösartigen Ideen durch künstliche Interventionen an der Grenze des alltäglichen Lebens. Hat seine Arbeit dich beeinflusst? Ich denke dabei besonders an deine Serie der Abandoned Houses.

Es gibt eine Beziehung zwischen meinen und Gordon Matta-Clarks Arbeiten. Ich kenne seine Arbeiten sehr gut und bewundere sie kolossal. Ich denke, die Tatsache, dass ich Zimmermann war, beeinflusste die Art und Weise wie ich seine Arbeiten sehe. Viele der Dinge, die er in seinen Arbeiten tut, waren Teil meines Berufs, z.B. Häuser in zwei Teile zu sägen, Gebäude anzuheben oder Löcher in Wände zu bohren. Ohne Zweifel findet man seinen Einfluß in den Abandoned Houses (Verlassenen Häusern). 1989 gab es hier im MOCA eine Ausstellung über die Case Study-Häuser. Das war ungefähr die Zeit, in der

GORDON MATTA-CLARK
WINDOW BLOW OUT, 1976, DETAIL
8 BLACK-AND-WHITE
PHOTOGRAPHS; 11 x 14 INCHES
EACH
COURTESY DAVID ZWIRNER,
NEW YORK

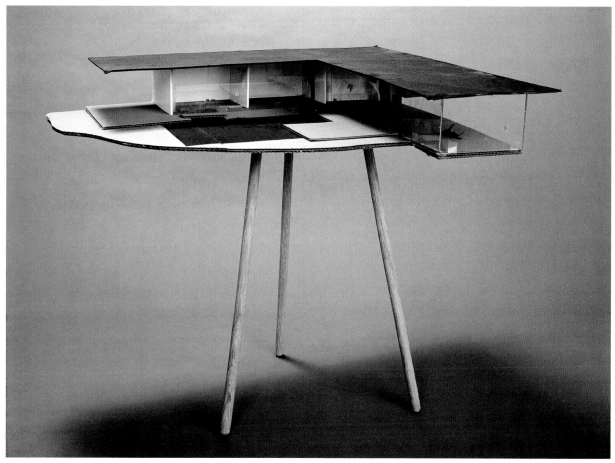

ABANDONED HOUSE #1, 1995

viele Leute, ich eingeschlossen, Interesse am Design und der Architektur aus der Mitte des Jahrhunderts entwickelten. Es hat nicht nur mein Interesse am Design angestachelt, sondern auch an seinem philosophischen Unterbau und den begleitenden ökonomischen, sozialen und politischen Faktoren. Zum Zeitpunkt der Ausstellung ging die Fetischisierung der Architektur noch nicht so weit wie heute. Viele der Menschen, die in Case Study-Häusern wohnten, sahen sie nicht als bedeutende Architektur; sie waren einfach Häuser. Die Eigentümer modernisierten, ohne an die architektonische Integrität zu denken: Sie hängten Gardinen auf, legten Teppiche, rissen Küchen heraus usw. Die Idee, dass Architektur die Lebensweise der Bewohner ändert, wurde völlig unkenntlich dadurch wie die Leute wohnen wollten, durch die traditionelle Auffassung von einem Heim. Meine Modelle sind schlecht gebaut, mutwillig zerstört und versaut. Das ist als Allegorie für den Schaden gedacht, der der Architektur schlicht durch das Bewohnen zugefügt wird.

Ein theoretisches Utopia in eine bewohnbare Realität mit Teppichen und Gardinen zu transformieren heißt, es zu ruinieren?

Genau. Die menschliche Anwesenheit ist das Problem.

Der Mensch ist in deinen Collagen äußerst präsent. Als ich den rekonstruierten Barcelona Pavillon von Mies van der Rohe besuchte, fühlte ich, dass meine Gegenwart zuviel war, dass ich augenblicklich die Perfektion der geraden Linien, die Schönheit des Gebäudes störte, einfach durch die Anwesenheit meines Körpers und meiner Bewegungen. Wenn ich deine Collage sehe, kommt mir diese fast unerträgliche Erfahrung in den Sinn.

Mich interessiert der Aspekt der Repression. Ich fragte mich, ob etwas unterdrückt wird, wenn die Form völlig auf Funktionalität reduziert wird. Die Collagen stellten eine Möglichkeit dar, eine absurde und gehässige Kritik an den herausragenden Aspekten des Designs der Mitte des Jahrhunderts zu äußern. Ich sah das Einkleben von »White-Trash«-Partylöwen und dekorativen Möbeln als die Rückkehr des Unterdrückten. Das ergab sich durch eine psychologische Interpretation der Architektur.

In deinem Woodsheds Poster *(1999) klebst du Bilder von Robert Smithsons* Partially Buried Woodshed *(1970) zusammen mit oder auch auf Werbungen von Holzhütten-Bausätzen, die »einfach zu montieren« und »geradezu wartungsfrei« sind. Diese tragikomischen Nebeneinanderstellungen erinnern mich an die sich wiederholende Ästhetik und Massenproduktion, die Dan Graham 1966 in seinen Homes for America fokussierte. Die Hütten in den Collagen haben Namen wie »Baltimore Shed« oder »Yorktown Shed«, als trügen sie bestimmte regionale Identitäten. Andererseits sind sie tragbar, eine Form allgegenwärtiger Architektur. Deplatzierung kann neue Bedeutung schaffen oder jede Bedeutung ausmerzen. Das steht im Mittelpunt deiner Arbeit. Kannst du dein Interesse an Deplatzierung beschreiben?*

Ich kann mich nicht an die genauen Umstände erinnern, die zu diesem Poster geführt haben. Ich glaube ich wollte eine Sackgasse produzieren. Die Beziehung zwischen *Partially Buried Woodshed* und der Gartenhütte besteht ausschließlich im Namen. Ich habe eine falsche Dialektik aufgestellt; es funktioniert nicht oder es schließt sich aus. Ich glaube diese Gartenlauben sind eine Art von Negation. *Partially Buried Woodshed* war sicher eine oder

zumindest das Auskippen der Erde war eine. Die Idee, Negation als eine Form der Deplatzierung zu sehen, ist sehr interessant; ich hatte darüber noch nicht nachgedacht. Auf dem Foto *What's the Opposite of Entropy?* (1999) vollzieht sich Deplatzierung sowohl formal als auch konzeptuell. Da sind zwei menschliche Modelle, ein Mann und eine Frau, über ein naturgetreues Modell der von Smithson genutzten Hütte drapiert. Die Modelle sind formal arrangiert und entsprechen der Erde, die auf die Hütte und um sie herum gehäuft wurde. Sie bilden ein menschliches Äquivalent, übernehmen einerseits genau die Funktion der Erde und verweisen andererseits auf Smithson und Allison Krause, die während des Ereignisses in Kent State ermordet wurde.

Die allgemeine, abstrakte Vorstellung von Entropie und Dystopie, die Smithson mit seinem Partially Buried Woodshed *zum Ausdruck brachte, markierte den Beginn eines destruktiven Prozesses, der an diesem Ort stattfand.*

Meine Interpretation der Hütte ist präsumptiv, allegorisch, und vielleicht weit entfernt von Smithsons Vorstellungen. Ich interpretiere sie als Grabstätte und als Vorahnung sowohl von den Morden an den Studenten als auch von Smithsons eigenem Tod. Das steht in gewissem Sinne in Einklang mit dem, was damals politisch gesehen vor sich ging. Er wollte eine Situation entwerfen, die den Prozess der Entropie verdeutlichte. Einige Monate später wurden auf dem Gelände von Kent State, auf dem *Woodshed* gebaut wurde, vier Studenten während einer Protestveranstaltung von der Nationalen Garde getötet. Die Arbeit wurde zum Untergrund-Monument dieses Ereignisses und repräsentierte somit eine andere Art der Entropie: Politische Entropie. Rückblickend wird einem klar wie scharfsinnig er politisch gesehen war. Sein Text »Kunst und der Strudel der Politik, oder die Politik des Ekels« (1970) ist einfach fantastisch. Er zitiert Georges Bataille, was für mich sehr wichtig war, da es meine Interpretation vieler von Smithons Arbeiten insofern bestätigte, als ich darin skatologische Impulse sah.

Ich habe eine Arbeit mit dem Titel *Partially Buried 1960s/70s Utopia Reflected* und *Partially Buried 1960s/70s Dystopia Revealed* (1998) gemacht, das eine Illustration der berühmten schwarz-weißen Sandkasten-Analogie von Smithson war.[1] Es war eine meiner ersten Skulpturen, die direkt mit seinen Ideen arbeitete, und ich gebrauchte dabei sein Konzept der Entropie, um eine politische Analogie zu bilden. Ein Soundtrack einer sehr positiven, einer Art »everything is beautiful« Bühnenansprache des Konzertes in Woodstock hört man aus einem der Erdhügel. Aus dem anderen Haufen hört man Mick Jagger, der während des Altamont-Konzerts darum fleht, die Schlägereien zu beenden. Ein Erdhügel markiert den weißen, der andere den schwarzen Sand. Da sich die Stimmen der Tonbänder vermischen, stellt sich beim Betrachter der Effekt ein, als vermischte sich der Sand. Das Konzert in Altamont signalisierte das Ende des utopischen Momentums der Hippiekultur und ließ die in den 70er Jahren beginnende politische Entfremdung vorausahnen, die von Ereignissen wie dem Watergate-Skandal, der geheimen Bombardierung Kambodschas, der Zerstörung der Black Panther und anderer gesellschaftlicher Organisationen durch das FBI, und den sukzessiven Ermordungen von Kennedy, Malcolm X, und Martin Luther King ausgelöst wurde.

Die Entscheidungen über Form, Maßstab und Erscheinung scheinen in deinen Arbeiten von öfentlicher und privater Ästhetik ebenso wie von historischen Bildhauerpraktiken beeinflusst zu

1. »Stellen Sie sich vor Ihrem geistigen Auge vor, dass dieser Sandkasten jeweils zur Hälfte auf der einen Seite mit weißem Sand und auf der anderen Seite mit schwarzem Sand gefüllt wäre. Nun nehmen wir ein Kind und lassen es einige hundert mal im Uhrzeigersinn durch den Sandkasten laufen, bis der Sand sich vermischt und grau wird; danach lassen wir es gegen den Uhrzeigersinn laufen, was aber nicht zur Wiederherstellung der ursprünglichen Teilung führen wird, sondern zur Vermehrung des Graus und zur Zunahme der Entropie«. Smithson, »Eine Fahrt zu den Monumenten von Passaic, New Jersey« (1967), in: *Robert Smithson, Gesammelte Schriften*, Kunsthalle Wien, 2000, S. 102

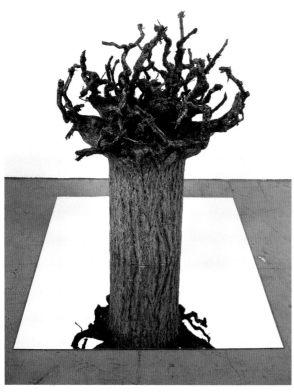

UPSIDE DOWN: PASTORAL SCENE, 2002, DETAIL

sein. Dennoch, die Kombinationen von eher abstrakten Elementen, Readymade-Teilen, überrealen Imitationen natürlicher Elemente und »erfundenen« Formen sind sehr eigenartig. Manchmal erscheinen sie wie zusammengestellte Stills oder Requisiten verschiedener Filme oder Bühnenbilder. Jedem Element wohnt eine Geschichte und eine Zukunft inne.

Ich halte immer nach Materialien, Objekten und Phänomenen Ausschau, die sowohl spezifische als auch konnotative oder assoziative Bedeutung haben. Die Rolling Stones sind ein Beispiel dafür. Ich gebrauche sie, um eine Vielzahl von Dingen zu repräsentieren: Das Konzert in Altamont, die Aneignung afro-amerikanischer Kultur, skatologische Impulse, Drogen und Tod.

Bestandteil vieler deiner Installationen sind Serien von Zeichnungen, die Hintergründe zeigen: Sie erklären nicht, sondern bieten Hinweise. In letzter Zeit sind diese Zeichnungen viel spezifischer geworden; sie sind fast schon posterähnliche Ankündigungen, die Porträts zeigen und nicht mehr nur Felsen oder Klumpen.

Mit den Zeichnungen habe ich vor zehn Jahren begonnen. Sie bieten die Möglichkeit, die Beziehungen zwischen den verschiedenen Dingen aufzuzeigen. Sie sind im Grunde traditionelle Arbeitsskizzen. Im Laufe der Jahre haben sie sich zu einer Art Index für jedes Projekt entwickelt oder vielleicht auch zurückentwickelt. Oft mache ich eine Serie von »Ausstellungs-Zeichnungen«, die die verschiedenen Elemente innerhalb eines jeden Werkes erklären. Einer der Aspekte, der mir an ihnen gefällt ist, dass sie recht gut auch außerhalb des Kontextes der Ausstellung funktionieren, für die sie gemacht wurden. Sie sind wie Poster, die sich auf ihre Quelle beziehen, sowohl in Bezug auf den Inhalt als auch auf ihren Platz in der ursprünglichen Installation. Vielleicht ist das auch ein Beispiel für die von dir vorhin genannte Deplatzierung.

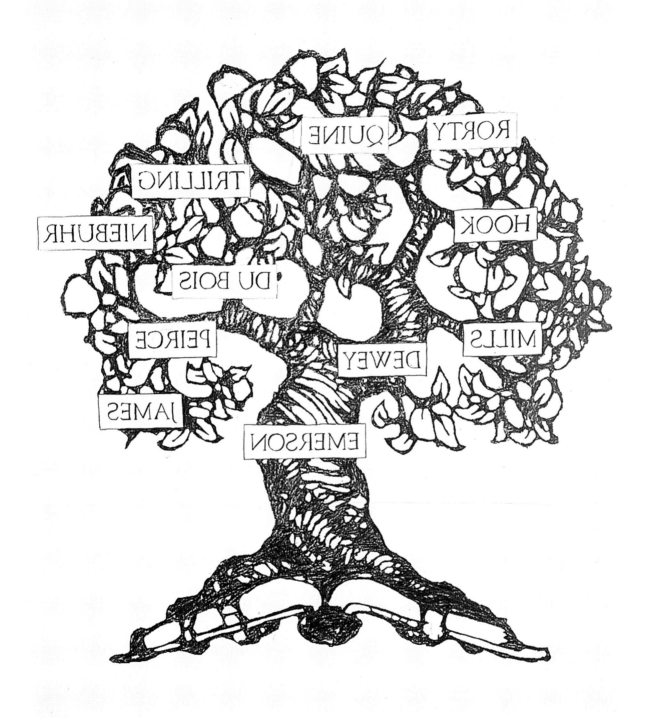

STANDING ON OUR HEAD, 2001

In deiner neuesten Arbeit, Southern Tree, Tree of Knowledge, Dead Tree *(2001) ist der Spiegel als Material prominenter denn je zuvor.*

Ich habe aus zwei Gründen begonnen, Spiegel zu verwenden. Erstens: Alle, die mich interessierten, verwandten vor mehr als 30 Jahren Spiegel – Dan Graham, Joan Jonas, Robert Smithson, Robert Morris, Bruce Nauman, usw. In den späten 60er Jahren waren Spiegel eines der weitverbreitetsten Materialien. Jeder konnte Spiegel verwenden; sie standen nicht für einen gewissen Bereich. Und da sie nicht spezifisch irgendeinem Künstler oder einem Kunstwerk zugeschrieben werden konnten, dachte ich, ich könne sie in meinen Arbeiten gebrauchen, um mich auf die gesamte Situation zu beziehen. Zweitens: Sie haben solch eine symbolische Kraft. Sie sind Signifikanten für den Akt der Reflektion, sowohl im gedanklichen als auch im physischen Sinne. Spiegel geben Zugang zu einer scheinbar endlosen Konstellation von Referenzen.

In der Kunstgeschichte hat der Spiegel eine lange Tradition als reflexives Medium. Er wurde gebraucht, um das Bild und das Nachbild, das Original und die Projektion zu erforschen. Du hast seit 1998 auf verschiedene Weise Spiegel in deinen Installationen verwendet, selbst Video hast du als einen fortlaufenden Spiegel genutzt. Spiegel reflektieren die Bilder außerhalb des Ortes, an dem sie sich befinden. Das ist auf eine Art, glaube ich, eine metaphorische Beschreibung dessen, was du in deiner Arbeit tust.

Ich würde all dem zustimmen. Meine Arbeit deplatziert Ideen, die nicht denselben Ort wie der Spiegel besetzen. Im Grunde bestärkt der Spiegel die Idee, dass die Arbeit sich auf außerhalb liegende Dinge bezieht. Vielleicht ist am wichtigsten, dass er auf gedankliche Reflektion verweist, auf die Idee von Prüfung und Distanz. Er ist auch ein Instrument zur Verdoppelung, das auf mehrere Perspektiven deutet. Im Hinblick auf die Themen bestimmter Arbeiten erhoffe ich, dass dieses Verdoppeln der Problematisierung von Geschichte dient. Wenn es mehrere Interpretationen von Ereignissen gibt, kann der Betrachter keine monolithische Lesart konstruieren.

Das Medium Spiegel ist verbunden mit Theatralität, ein historisch geladener Ausdruck, der von Michael Fried in seiner dubiosen, jedoch essentiellen Kritik am Minimalismus definiert wird. Die Idee der Erweiterung von Autonomie zu Interaktion spielt eine wichtige Rolle. Nicht nur der Gebrauch von Spiegeln, auch deine Lichtarbeit mit der Aufschrift »Like, Man, I'm Tired (of Waiting)« erinnert mich an Frieds Analyse der Beziehung zwischen Kunstwerk und Betrachter in »Art and Objecthood: In Anbetracht der Tatsache, das minimalistische Kunst vom Betrachter abhängt, also unvollkommen ohne ihn ist, hat *sie auf ihn gewartet (*has been waiting for him*)«.*

»Art and Objecthood« ist sehr wichtig für viele meiner Arbeiten, auch für meine Ideen über das Wesen der Kunst. Fried hatte Unrecht in »Art and Objecthood«. Wenn man seine Argumente auseinandernimmt, bleibt nichts übrig; sie sind unvertretbar. Doch wenn man seine Kritk umdreht, ins Gegenteil verkehrt, oder sie gegen sie selbst richtest, dann bietet sie fantastische Theorien dazu, wie Kunst funktionieren kann. Douglas Crimp hat das in seinem Essay »Pictures« getan als er über Künstler wie Sherrie Levine und Richard Prince geschrieben hat. Die Vorstellung von Theatralität und Zeitlichkeit, von einer Kunst, die »zwischen« den Kategorien der Kunst liegt, ist ein großartiges Konzept. Natürlich tut gute Kunst mehr als nur ihre formalen Komponenten zum Ausdruck zu bringen. Auch meine Arbeiten liegen zwischen den Künsten wie Fried sagen würde. So habe ich wohl darüber nachdenken müssen, diese Position zu verteidigen.

Der Zuschauer spielt eine wichtige Rolle in deinem Werk. In vielen Arbeiten mit Spiegeln integrierst du den Betrachter als eine reflektierte Projektion, eine zentrale Figur, fast wie ein Motiv – analysierend, sinnend, kombinierend und lachend. Aber er ist auch in die Position einer

COUNTERCLOCKWISE, 1999

RepoussoirFigur gebracht, die die Szene betritt und stellvertretend die Perspektive des Künstlers einnimmt. Der Betrachter blickt ins Bild und ebenso blickt er innerhalb des Bildes.

Es ist sehr wichtig, dass die Betrachter sich als aktiver Teil in ihrem Engagement mit der Arbeit verstehen. Selbstbewusstsein und Reflektion sind Teil des interpretierenden Prozesses.

Robert Smithson sagt: »Ich bin für eine Kunst, die den direkten Effekt der Elemente in Betracht zieht, so wie sie Tag für Tag unabhängig von Repräsentation existieren«. Smithson glaubte, dass die Dinge im Museum verflachen und verblassen; in diesem leeren Raum, dieser Gruft. Deine Arbeiten hingegen werden immer mit dem »White Cube« im Hinterkopf realisiert.

Ja.

Anders als Smithson, dessen Ausgangspunkt die Problematisierungs des Museums war, stellst du es nicht in Frage. Aber die Arbeiten, die du in Museen zeigst, sprechen eigentlich über die Welt außerhalb des Museums; einige sind sogar Modelle, die außerhalb ausgeführt werden könnten.

Ich bin nicht so sehr an einem Dialog mit dem »White Cube« oder dem Museum interessiert. Es gibt so viele Künstler, die das sehr gut tun, und ich überlasse ihnen das Projekt gerne. *Proposal for Monument at Altamont Raceway, Tracy, CA* (1999) ist ein Beispiel für den zweiten Teil deiner Frage. Das Modell ist ein Kunstwerk und darüber hinaus ein architektonisches Modell eines realistischen Entwurfs. Ich bin einfach darauf verfallen, Modelle zu machen als ich die Abandoned Houses anging. Als ich an dem ersten Modell arbeitete, dachte ich nicht, dass ich es überhaupt zeigen würde. Ein Freund sah es und überzeugte mich, dass es ein lohnendes Projekt sein könnte. Nach den Abandoned Houses habe ich angefangen, über Monumente nachzudenken. Ein Monument ehrt irgendetwas, es erinnert dich an einen Tod, eine Tragödie, einen großen Sieg – es schreibt Geschichte. *Partially Buried Woodshed* war ohnehin ein inoffizielles Monument für die Morde in Kent State. Meine Modelle haben das nur verdeutlicht und durch den Gebrauch von Musik umfassender auf eine Kosmologie von Tod und Zerstörung hingewiesen. Der Bezug zu Neil Young ist einfach herzustellen, schon wegen seines Liedes »Ohio« und seiner Beziehung zu Kurt Cobain, die sich durch das Zitat einer Zeile von Neil Young in seinem Selbstmordbrief ergab. Altamont ist ebenfalls ein sehr problematischer historischer Augenblick. Ich nehme an, ich werde zu diesen traumatischen Ereignissen hingezogen.

Auf dem Modell sieht man keine Lautsprecher. Es erscheint als reine Konstruktion ohne irgendwelche erkennbaren funktionalen Elemente des wirklichen Altamont-Szenariums. Es erinnert mich an den utopischen Turm von Vladimir Tatlin.

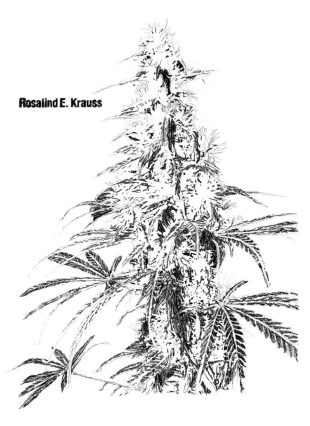

Rosalind E. Krauss

ROSALIND KRAUSS, 1998

Das Monument für die Dritte Internationale.

Könntest du dir die Ausführung dieses oder anderer Arbeiten in großem Maßstab vorstellen?

Ich versuche tatsächlich gerade, ein Altamont-Monument in der Nähe der Rennstrecke zu bauen. Unglücklicherweise sind die Grundstücke nicht mehr so billig wie 1970.

Deine Arbeiten gehen von der Annahme aus, dass das Publikum mit deinen Referenzen vertraut ist. Würdest du dem zustimmen?

Ja und nein. Ich denke, dass die Dinge, mit denen ich in den vergangenen vier oder fünf Jahren gearbeitet habe, einfach zu verstehen sind. Die Popmusik, Kunst und Architektur, auf die ich mich beziehe, sind ziemlich bekannt. Meine Refenrenzen sind vielleicht nicht die populärsten aber mit Sicherheit nicht abgehoben.

Es geht hauptsächlich um amerikanische Kultur.

Aber ja, ja sicher. Alles dreht sich um amerikanische Kultur und Geschichte. Ich glaube, dass die meisten Betrachter auf einer oberflächlichen Ebene Zugang finden, da ich Themen wie die Rolling Stones und Neil Young gebrauche. Sie sind international berühmt; jeder kennt sie und weiß, was sie sind. Ich verwende keine schwer verständliche Avantgarde-Musik. Auf dieser Ebene sind die Arbeiten sehr zugänglich. Aber man muss schon einige Kenntnisse haben, um allen Referenzen in den Arbeiten folgen zu können, dem stimme ich zu. Natürlich erwarte ich nicht, dass der Betrachter mit allen Dingen, die ich verwende, vertraut ist, dennoch erlauben die populäreren, erkennbaren Dinge einen ersten Zugang. Jeder kann

sich etwas ansehen und es auf einer ästhetischen Ebene genießen. Wenn man aber etwas schafft, das mehr als nur ästhetischen Wert hat – etwas, das sich auf außerhalb der Arbeit befindliche Dinge bezieht – dann ist man mit dem Problem des Wissensgrades der Betrachter konfrontiert. Jede Arbeit kann auf verschiedenen Ebenen gelesen werden, und das ist sehr wichtig. Man hat mich dafür kritisiert, zu schwer verständliche Arbeiten zu machen, doch bin ich da anderer Meinung. Ich denke, meine Arbeiten sind im Grunde sehr einfach zu verstehen. Es gibt eine Menge von Informationen, und der Inhalt mag nicht immer dem entsprechen, womit Betrachter sich normalerweise angesichts von Kunstwerken beschäftigen. Ich glaube im übrigen, dass einige Betrachter ihre Erwartungen auf die Kunstwerke projizieren anstatt direkt darauf einzugehen, was wirklich vor ihnen steht.

Ich kenne keinen Künstler, der so intensiv mit einer so spezifischen Zeitperiode wie du arbeitet. Freud glaubte, dass man Kontrolle über die Vergangenheit haben muss. Im Grunde ist die einzige Lösung für eine erfolgreiche Gegenwart das Wissen um zentrale Erfahrungen in der Vergangenheit. Siehst du eine Beziehung zwischen dieser Aussage und deiner künstlerischen Praxis, jedenfalls in kollektiver Hinsicht?

Vielleicht auf kollektiver Ebene, ja, jedoch nicht auf einer persönlichen Ebene.

Einige Titel deiner Arbeiten spielen auf Freud an, z.B. Reflected Upside Down and Backwards *(1999), und mehr noch* What's Underneath Must Be Released and Examined to Be Understood *(1998).*

Genau. Der Titel *What's Underneath Must Be Released and Examined to Be Understood* bezieht sich auf ein psychoanalytisches Modell. Es bildet den Rahmen für die Interpretation der Arbeit. Ein Titel wie *Reflected Upside Down and Backwards* problematisiert das Thema dieses Stückes und ebenso die Subjektivität des Betrachters. Darüber hinaus funktioniert er wie die Linse in deinem Auge. Psychologisch gesehen wird die Welt zuerst seitenverkehrt und rückwärts wahrgenommen. Dann wird sie in deinem Gehirn umgestellt, mit der richtigen Seite nach oben und vorwärts laufend.

Die Geschichte zu reflektieren dient der Gegenwart. Herbert Marcuse, dessen Ideen sowohl bei den Hippies als auch für die Civil-Rights-Aktivisten sehr einflussreich waren, glaubte, dass das Leben nur in der Gegenwart gelebt werden kann. Was bedeutet das hier und heute für dich?

Wir gehen davon aus, dass Geschichte fortlaufend ist. Malcolm X sagte, dass das Verstehen der Geschichte das wichtigste ist. Du kannst die Bedingungen der Gegenwart nicht verstehen, ohne die Beweggründe für diese Bedingungen zu kennen. Es gibt eine Hypothese, die besagt, dass die Erfahrung von Zeit als etwas ständig vorwärts laufendes völlig willkürlich ist. Genau genommen ist uns nichts bekannt, das die Zeit davon abhält, rückwärts zu laufen. Eine interessante Randbemerkung dazu war die Annahme, dass das Gesetz der Entropie der Grund für die Vorwärtsbewegung der Zeit ist und zwar aufgrund der Tatsache, dass Materie unwiderruflich degeneriert. Das ist inzwischen widerlegt. Es gibts nichts, was diese Umkehrung verhindert.

In einem Artikel von James Meyer wirst du wie folgt zitiert: »Erfahrungen waren klarer« und »Dinge bedeuteten mehr« in den 60er Jahren. Angesichts deiner Distanz und forschenden Haltung gegenüber dieser geschichtlichen Periode, überrascht mich das in diesen Behauptungen vermittelte Gefühl von Sehnsucht. Es scheint, als repräsentieren die 60er Jahre für dich eine »wirklichere« Realität als heute.

Da habe ich falsch gelegen. Ich versuchte, herauszufinden, warum ich an dieser Periode so interessiert war, und ich hatte nicht gründlich genug darüber nachgedacht. Obwohl es mich dann verfolgte, so gedruckt zitiert zu werden, hat es mir andererseits geholfen, diese Dinge

gesagt zu haben. Sie haben mich dazu gezwungen, die Funktionsweise meiner Arbeiten besser in den Griff zu bekommen.

Was wir über diese Zeit wissen, ist uns durch Film, Musik und Literatur vermittelt worden. Du hast Robert Smithson nicht erlebt; dein Wissen über ihn ist dir indirekt durch unterschiedliche Quellen übermittelt worden, und einiges davon hat dazu beigetragen, ihm eine mythische Rolle zuzuteilen.

Ich mag Smithson eben weil er eine mythische Gestalt ist. Sein Tod ist Teil des Kontinuums all der tragischen Tode von Pop Stars und Berühmtheiten. Dies ist einer der Wege, auf dem er mythisiert wurde. Es ist auch einer der Gründe, die ihn in meinem Kopf mit Cobain verbunden haben. Ich hoffe, dass durch die Verkoppelung dieser auf verschiedene Weise verbundenen Menschen und Ereignisse die Mythisierung klar wird und ein wenig Perspektive gewonnen werden kann.

Deine Arbeiten sind in Europa sehr nachdrücklich aufgenommen worden. Im Grunde überraschend, wenn man deine spezifisch amerikanischen Themen bedenkt.

Der politische Nonkonformismus der 1960er Jahre war nicht auf die Vereinigten Staaten beschränkt—Revolutionen wurden überall auf der Welt inszeniert. Neben den wohlbekannten Ereignissen in Europa gab es afrikanische Freiheitsbewegungen sowie Aufstände und Auseinandersetzungen in Zentralamerika, Asien, Korea, Zypern, dem Nahen Osten und Palästina, um nur einige zu nennen. Das Buch *1968: Marching in the Streets* von Tariq Ali und Susan Watkins verdeutlicht die globale Natur der Freiheitsbewegungen dieser Zeit.

Diese Auseinandersetzungen waren im großen und ganzen das Ergebnis von Gesellschaften, die die Erfüllung einer utopischen Vision anstrebten. Ist der Ausdruck »Utopie« auf die Kunst anwendbar?

CONSCIOUSNESS RAISING HISTORICAL ANALYSIS, PAIN PLUS TIME SEPARATED AND ORDERED WITH EMPHASIS ON REFLECTION, 2001
EXCAVATION, FENCE, AND AUDIO SYSTEM; 12 x 40 x 20 FEET
INSTALLATION AT KUNSTHOF ZÜRICH, 2001

DISPLACED SIGN, 2001
STEEL, ACRYLIC, AND FLUORESCENT TUBES; 24 x 94 ¹/₂ x 10 ¹/₂ INCHES
INSTALLATION AT MAK CENTER FOR ART AND ARCHITECTURE, LOS ANGELES, 2001

Ich denke schon. Als ich jünger war, löste die sogenannte »Institutionskritik« große Enttäuschung bei mir aus. Aus meiner Sicht war es gescheitert, wirkliche Veränderungen in Gang zu bringen. Die kritisierten Institutionen absorbierten die Bewegung einfach. Deshalb war sie für mich wertlos, hat versagt. Heute glaube ich nicht, dass das zutrifft; Veränderungen sind nicht immer auf diese Weise messbar. Zustände verändern sich im kleinen über einen sehr langen Zeitraum bevor sie große Veränderungen auslösen. Es ist sehr wichtig, diese kleinen Veränderungen in Gang zu halten. Die Auseinandersetzung geht weiter.

Machst du auch ortspezifische Arbeiten?

Normalerweise nicht. Ich habe *Partially Buried 1960s/70s Utopia Reflected* und *Partially Buried 1960s/70s Dystopia Revealed* in anderer Form in Zürich realisiert. In einem Außenhof habe ich ein etwa zwei Meter tiefes Loch mit einem Durchmesser von ca. fünf Metern gegraben. Ich habe Erde neben das Loch gehäuft und je einen Lautsprecher in das Loch und dem Erdhaufen platziert. Ich habe den gleichen Soundtrack wie in *Partially Buried 1960s/70s Utopia/Dystopia* verwendet.

Im vergangenen Jahr hast du speziell für das MAK Center for Art and Architecture ein Projekt im Schindler-Haus in Los Angeles entwickelt. Und nun arbeitest du an einem auf Joseph Beuys bezogenen Projekt für den Kunstverein in Düsseldorf.

Manchmal fallen eigene Interessen mit Orten zusammen. Ich bin von der Zeitschrift *Artforum* gebeten worden, einen Text über R. M. Schindler zu schreiben. Daraus ist ein Artikel über seine Kirche in South Central L.A. geworden. Kurz darauf lud mich das MAK Center ein, an deren Ausstellung »In Between: Art and Architecture« teilzunehmen, sodass es möglich war, die in meinem Text für *Artforum* aufgeworfenen Aspekte auch durch eine Arbeit in der Ausstellung zum Ausdruck zu bringen; das war großartig. Eure Einladung zu einer Ausstellung im Kunstverein in Düsseldorf traf sich mit meinem Interesse an Beuys. Ich bin sehr an der Beziehung zwischen der Düsseldorfer Kunstakademie und seinem Büro für Direkte Demokratie durch Volksabstimmung interessiert. Die materielle künstlerische Arbeit selbst interessiert mich weniger als der ihn und seine Ideen, Philosophien, pädagogische Theorien, und politisches Engagement umgebende Mythos. Smithson und Beuys waren beide in der von der Kunsthalle organisierten Ausstellung »Prospect 69« vertreten. Die Gelegenheit, hier eine Ausstellung zu machen, ist wirklich perfekt.

SOUTHERN CROSS, REFLECTED UPSIDE DOWN, 2000
GRAPHITE ON PAPER; DIPTYCH, 30 x 22 INCHES AND 22 x 30 INCHES
COURTESY BLUM & POE, SANTA MONICA

Für »Prospect 69« schuf Beuys Plastischer Fuß–Elastischer Fuß *(1969), eine mehrteilige Installation mit dem Titel als Text auf dem Boden und zwei großen, von der Wand hängenden Filzlaken. Smithson führte außerhalb des Museums eine Spiegel-Versetzung aus. Beide Arbeiten enthalten eine Reihe von Merkmalen, die auch in deinen Arbeiten gegenwärtig sind, z.B. die dichotomische Natur der Arbeiten und die Art des Aufbaus der Installationen. Genau wie du vermeiden beide Künstler eine einseitige Perspektive, indem sie Materialien wie Spinnen im Netz sammeln, ohne die Materialien selbst ausdrücklich zu zeigen. Die Arbeiten sind mehr Gestalt, weniger Botschaft. Stimmt das auch auf deine Arbeit bezogen?*

Ja, in meinen neueren Arbeiten findet man weniger die direkte Kritik als mehr eine übergreifende Problematisierung des Themas. Der Betrachter kann auf verschiedenen Wegen zur Kritik kommen; da ist nicht immer eine genau beschriebene Route. Aber ich würde nicht sagen, dass die Arbeit am Ende offen bleibt, weil eben die Parameter genau definiert sind und jedes Projekt eine spezifische Bedeutung hat.

Kannst du ein Beispiel geben?

Southern Tree, Tree of Knowledge, Dead Tree entwickelte sich aus *Proposal for Monument in Friendship Park, Jacksonville, FL (2000)*. Im Rock der Südstaaten vibriert das Rassenproblem gleich unter der Oberfläche. Das war mir sehr bewusst, als ich am Projekt *Friendship Park* arbeitete, und ich wollte mich damit in der nächsten Serie von Arbeiten auseinandersetzen. Billie Holidays Song »Strange Fruit« ist der Schlüssel des ganzen. Dieser Song verändert einfach völlig die Art, einen Baum zu betrachten. Wenn man es hört, schießt der Baum blitzartig zur Lynchjustiz und Sklaverei. Ich wollte auch die Referenzen zu Genealogie, Familie, Philosophie, und all die symbolischen Bedeutungen des Baumes einbringen, was auch durch das direkte Zitat von Smithsons Upside-Down Trees passiert. Goodie Mob, eine Hip-Hop Band aus Atlanta, hat eine Platte mit dem Titel *Still Standing* aufgenommen, auf dessen Cover ein Baum gezeigt wird, und dies passte genau in meine Kosmologie. Cornel Wests *The American Evasion of Philosophy* mit der Cover-Illustration eines Baums, der die Namen von Philosophen wie Früchte an seinen Ästen trägt, bewegt die Arbeit in eine

andere Richtung. Das Projekt ist sozusagen von selbst gewachsen, eine Referenz führte zur nächsten. Das ist komisch, weil ich das Projekt nicht wie das Baummodell, sondern eher wie ein Feld wirken lassen wollte. Es sollte sich eigentlich horizontal, auf eine unhierarchische Weise ausdehnen. Formal ist die Arbeit nicht vertikal, sondern ein Feld von umgestülpten Baumstümpfen mit einer umherwirbelnden musikalischen Komposition.

Und sie wirkt bühnenhaft...

Sie ist sehr theatralisch. Formal liegen meine Skulpturen irgendwo zwischen Modellen, Requisiten, und Skulpturen, besonders das Stück *Friendship Park*, das buchstäblich eine Bühne ist. Meine Entdeckung von Isamu Noguchis Bühnenbildern für Martha Grahams Tänze spielten eine große Rolle bei der Entstehung dieser Form. Auf eine Art sind die Elemente Requisiten. In einem anderen Sinn ist die Installation ein komplett funktionierendes Monument und obendrein eine interaktive Skulptur. Bei *Southern Tree, Tree of Knowledge, Dead Tree* ist der Bühneneffekt weniger deutlich, jedoch genau so wichtig.

Wird das Projekt für den Kunstverein in Düsseldorf ähnlich funktionieren?

Ich glaube schon. Ich denke, dass das neue Projekt wie die Entwürfe der Monumente funktionieren wird, indem stark mythisierte und übergreifende Elemente zusammen in einem Feld platziert werden. Ich bin sehr daran interessiert, eine Situation zu entwerfen, die verschiedene Aspekte aus dem Leben und der Arbeit von Beuys vereinigt. Ich bin sicher, dass die Arbeit Aspekte wie seine Position an der Düsseldorfer Kunstakademie, einige soziopolitische Performances und die Mythen, die er um sich selbst bildete, aufgreifen wird. Ich kann mir vorstellen, auf die Filz- und Fettmaterialien hinzuweisen, besonders auf *Plastischer Fuß–Elastischer Fuß* aus der »Prospect« Show. Vielleicht werde ich auch einige der in Deutschland geschaffenen Arbeiten von Smithson wie *Mirror Displacement on a Compost Heap* (1969), *Dead Tree* (1969) und die Oberhausener Schlackenarbeiten (1968) integrieren. Es ist sehr wichtig, dass die neue Arbeit die Rollen der Mythen und Rituale im Leben von Beuys repräsentiert und eine kritische Perspektive dazu aufwirft. Es ist so viel in seiner Praxis unterdrückt, und ich möchte einiges davon ans Licht bringen und mir ansehen. Aus Repression ergibt sich immer etwas Interessantes.

Los Angeles, 8. Februar 2002

Übersetzung: Hans-Jürgen Schacht

JOSEPH BEUYS
PLASTISCHER FUß–ELASTISCHER FUß, 1969
INSTALLATION AT "PROSPECT 69," DÜSSELDORF, 1969
© MANFRED TISCHER, DÜSSELDORF/VG BILD-KUNST, BONN 2002

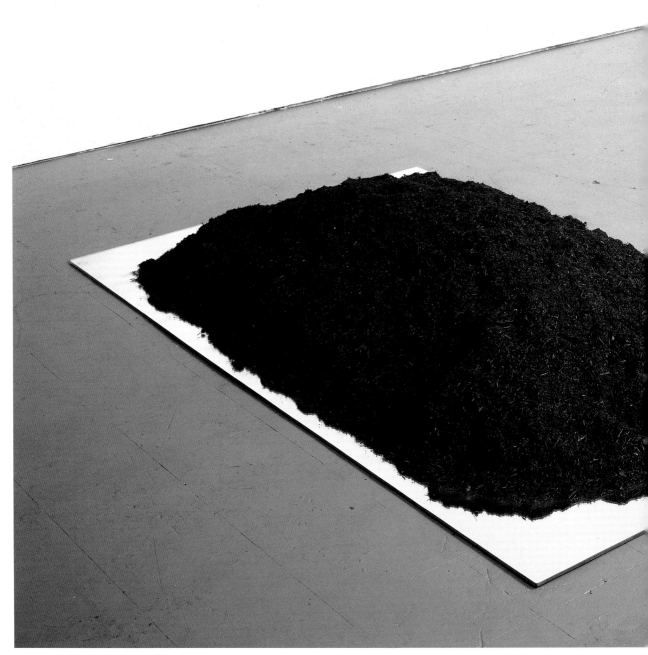

LEFT TO RIGHT: *PARTIALLY BURIED 1960S/70S DYSTOPIA REVEALED (MICK JAGGER AT ALTAMONT)*; AND *PARTIALLY BURIED 1960S/70S UTOPIA REFLECTED (WAVY GRAVY AT WOODSTOCK)*, BOTH 1998

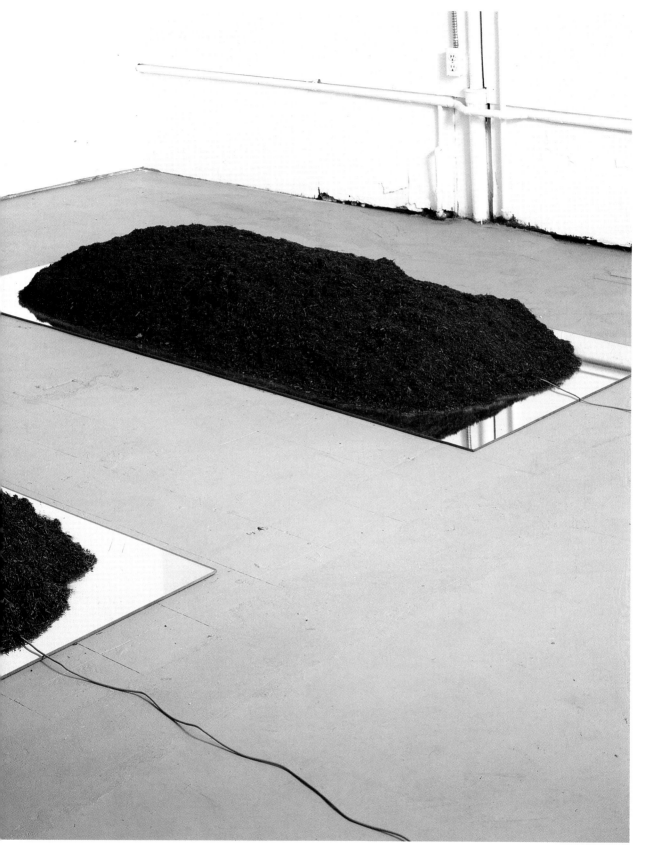

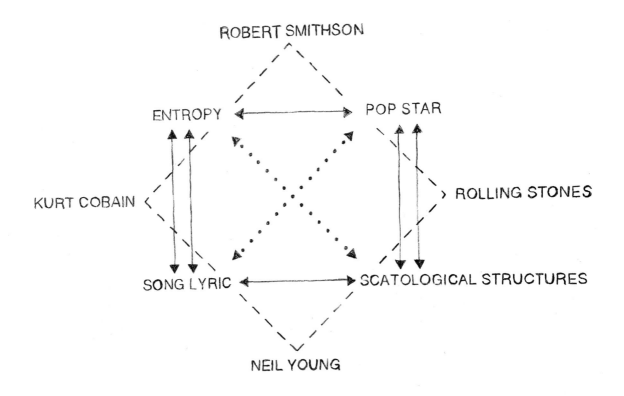

QUATERNARY FIELD/ASSOCIATIVE DIAGRAM, 1998

COVER SONG

KEVIN YOUNG

One true test of musicianship is the cover song. Often we cannot tell just how good someone's song is till it emerges from someone else's mouth; likewise, we often only find out how good musicians are when they take someone else's words and make them their own.

However, it seems that, now more than ever, some only know how to take from others. Pop recyclings and postmodern posturings seem to be all around us and, while the repetition so necessary to pop (and made formal in pop art) may not make the heart grow fonder, it can sometimes make us hum along despite ourselves. Still, hearing a song made new by an artist, often an unexpected one, can make us realize just how powerful a song is, not to mention the artist now rendering it.

In the largest sense, this is what Sam Durant has done in his work: making the song his own, "covering" it in order to uncover how it works, and how the world works as well. Much like Nirvana unplugged or Bob Dylan going electric, Durant's work gives us an opportunity to see the song within the song, the way that transformation meets tradition, whether to honor or overthrow it. Or more likely both. Inspired by Durant's rough and revelatory vision, I have tried to organize this piece with my thoughts on his work and some pieces of my poetry, in what may best be thought a "proposal" for a view of Durant's work, serving as much complement (and compliment, I hope) as critique.

FRIENDSHIP PARK
SOUTHERN ROCK

Repetition is part of the postmodern condition, you could say. This is especially true of Andy Warhol, who made an art out of repetition and grids and made paintings move like movie frames (*Elvis I & II*, 1964, or *Orange Car Crash Fourteen Times*, 1963) and movies still as paintings (*Empire*, 1964). Such transformations are behind Durant's work, and arguably behind all that we see around us veering between sameness and strangeness—indeed, what the cover song does at its best is make sameness suddenly strange. Nirvana's haunting, hollering version of their favorite singer Lead Belly's "Where Did You Sleep Last Night" takes what may be familiar and makes it their own, just as Lead Belly before him made the song "In the Pines" (an old ballad) his own.

"Own" becomes a tricky word; we are constantly aware, at least today, of the ownership of culture, who owns what. Indeed, before performing "Where Did You Sleep" on *Nirvana Unplugged in New York*, lead singer Kurt Cobain relates the story of being offered Lead Belly's guitar at the outrageous price of $500,000—then jokes that he even asked David Geffen, the record label head, to buy it for him. Cobain mocks both prices and patronage—the products that our folk heroes have become—before heading into the past to reclaim and re-cover the song. Durant's work engages in this unromantic nostalgia, one that isn't simply attached to the products of the past but to their sources, even as it seeks to remake them.

That Cobain mocks ownership while making the song his own is a sly nod to our present predicament in which ownership seems more important than originality. Perhaps what's worse is that where high modernist culture once regarded the blues as unmusical or unoriginal (at best, raw material to be borrowed), the new postmodern focus on ownership still manages to serve the same masters—masters that artists from bluesmen to Bob Marley do not control.

Even those who honestly sought to preserve folk culture (rather than those who merely profited from it) saw that culture as static and unchanging, pure rather than in process like all other arts. Indeed, in their reaction to a numb, postwar society, folkies ended up cherishing and then marketing the kind of innocence and untouched quality that folk culture inspired in them. In the end, folk culture is neither untouched nor untouchable, despite what its devotees might think. Roy Lichtenstein can just as easily paint a handmade Mickey Mouse (as he did in *Look Mickey*, 1961) as Henry Darger can paint bootleg Mickeys. Or, for that matter, look at any fair or junk store's array of handmade Mickey Mice for evidence of folk lifting from pop. We shouldn't ignore the ways in which the public takes from pop culture and uses it for its own folk purposes, or the way that high art is full of borrowings.

Durant knows this, not only bridging high and low as many before him have, but recognizing that low art contains many of our highest aspirations and that high art may contain some depressingly low points. Durant's work manages to turn repetitions, both folk and pop, into a useful strangeness, fulfilling a tradition inherited from the likes of Marcel Duchamp, Warhol, and Jean-Michel Basquiat, but with a style all his own. Take for instance his *Proposal for Monument in Friendship Park, Jacksonville, FL* (2000). Not only has he recouped the pebbly trashcan—who knew I'd feel nostalgia for seeing one of those in a museum setting—but also the sounds and experiences of Southernness, so often dismissed or caricatured. The trashcan seems to give us the feeling of the road or, more properly, the roadside attraction or scenic point where those trashcans are found,

in my experience. The porch (complete with newspaper as curtains in the window and rocking feet attached to lawn and folding chairs) does not keep us out, left to stare at the (preferably poor, white or black) Southerners as subjects on a porch as in many archetypal photographs of the South, but rather invites us in as participants. Or to be more specific, the porch invites us up, to sit a spell, and play some of the records arranged behind the chairs.

As the folks rocking on the porch then, it is the museum-goers—the would-be observers of Southernness or whatever otherness we wish—that are under scrutiny. But by finding that the porch is just a porch, we too realize that even when setting a spell we ain't crossing the threshold into the interior of the experience. In other words, by wisely making us participate in the experience of the monument, yet by acknowledging the limits of the museum or any experience, Durant makes the threshold the very subject of his monument. We not only participate, but are shaded and kept out by newsprint, by the black and white (and some color) that comes to us daily.

Recently, the nature of and need for monuments has become more pointed and poignant. How can we provide a monument to a large-scale tragedy or, indeed, to anything? The greater the event, the greater the need for the monument, as well as the greater difficulty in creating the proper one—although the twin beams of light, used to mark the six-month anniversary of the events of September 11 and the Twin Towers' collapse, came close. With Durant, we have monuments to things serious and things small, often favoring strangeness in order to combat the sameness that monuments have traditionally opted for; this white marbled, figurative sameness may seem less and less effective, as we continue to try (and need) to remember more and more. We may be reminded of the initial resistance to the Vietnam War memorial wall—its strangeness—and the demand for a more traditional figurative representation of the soldiers. Ultimately, both *The Three Servicemen Statue* (the figures) and the *Vietnam Veterans Memorial* (the wall) were built and now stand just yards apart—however, of course, it is the wall that folks find the most powerful, what they choose to remember.

Any notion of the monument as literal and figurative, as representation or likeness, underestimates the power of memory and imagination, nostalgia and invention—things that Durant's work relies on to make it unique and strange but also oddly comforting and public. Durant's *Friendship Park*, as its name implies, serves as a monument and an offering both permanent and temporary—it is both the wall we come to see and what we leave at the wall—made all the more powerful because of its rough, rural beauty.

The piece puts me in mind of the signs alongside roads in the South, both handmade signs offering P'NUTS and church signs with often cryptic warnings like *Think it's hot now just wait.* The result is a vernacular of prayer and condemnation, redemption and retail, that Durant's piece knowingly brings into the museum. This poem of mine, in progress, tries to travel some of the same ground:

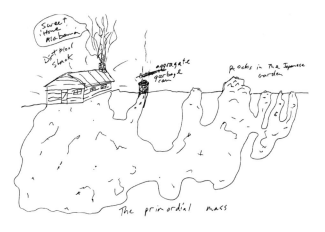

FRIENDSHIP PARK–PRIMORDIAL MASS, 2000

SIGNS

*Does the road you're on
lead you to me*
 —God

*

Dixieland
Weekly Rates

The Alamo

*

Drive-In
Something Mary
Armageddon

*

PRODUCE

*

He Who Takes the Son
Gets It All

*

Young's Pawn
& Gun

*

FAX IT HERE
COLLARDS

*

It's hard to fall
when you are already
on your knees

*

Red Star
Fireworks Peaches

*

GAL SK MLK

*

Our Beer's
The Coldest Around

*

THROW PILLARS

*

Fragments
Wool Suit Crepe
699

Try God

*

UNRECONSTRUCTED

*

If You Can't See
My Mirrors
I Can't See You

*

When Hell Freezes Over
I'll Climb
There Too

```
Let it Loose Monkey Man. You Gotta Move
Brown Sugar, a Black Angel,
have some sympathy.
Turd on the Run, partially buried, spiraling,
All Down the Line, counterclockwise,
2,000 Light Years from Home—
It's a Midnight Rambler, Factory Girl,
Parachute Woman, Street Fighting Man,
Little T & A, Down Home Girl, Bitch,
Honkey Tonk Woman, Prodigal Son.
Crystalline Brown Sugar, Sticky Fingers,
Salt of the Earth.
Mud, salt crystals, rocks, water,
formless, swirling, Under Cover of the Night,
Gimme Shelter
```

GIMME SHELTER, 1998

Of course, one of the key aspects of Durant's Friendship Park is that it exists as a proposal. In his *Friendship Park–Primordial Mass*, *Friendship Park with Flags*, and *Appalachian Spring* (all 2000), Durant manages to sketch out versions of the work—"covers," as it were—that are even larger in some ways than the work itself.

All Durant's proposals revisit loss and acknowledge it. One only need look at the "primordial mass" beneath his proposal and his "Dirt Floor Shack" to know there are things we can't know, things we may have lost without even knowing. "Allegorical landscape outside shopping mall" may describe *Friendship Park with Flags*, but might easily also describe America. In Durant's drawing, "Sweet Home Alabama" plays out of the chimney like a Confederate flag flying above a statehouse, eliciting either home or hatred; in Durant's vision we recognize both as true, the undiscussed "primordial mass" of meaning just below the surface.

The primordial mass of meaning may also be nostalgia's place in this and much of Durant's work. We may be reminded that nostalgia itself means "homesickness"—what better way to recognize this feeling than making a rough-hewn home that lives for a time in the museum? Ultimately, this homesickness is what Durant challenges us to feel (or refuse to feel). In the end, he recognizes that not just the monument, but the many proposals that accompany it, may be the best way to honor such fugitive emotions.

REFLECTED UPSIDE DOWN AND BACKWARDS
THE ROLLING STONES

I do not own a single Rolling Stones album. This comes as a shock to many, if not most people, but I suppose like most failings it has now become something of a source of pride: there isn't a single Rolling Stones song in my music collection. That is, unless you count "Love in Vain" by Robert Johnson, a song I didn't even know was recorded by the Stones until I played the original (and for me, the only familiar) version to a class, and a slightly older woman in the front mouthed every single word.

Afterwards, she came up and said she did not know that someone else had recorded the song—she only knew the Stones' version. This was shocking to me, not only because she was missing out on great American music and a genius of the twentieth century, but also because the typical defense of the Stones covering dozens of black musicians is that they are homages and not simply covers.

The difference between an homage and a cover is slight yet significant, one that plagues postmodern art (where a critic like Frederic Jameson might term the former parody and the latter mere pastiche). A cover band may be a good thing at a wedding, but it remains somewhere far below pop group in the hierarchy of musicians (in which singer-songwriter is either the tops or, if not to your taste, at least a higher level than prefab pop group). For those in the know, bluesman,

rock-n-roller, and soul singer all vie for top rank, but the cover band—part garage band, part not even that—must rank lowest. In this regard, to say the Stones are simply a newfangled cover band is a heresy beyond not even knowing, much less owning, any of their music.

Despite the Stones' achievements, one can certainly wonder at the heights to which they have ascended in our collective culture. Folks who ponder Otis Redding's cover of the Stones song "Satisfaction" may agree, as Keith Richards apparently does, that Redding's is the definitive version. This may come as no surprise—Redding, with the (multiracial) Rhythm Section behind him, is a fellow inheritor of the rhythm-n-blues (and gospel) which he helped make soul out of, a sound that Jagger and Co. were trying to recapture whether in covers or their own "originals." This is no secret: even in their sleep, in Richard's famous dreaming up (and recording) that irresistible, seemingly subliminal "Satisfaction" riff, the Stones are channeling "soul." But how is dreaming soul different from the black booty being dreamt of in "Brown Sugar"?

Though "The Blues Had a Baby and They Called It Rock-n-Roll," the paternity remains too often ignored or, worse, denied, largely because folks don't want to admit that "nigger music" was the British Invasion's baby daddy. Like Lennon and McCartney, Jagger and Richards were drawn to and acknowledged blues and early rock-n-roll (both black musical forms). Part of this attraction was simply good taste. However, was the result—a combination of freedom and fascination for a culture that must have seemed both refreshing and forbidden in postwar Britain—all that different from the manner black expression has served white culture, especially youth culture, since the twentieth century began? Flappers, beatniks, hip-hop heads—the beat of black culture has a steady pull, and is arguably the basis of much American culture, and undeniably all of American music (including country). Even in its journey back across the pond, the British Invasion may be seen as a kind of black repatriation.

These dark roots are what Durant's installation of trees set about exposing, uprooting like the willow tree that fell down in my backyard, almost hitting my house—for hours I stared at the top of it, pretending I was the sky, watching the birds who still sat in its fallen branches. Durant's choice of songs, from Billie Holliday's "Strange Fruit" and Public Enemy's "Fear of a Black Planet," to Robert Johnson's "Crossroad Blues," spares us little, describing falls of a different sort.

His reversals, which I will discuss more in a moment, refer not just to art history but history history, of which the

reversed family tree (*Standing on Our Head*, 2001) is another version. An un-cover. In the case of his various pieces for Altamont, Durant casts his light (in miniature) on the tragedy at the Stones concert at the Altamont speedway, when the Hells Angels, hired for security, did in a concertgoer. Unlike Pauline Kael who, in a 1970 film review, described Jagger as complicit in if not culpable for the tragedy, I do believe the deaths were felt profoundly by Jagger and the Stones—feelings chronicled, both as tragedy and as regret, in the brilliant film by the Maysles brothers, *Gimme Shelter* (1970). As we watch the film alongside Jagger while the filmmakers rewind for him the footage of the attack over and over, we see the violence not so much unfold as explode with what should have been known. (In this, it is quite the opposite of simple nostalgia and more like the dance Durant manages between an impossible nostalgia and an unenviable rootlessness.) Inevitability and irony merge as Jagger in his star shirt goes into "Sympathy for the Devil," and the crowd goes wild.

The visual repetition of the violence that follows, as the horror is replayed again and again, only reinforces our inability to keep it from happening. But where I see the audience implicated by the film as mere bystanders, Kael sees the Stones and filmmakers as disingenuously orchestrating an event and simply "standing by" while the inevitable occurred. For her, *Gimme Shelter* "plays the game of trying to mythologize the event (Altamont) and to clear the participants (the Rolling Stones and the filmmakers) of any cognizance of how it came about,"[1] when indeed the Jagger persona makes voyeuristic danger his dance partner. Whatever we may think, certainly too many of the accounts fail to mention that the victim of the Hells Angels stabbing was black. Discovering this increases the strangeness of the event, yet also its horrifying sameness: as the Hells Angels, who were violent towards others at the show, chose to murder a black concertgoer (though, granted, one who may have been armed), there is something about the intimacy of the murder, its quickness yet blurriness, that remains all too familiar. In this the Altamont tragedy defines, as is popularly thought, the end of the sixties. The violence of the era (racial violence at that), which was miraculously missing from Woodstock one year before, had visited what was hoped to be another terrific moment.

Durant's *Proposal for Monument at Altamont Raceway, Tracy, CA* (1999), covered in white foam and equipped with a looped recording of "Brown Sugar," un-covers the racial background of both the Stones' success and the tragedy at the speedway. (And any wish in the Stones' music to honor or free black sources seems far-off in light of "Brown Sugar," the plantation owner's lustful lullaby.) Just as revealing is

1. Pauline Kael, "The Current Cinema: Beyond Pirandello," *The New Yorker* 46, no. 44 (19 December 1970): 112.

Durant's foregrounding the desire (theirs and ours) expressed in the Stones' lyrics and song titles in his drawing *Gimme Shelter* (1998). In this work, titles and lyrics are interspersed with references to artist Robert Smithson in what amounts to a tone poem of desire, even desperation.

This desperation is indeed at the heart of the Altamont tragedy, and perhaps even ironically at the core of some of the Stones' biggest hits—"Sympathy for the Devil," "Gimme Shelter," "Brown Sugar," even "Satisfaction"—though the difference between The Rolling Stones and Otis Redding versions may be exactly the difference between being never satisfiable and never satisfied, between ennui and agita. Both versions of "Satisfaction" of course signal deeper and wider cultural dissatisfactions that echo with meanings perhaps no one could have intended (such is good art). However only one seems to spring from being dissed by (and not just pissed at) the broader culture. The devil may get sympathy, but I want me a hamburger in my hometown.

In the end, Durant's *Proposal for Monument at Altamont* remains effective because it is so raw, a thing of plywood and steel and that sad foam. Less than a foot high, we look down at it, god-like, or like me with my fallen tree. Two structures evoking the lighting or sound rigs are ominous yet pathetic, a symbol of what's to happen by the end of the film, but not the end of the event, which Durant's monument proposes still goes on. Is an event over once we memorialize it? Is a monument also, to paraphrase what Robert Lowell said of a poem, not just the record of an event, but an event in itself? Do we need a memorial to remember?

On a far smaller scale, do we need the Stones version of "Love in Vain" to hear the original? Perhaps, if T. S. Eliot was right in proposing that a new work of art not only adds to the tradition, it changes it—so that we may not be able to properly hear the Metaphysical poets, say, until reading Eliot's twentieth-century cover of them. This is the argument I hear again and again justifying Stones covers, but I'm not sure it's convincing. For one, with the uneven distribution of power and money that has characterized the history of the record business, we must realize that black music in white mouths is often more than simply poetic homage. However, appropriation is not simply a question of the covering artist's race, but also the quality of the transformation: a white artist like Bob Dylan manages to honor and create his own new blues without simply borrowing. Songs like "Bob Dylan's Blues" or "Like a Rolling Stone" achieve a synthesis that sounds both old and new, folk and electric, traditional (which is often another way of saying black-influenced), and transformed.

The ultimate yet elusive goal of art may be just this: the paradoxically organic synthesis, a grafting you could say, that remains fruitful, whether it hides or honors its roots. You can hear such breakthroughs in a few rare moments—the first chords of Nirvana's "Smells Like Teen Spirit" and Prince's "When Doves Cry," De La Soul's *Three Feet High and Rising*, Dylan's *The "Royal Albert Hall" Concert*—when sounds startle us at first listen with their strangeness, yet also intrigue us with a hint, however submerged, of what may someday sound familiar. Later, not only do we experience nostalgia in hearing the songs again, remembering that initial, thrilling moment of encountering the new, but we experience a sort of double nostalgia upon hearing both the origins of something new (Dylan going electric or jazz going bebop) and the old it's grafted onto (the folk traditions of blues and ballads that each are made from). It is this double nostalgia for the force of that first, exciting synthesis and the tradition it honors—as well as mourning the commercialized sameness that too often follows such breakthroughs (bebop goes beat, Dylan goes downhill, grunge goes pop, or so the story goes)—that Durant reenacts. This is harder than it sounds; even the unmistakable riff of "Satisfaction," whether we once found it powerful or not, has long since been stripped of its force through repetition ad nauseam. Millions in residuals may leave only residue. How to recoup the original (even if copied) power? Neither copy nor clone, the cover can be something entirely new while also old, regaining that initial power (one lost, ironically, by the billion other lesser covers that have come between). Like Otis Redding's version, Cat Power's "Satisfaction," from her aptly titled *The Covers Record*, is all the more powerful for what's unsaid: by leaving out the chorus that we all can fill in by heart (or rote), the song becomes all the more, or once again, filled with yearning.

Organic synthesis, double nostalgia, a stripped-down sound: all these are at work (and play) in Durant's work, one which acknowledges tradition while transforming it, sometimes by jumbling it (*Glue Horizon*, 1999), sometimes by stripping it down to impure image (his portrait of Cobain, titled *Into the Black/Rockstar*, 1998), all in an effort to reclaim the original power of the piece of art or music or power itself. In this process, the Stones become a kind of counterexample and unlikely collaborator, made all the more improbable because the cover-hungry Stones ironically despise sampling: witness their recent and successful suit against The Verve for their unauthorized looping of a snippet of an authorized, orchestral cover of a Stones song. "Bitter Sweet Symphony," indeed. As a result, you will never hear the song on any Greatest Hits. What makes sampling worse than covering a song? Is it musicianship and the ease of technology? Or do objections arise when culture travels the wrong way, whether in terms of race, or money, or power?

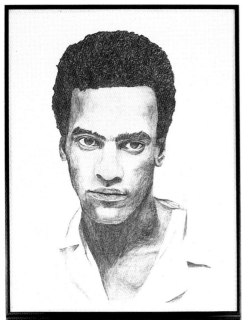

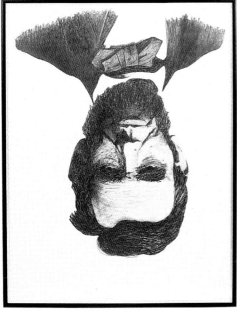

INVERSION, PROPOSAL FOR THE FIVE DOLLAR BILL (HUEY NEWTON,
FOUNDER OF THE BLACK PANTHER PARTY FOR SELF-DEFENSE), 2001
GRAPHITE ON PAPER; DIPTYCH, 100 x 38 INCHES OVERALL
COLLECTION OF EUGENIO LOPEZ, MEXICO CITY

and the folk music they brought with them that later became West Coast country and space-age funk. L.A. is fittingly also home to Beck, whose attempts to capture black style and substance occasionally favors the former. Even though his album *Midnite Vultures* is a perfect pastiche of early 80s Prince-style funk, we may rather just put on Prince's *Dirty Mind* and be done with it. Still, Beck's country-style "Rowboat" remains both homage and original—a fact highlighted when Johnny Cash covered the song for his 1998 album *Unchained*—while his lesser-known indie record *One Foot in the Grave* animates a range of redo-blues and lo-fi breakdowns, loose originals and covers, that mirror fellow Angeleno Durant's work.

Of course, California is also home to Altamont, and now Durant's memorial of it: all that white foam, like snow or a cover up, in a place not known for snow. As the term implies, the cover both replaces and obscures an event—though, like the cover of a great record or book, it might just provide something we open, another totem to take with us, before we rewind or put down the needle or press play to hear the words again.

HEAP OF LANGUAGE
BLACK PANTHERS
Durant's *Inversion, Proposal for the Five Dollar Bill (Huey Newton, Founder of the Black Panther Party for Self-Defense)* (2001) is a brilliant piece, marrying Huey Newton and Abraham Lincoln. Neck-and-neck. We may think they are linked by a vision of freedom for black people, or by the fact that they were both killed. Do we make a distinction between a death ostensibly for drugs and one for political reasons? Most important, however, might be the notion of "inversion," here made literal, that is frequently at the heart of black culture—"bad" meaning good, "cool" as opposed to "hot," and "black" being reclaimed from its status as insult and as a counter to "white." Lemons into lemonade; Lincoln into Newton. The piece asks about what's right-side up, and when and what reversal may appear.

Rather than sideways—the orientation of records or money, both of which as we've seen Durant consider—the inversion here is up-and-down. Part of this is the difference between a book and history: it is not about reading left to right, or front to back, but trying to make us as viewers want to put things back together and to put things right. In Durant's *Inversion*, Newton and Lincoln meet over money, which represents for some a form of freedom, for others a slow, symbolic murder. By linking the two figures—by a fin, no less—Durant asks how else they might meet. And what might we gain from their meeting?

Durant's manner of addressing race and racism can be as playful and direct as "Like a Rolling Stone"—asking *How does it feel?*—or better yet, can be as inspiring as the Muddy Waters song that gave name to both the Dylan song and the British band. Durant takes in order to make—like his fellow Seattle-born Kurt Cobain or Dylan, he makes something new yet all the more powerful for its familiarity. There is something in all this that adds up to Los Angeles: city not just of angels and Hells Angels, or the hyperreal of Hollywood and gangsta rap, but of Okies and Exodusters

Teach yourself to swim. Borrowing a car
for a day, joyride eight leagues across
state lines. Catch yourself the moment
before the pigs catch you, hands white

on the wheel. You have the right to remain
etcetera. Officer Le Fervour from the Fraternal
Order of Police will slap you on the wrists,
convince you to join the Panthers. You will

learn to remember your meals, record
conversations, how to write backwards
in the dark. Monitor all nefarious
activity, the Breakfast for Children Program,

the grits, the jelly. Relax and your body will
float naturally. After you become Minister
of Security, Special Agent M will contact you
intermittently to obtain the locations of weapons

and boxes of cereal. All milk shall be burned
in due time. Give your brother sleeping
pills drowned in water so he won't hear
our fire; after his file closes you'll see plans

of the headquarter*slash*bedrooms we drew
from your eyes. You never even raised
a fist. Take your two-hundred bones
for years of uniquely rendered service

and keep treading, remembering to breathe.

Recently, I saw Suzan-Lori Parks's new Pulitzer Prize-winning play, *Topdog/Underdog*, whose very title recognizes the kinds of dichotomies and dialectics made visual by Durant. In the play, two brothers, Booth and Lincoln, hustle for three-card monte and pride, victims of family as much as society. As a black man who dresses (in whiteface) as Abraham Lincoln and gets paid to reenact the assassination, Jeffrey Wright's performance as Lincoln is both exact and exacting, asking us at what price is success, or failure, or family, too high? Five hundred dollars? A Lincoln penny? A fiver on which we may forget Lincoln sits already? Or the six bucks that Durant's *Heap of Language (Soul on Ice)* (2001) tells us that Eldridge Cleaver's book *Soul on Ice* is now worth?

In uniting the two fallen leaders—or even in his loving, almost photographic drawings of Bobby Seale and multiple copies of *Soul on Ice*—Durant reveals both the promise and tumult (and largely external sabotaging) of the Black Panthers. It is interesting to note the difference in tone between the somewhat tongue-in-cheek Cleaver piece and Durant's pristine, honorific portraits of Newton and Seale. If you were Joan Didion in her essay "The White Album," you might say it's the all-too-commercialized style of the Los Angeles Panthers (and the ultimate contradictions of the 1960s) versus the substance and idealism of the original Oakland branch founded by Seale and Newton. Regardless, in each case Durant captures the sense of pride and possibility in the Panthers (a double nostalgia) as well as the threat of it all amounting to a heap of language—being made mere symbol and sale by a culture and a market that devalues words, black type on a white page.

Throughout his work, Durant is unafraid of highlighting the presence of race in popular culture (and pop art), and the racism our culture often denies yet feeds on. Watching *Topdog/Underdog*, I was reminded of another common visual doubling and inversion in the form of a playing card. In Parks's play, it's the two of spades the characters and the audience end up hoping for; at stake is not just the money wagered on three-card monte, but also whether blackness and brotherhood are what we're after. In Durant's *Inversion*, joining Newton and Lincoln makes them brothers—"bloods" in a vernacular and metaphoric sense—while also making them mirror images, much like a king, perhaps of different "suits," on the same face card. (You could call it the race card.) For Durant, these two historical figures remain constantly in flux, up and down like the stock market. I can perhaps best highlight this sense of inversion by a poem of my own:

NEGATIVE

Wake to find everything black
what was white, all the vice
versa—white maids on TV, black

sitcoms that star white dwarfs
cute as pearl buttons. Black Presidents,
Black Houses. White horse

candidates. All bleach burns
clothes black. Drive roads
white as you are, white songs

on the radio stolen by black bands
like secret pancake recipes, white back-up
singers, ball-players & boxers all

white as tar. Feathers on chickens
dark as everything, boiling in the pot
that called the kettle honky. Even

whites of the eye turn dark, pupils
clear & changing as a cat's.
Is this what we've wanted

& waited for? to see snow
covering everything black
as Christmas, dark pages written

white upon? All our eclipses bright,
dark stars shooting across pale
sky, glowing like ash in fire, shower

every skin. Only money keeps
green, still grows & burns like grass
under dark daylight.

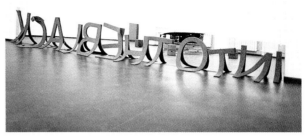

INTO THE BLACK, 1999

Seeing Durant's work I am reminded of the way that Basquiat saw his work often literally as a kind of alchemy, relating that once he began writing "money" on and in his work, he began making some. Or we may think of J. S. Boggs, whose work approaches money with an exactness that questions the difference between false and real, between a picture of money and money itself. Durant asks us many of the same questions, while explicitly recognizing that what money represents isn't just value, but also power—his work questions the difference between Cleaver, a photograph of Cleaver, Cleaver on the cover of *Soul on Ice*, and *Soul on Ice* being covered by Durant himself.

In the end, Durant's work does what a good cover should: it recognizes a tradition while transforming it, making it new and whole without erasing or concealing it. Perhaps it's something as simple as the difference in the way all Stones songs, whether originally theirs or not, sound like the Stones—as if they've been Stones-ified. While this certainly makes the work distinctive (or at least branded), it may sit in stark contrast to the almost chameleon range of Bob Dylan or Miles Davis, whose distinctness and desire for constant self-transformation leads to their oeuvres being radically eclectic, even contradictory, at least on the surface. Yet in the end the work is unified by its difference from and relation to all that's gone before (including their own previous work). For Durant, before is also now, as he transforms race, pop, and art history into an art both familiar and foreign, while recognizing the way history itself has a music to uproot, mirror, rewind, make his own—and ultimately and intimately, ours.

Kevin Young is a poet and the Ruth Lilly Professor of Poetry at Indiana University. He is the author of *To Repel Ghosts* (2000) and the forthcoming *Jelly Roll* (2003).

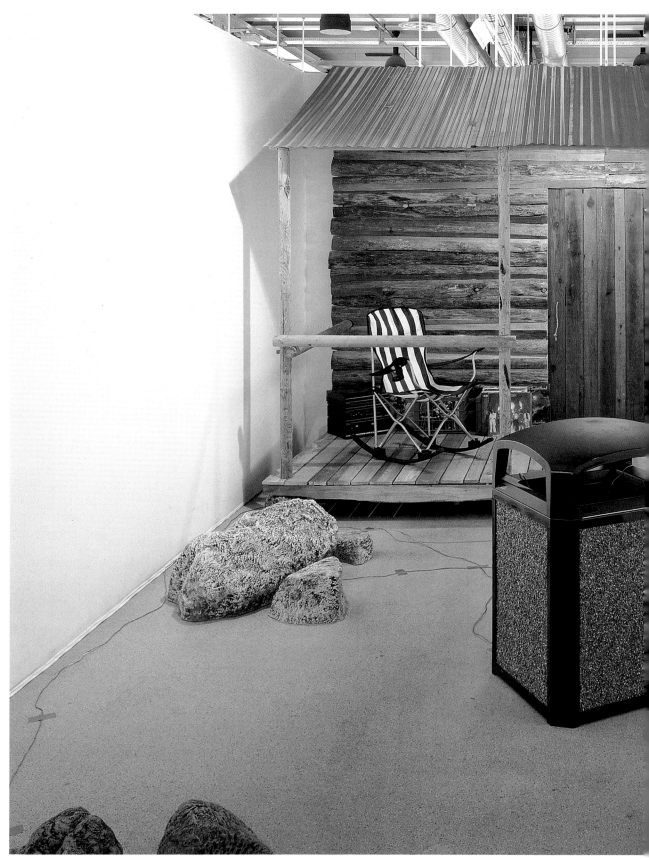

PROPOSAL FOR MONUMENT IN FRIENDSHIP PARK, JACKSONVILLE, FL, 2000

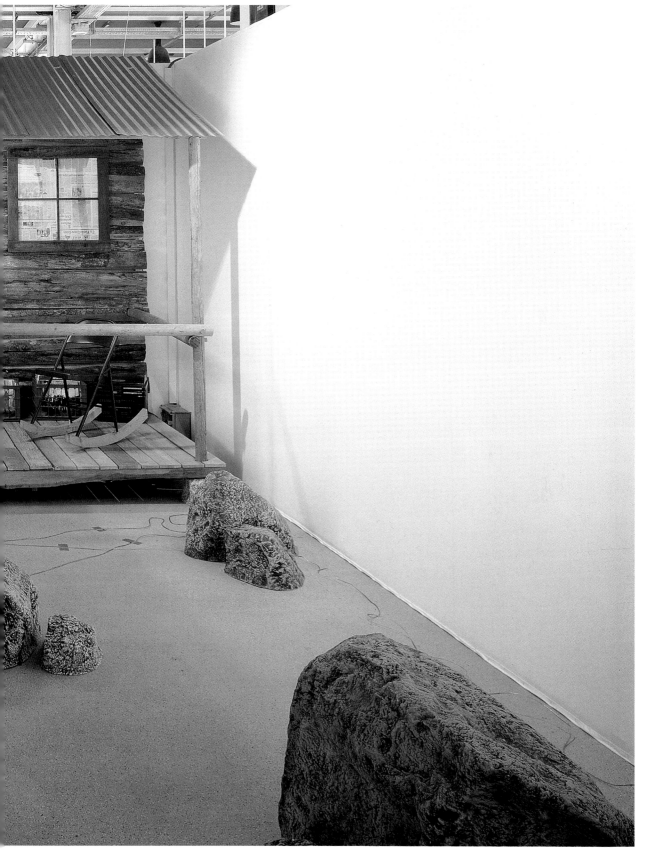

COVERSONG

KEVIN YOUNG

Der Coversong bildet nach wie vor ein Kriterium für den Beweis wahrer Musikalität. Häufig zeigt sich die Qualität eines Songs erst dann, wenn man ihn aus dem Munde eines anderen hört; ähnlich zeigt sich oftmals die Qualität von Musikern erst, wenn diese fremde Worte benutzen und sie zu ihren machen.

Heute allerdings verstehen sich einige ausschließlich darauf, von anderen zu nehmen. Offenbar sind wir umgeben von recyceltem Pop und postmodernen Haltungen, und obwohl die für Pop so notwendigen (und in der Pop Art formalisierten) Wiederholungen nicht unbedingt Glücksgefühle erwecken mögen, können sie uns dennoch zum Mitsummen bringen. Und beim Hören eines von einem Künstler neu aufgelegten – nicht selten unerwarteten – Stücks können wir plötzlich erkennen, über welche Stärke der Song sowie der Musiker verfügt, der den Song interpretiert.

Dies ist, grob gesagt, die Vorgehensweise von Sam Durant, nämlich das Vereinnahmen eines Songs, das »Covern« als Mittel der Enthüllung (engl. uncover, Anm. d. Übers.) dessen, wie er und wie die Welt funktioniert. Genau wie der *Nirvana Unplugged*-Auftritt oder Bob Dylans erster elektrifizierter Auftritt ermöglichen die Ausstellungen von Durants Werk die Enthüllung des Songs im Song und der Art und Weise, wie Transformation auf Tradition trifft und diese dabei entweder gewürdigt oder hinter sich gelassen wird (oder wahrscheinlicher: beides). Angeregt durch Durants grobe und offenbarende Sichtweise habe ich versucht, meine Gedanken zu seiner Arbeit mit einigen Auszügen aus meinen Gedichten zu kombinieren, um mich so der Idee eines »Vorschlags« für eine Betrachtung von Durants Werk anzunähern. Dieses Betrachtungsangebot soll gleichzeitig Komplement (und hoffentlich Kompliment) wie Kritik sein.

FRIENDSHIP PARK
SOUTHERN ROCK

Die Wiederholung ist ein wesentlicher Bestandteil der Postmoderne, könnte man sagen. Dies gilt besonders für Andy Warhol, der aus Wiederholungen und Rastern Kunst machte und in Gemälden eine Bewegung wie in Filmbildern erzeugte (*Elvis I & II*, 1964, oder *Orange Car Crash Fourteen Times*, 1963), während er Filme wie Gemälde behandelte (*Empire*, 1964). Solche Transformationen bilden den Hintergrund von Durants Arbeiten, vielleicht auch den Hintergrund von allem, das um uns herum zwischen Identität und Fremdheit hin – und herdriftet. Tatsächlich besteht die größte Leistung einer Coverversion darin, aus Identität plötzlich Fremdheit werden zu lassen. In der spukhaften, brüllenden Version des Songs »Where Did You Sleep Last Night« ihres Lieblingssängers Lead Belly nehmen Nirvana etwas vertraut Erscheinendes und machen es zu ihrem Eigentum, wie vor ihnen bereits Lead Belly den Song »In The Pines« (eine alte Ballade) zu seinem Eigentum gemacht hatte.

»Eigentum« ist ein heikles Wort. Inzwischen sind wir uns ständig des Eigentums von Kultur, dessen, was wer besitzt, bewusst. Tatsächlich erzählt der Leadsänger Kurt Cobain vor »Where Did You Sleep« bei *Nirvana Unplugged in New York*, wie ihm Lead Bellys Gitarre zum Wucherpreis von 500.000 Dollar angeboten wurde – um anschließend zu witzeln, er habe sogar David Geffen, seinen Labelchef, gebeten, sie für ihn zu kaufen. Cobain spottet über Preise wie über Förderer – die Produkte, zu denen unsere Volkshelden verkommen sind–, bevor er sich in die Vergangenheit stürzt, um den Song ein weiteres Mal zu covern und für sich zu beanspruchen. In Durants Arbeit geht es um diese unsentimentale Nostalgie,

die nicht einfach den Produkten der Vergangenheit anhaftet, sondern ihrem Ursprung, auch wenn stets versucht wird, ein Remake dieses Ursprungs zu erschaffen.

Wenn Cobain sich über Eigentum lustig macht und sich gleichzeitig den Song einverleibt, ist dies eine gewiefte Anspielung auf das gegenwärtige Dilemma, dass Eigentum wichtiger zu sein scheint als Ursprünglichkeit. Viel schlimmer vielleicht ist die Tatsache, dass dort, wo der Blues innerhalb einer Kultur der Moderne einst als unmusikalisch und nicht ursprünglich galt (oder im besten Falle als Rohmaterial, dessen man sich bedienen konnte), auch heute noch, mit einer postmodernen Betonung des Eigentums, den alten Herren gedient wird – Herren, die weder von Bluesmusikern noch von Bob Marley kontrolliert werden konnten.

Selbst die ernsthaften (und nicht lediglich an Profit interessierten) Bewahrer der Volkskunst betrachteten diese Kultur als statisch und schwankungslos, als rein und nicht wie alle anderen Künste Entwicklungsprozessen unterworfen. Tatsächlich reagierten Folkloristen auf die abgestumpfte Nachkriegsgesellschaft, indem sie die Art von unschuldigem und unberührtem Folk, der sie anregte, hegten und schließlich vermarkteten. In Wahrheit ist Volkskunst weder unberührt noch unberührbar, trotz allem, was selbst ihre eifrigsten Apologeten denken mögen. Roy Lichtenstein kann ohne weiteres eine Mickey Mouse abmalen (wie er es 1961 in *Look Mickey* tat), ebenso gut kann Henry Darger Mickey-Fakes kreieren. Als Beleg dafür, wie sich Folklore aus Pop emporhebt, werfe man nur einmal einen Blick auf die vielen handgemalten Mickey-Mäuse auf Jahr- und Flohmärkten. Man darf nicht ignorieren, wie sich die Öffentlichkeit der Populärkultur bedient und sie für ihre eigenen Folklorezwecke nutzt, ebenso wenig wie die Tatsache, dass Entlehnungen Bestandteil der Hochkultur sind.

Durant ist sich all dessen bewusst und verbindet nicht nur wie viele vor ihm high und low, sondern stellt darüber hinaus fest, dass jene low art zahlreiche unserer höchsten Ansprüche erfüllt, während die so genannte Hochkunst manchmal in bedrückend tiefe Täler führt. Durants gelingt es, Wiederholungen aus dem Bereich Folk und Pop in eine sinnreiche Fremdheit zu verwandeln und dabei die Tradition aus dem Erbe Marcel Duchamps, Warhols und Jean-Michel Basquiats fortzuführen, allerdings in einem gänzlich eigenen Stil. Nehmen wir beispielsweise seine Arbeit *Proposal for Monument in Friendship Park, Jacksonville, FL* (2000). Hier wird nicht nur der Kies-Mülltonne die Referenz erwiesen – wer hätte gedacht, dass ich jemals beim Anblick eines solchen Gegenstandes in einer Museumsumgebung nostalgisch werden würde –, sondern auch den Geräuschen und Erfahrungen des typisch Südstaatenhaften, das schon so oft parodiert und karikiert wurde. Die Mülltonne scheint uns das Gefühl der Straße zu vermitteln, oder genauer der Attraktion oder Szenerie des Straßenrandes, an dem sich derartige Mülltonnen nach meiner Erfahrung gewöhnlich befinden; die Veranda (einschließlich der zu Gardinen umfunktionierten Zeitungen und den an Klapp- und Gartenstühlen angebrachten Schaukelkufen) hält uns nicht auf Distanz, so dass wir die (vorzugsweise armen weißen oder schwarzen) Südstaatler auf der Veranda wie auf vielen archetypischen Fotos aus dieser Region als Gegenstände anstarren, vielmehr lädt sie uns als Teilnehmer ein. In diesem speziellen Fall sind wir aufgefordert, uns ein Weilchen auf der Veranda niederzulassen und ein paar der hinter den Stühlen arrangierten Schallplatten zu hören.

Die als Teil der Landbevölkerung in ihren Schaukelstühlen auf der Veranda Sitzenden sind hier die Museumsbesucher – die Möchtegernbetrachter des typisch Südstaatenhaften oder welcher Andersartigkeit auch immer –, diejenigen, die nun unter Beobachtung stehen. Doch indem wir eine Veranda vorfinden, die nur eine Veranda ist, erkennen wir außerdem, dass wir, selbst wenn wir uns »ein Weilchen setzen«, doch die Schwelle zum Inneren der Erfahrung nicht übertreten. Mit anderen Worten: indem Durant uns klugerweise am Erleben des Monuments teilnehmen lässt, allerdings unter Anerkennung der Grenzen des Museums bzw. jeden Erlebens, macht er die Schwelle zum eigentlichen Gegenstand seines

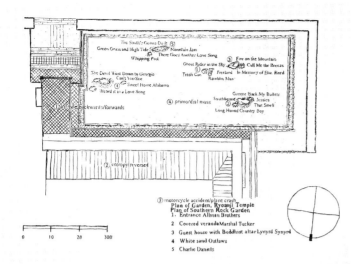

STUDY FOR SOUTHERN ROCK GARDEN, 2000
GRAPHITE ON PAPER; 22 x 30 INCHES
COURTESY BLUM & POE, SANTA MONICA

Denkmals. Wir nehmen nicht nur teil, sondern uns wird auch Schatten gespendet, und wir werden durch Zeitungen am Eindringen gehindert, durch das Schwarzweiße (und ein bisschen Farbe), mit dem wir täglich versorgt werden.

In jüngster Zeit ist das Wesen von sowie das Bedürfnis nach Denkmälern wieder stärker und eindringlicher in den Blickpunkt gerückt. Wie kann man ein Denkmal für eine Tragödie riesigen Ausmaßes oder überhaupt ein Denkmal für irgendetwas gestalten? Je größer das Ereignis, desto größer ist das Bedürfnis nach einem Denkmal und gleichzeitig die Schwierigkeit, ein passendes zu liefern (auch wenn die beiden Lichttürme, die sechs Monate nach dem 11. September und dem Einsturz der Twin Towers installiert wurden, eine Annäherung an das Ideal markierten). Bei Durant gibt es sowohl Denkmäler für bedeutende wie auch für kleine Anlässe, oftmals unter Bevorzugung des Fremden zur Bekämpfung des immer Selbigen, für das man sich bei Denkmälern traditionellerweise entscheidet: die figurative Identität aus weißem Marmor erscheint immer ineffektiver, je mehr wir versuchen, uns zu erinnern. Man denke auch an die anfänglichen Widerstände gegen die Vietnam War Memorial Wall wegen ihrer Fremdartigkeit sowie an die Forderung nach einer traditionelleren figürlichen Wiedergabe der Soldaten. Schließlich wurde sowohl *The Three Servicemen Statue* (die Figuren) als auch das *Vietnam Veterans Memorial* (die Mauer) errichtet, die heute wenige Meter voneinander entfernt stehen – allerdings ist es die Mauer, die die stärkere Wirkung auf die Bevölkerung ausübt und im Gedächtnis bleibt.

Jede Wahrnehmung des Denkmals, ob als wirklichkeitsgetreu oder übertragen, als Repräsentation oder Identität, unterschätzt die Kraft von Erinnerung und Vorstellung, von Nostalgie und Erfindung, von Dingen also, mit Hilfe derer Durant seine Arbeit einzig und fremd, aber auch seltsam behaglich und öffentlich erscheinen lässt. Durants *Friendship Park* dient, wie der Titel andeutet, als Denkmal und als dauerhafter oder vorläufiger Vorschlag – es handelt sich hier sowohl um die Mauer, die wir sehen wollen, wie um das, was wir auf ihr zurücklassen –, wobei die rohe, ländliche Schönheit besonders zur Kraft der Arbeit beiträgt. Das Werk ruft mir die Schilder ins Bewusstsein, die man in den Südstaaten am Straßenrand sieht, sowohl handgemalte Schilder, auf denen Erdnüsse (P'NUTS) angeboten werden, als auch Kirchentafeln mit häufig kryptischen Warnungen wie *Denke daran es ist heiß warte also nur*. So entsteht eine aus Gebet und Verdammung, Erlösung und Einzelhandel zusammengesetzte Volkssprache, die Durant ins Museum trägt. Im folgenden von mir verfassten und noch unvollendetem Gedicht versuche ich, mich auf ebendiesem Areal zu bewegen:

SCHILDER

Führt die Straße, auf der Du gehst
Dich zu mir
 —Gott

*

Dixieland
Wöchentliche Raten

The Alamo

*

Drive-In
Etwas Mary
Armageddon

*

PRODUZIERT

*

Der den Sohn hat
Hat alles

*

Young's Pfandhaus
& Waffenhandel

*

HIER FAXEN
COLLARDS

*

Es fällt sich schwer
wenn Du schon
auf den Knien bist

*

Red Star
Feuerwerkskörper Pfirsiche

*

ENTR MLCH

*

Unser Bier ist
das kälteste weit und breit

*

ZIERKISS'N

*

Restbestände
Wollanzüge Krepp
699

Versuchs mal mit Gott

*

ORIGINALZUSTAND

*

Wenn Du meine Spiegel
Nicht sehen kannst
Kann ich Dich nicht sehen

*

Wenn die Hölle zufriert
gehe ich
auch hin

ALTAMONT, 1999

Ein wesentlicher Aspekt von Durants Arbeit *Friendship Park* liegt zweifellos in ihrem Vorschlagcharakter. In *Friendship Park–Primordial Mass*, *Friendship Park with Flags* und *Appalachian Spring* (alle 2000) skizziert Durant verschiedene Fassungen einer Arbeit – »Coverversionen«, die in mancherlei Hinsicht das Original übertreffen.

Durants sämtliche Vorschläge kommen auf das Phänomen des Verlusts zurück und bestätigen ihn. Ein Blick auf die seinem Vorschlag zugrundeliegende »Urmasse« sowie auf die »Dirt Floor Shack« genügt, um zu erkennen, dass es Dinge gibt, die wir nicht kennen können, die wir verloren haben, ohne es zu wissen. »Allegorische Landschaft vor Einkaufszentrum« wäre eine passende Beschreibung für *Friendship Park with Flags*, doch ebenso passend als Beschreibung für Amerika. In Durants Zeichnung »Sweet Home Alabama« ist der Kamin wie eine Konföderiertenflagge ausgeführt, die über einem Parlamentsgebäude weht und entweder für Heimat oder für Hass steht. So erkennen wir in Durants Vision die Richtigkeit beider Bedeutungen jener nicht verhandelten »Urmasse« unmittelbar unter der Oberfläche.

Die Bedeutungsurmasse mag in der vorliegenden wie in vielen von Durants Arbeiten auch der Ort der Nostalgie sein. Vielleicht entsinnen wir uns der Tatsache, dass Nostalgie selbst »Heimweh« bedeutet – wie könnte jenes Gefühl des Heimwehs besser dargestellt werden als durch ein grob gezimmertes Heim, das sich vorübergehend in einem Museum befindet? Letztlich ist es dieses Heimweh, das zu empfinden (bzw. bewusst nicht zu empfinden) uns Durant herausfordert. Letztlich wird deutlich, dass nicht lediglich das Denkmal, sondern die zahlreichen Vorschläge, die mit ihm verbunden sind, am besten dazu geeignet sind, solch vergänglichen Emotionen die Ehre zu erweisen.

AUF DEM KOPF UND SPIEGELVERKEHRT
THE ROLLING STONES

Ich besitze kein einziges Rolling Stones-Album. Dies mag viele, wenn nicht die meisten schockieren, aber ich nehme an, dass es wie die meisten Schwächen inzwischen zu so etwas wie dem Quell meines Stolzes geworden ist: In meiner Plattensammlung findet sich nicht ein einziger Rolling Stones-Song. Zumindest, wenn man »Love in Vain« von Robert Johnson nicht mitzählt, ein Stück, von dem ich überhaupt nicht wusste, dass es auch von den Stones eingespielt worden war, bis ich die Originalversion (und für mich damals die einzige) einmal in einem Seminar vorspielte und eine etwas ältere Dame in der ersten Reihe jedes Wort mitsang.

Später sagte sie mir, sie habe nicht gewusst, dass dieser Song bereits von jemand anderem aufgenommen worden war – sie kannte lediglich die Stones-Fassung. Ich war schockiert, und zwar nicht nur, weil ihr großartige amerikanische Musik und ein Genie des zwanzigsten Jahrhunderts entgangen waren, sondern auch, weil die Stones ihre Dutzenden von Coverversionen schwarzer Musiker als »Hommage« und nicht bloße Coversongs verteidigten.

Der Unterschied zwischen einer Hommage und einer Coverversion ist klein aber entscheidend, er ist eine der Plagen der postmodernen Kunst überhaupt (wobei der Kritiker Frederic Jameson den ersten Begriff als Parodie und den zweiten als reinen Pastiche bezeichnen würde). Auf einer Hochzeitsfeier mag eine Coverband ja eine feine Sache sein, innerhalb der Musikerhierarchie (in der der Singer/Songwriter je nach Geschmack den ersten Platz einnimmt, zumindest aber vor den Retortenbands rangiert) allerdings bleibt sie weit hinter der Kategorie Popband zurück. Für alle Wissenden streiten Bluesmusiker, Rock'n'Roller und Soulsänger um den ersten Platz, doch die Coverband – teils Garagenband, teils nicht einmal das – bildet das Schlusslicht. In diesem Zusammenhang ist die Behauptung, bei den Stones habe es sich nur um eine neumodische Coverband gehandelt, ein Frevel, der über das Nicht-Besitzen oder gar die Unkenntnis ihrer Platten weit hinausgeht.

Trotz des von den Stones Geleisteten kann man sich doch darüber wundern, bis in welche Höhen der kollektiven Kultur sie aufsteigen konnten. Wer sich Otis Reddings Coverversion des Stones-Songs »Satisfaction« vor Ohren führt, mag mir zustimmen, dass es sich hierbei um die definitive Fassung des Stücks handelt. Das überrascht vielleicht nicht, denn Redding, mit einer ihn unterstützenden (multiethnischen) Rhythmusgruppe im Hintergrund, ist einer der Erben des Rhythm'n' Blues (und des Gospel), aus dem u.a. mit seiner Hilfe Soul wurde, ein Sound also, den Jagger und Co. in Coverversionen oder in ihren »Originalen« zurückzuerobern versuchten: selbst im Schlaf, in dem berühmten von Keith Richards erträumten (und schließlich eingespielten) unwiderstehlichen und scheinbar erhabenen »Satisfaction« – Riff höhlen die Stones den »Soul« aus. Wo aber liegt der Unterschied zwischen dem Traum vom Soul und dem Traum von einem schwarzen Hintern in »Brown Sugar«?

»The Blues Had a Baby and They Called It Rock'n'Roll« – trotz dieser Tatsache wird eine derartige Vaterschaft zu oft ignoriert oder, was schlimmer ist, geleugnet, hauptsächlich weil man nicht zugeben möchte, dass ausgerechnet die »Niggermusik« der Vater der British Invasion war. Wie für Lennon und McCartney waren auch für Jagger und Richards Blues und früher Rock'n'Roll (beides schwarze Musikformen) Objekte der Anziehung und des Respekts. Dies spricht zweifellos für ihren guten Geschmack. Aber ist das Ergebnis – eine Mischung aus Freiheit und Faszination für eine Kultur, die im Nachkriegsengland so erfrischend wie verboten gewirkt haben muss – so verschieden von der Art, wie schwarze Ausdrucksformen seit Beginn des zwanzigsten Jahrhunderts die weiße Kultur, vor allem Jugendkultur, bedient haben? Backfische, Beatniks, HipHopper – der Beat der schwarzen Kultur ist ein ständiger Magnet und die Grundlage für einen Großteil der amerikanischen Kultur und die gesamte amerikanische Musik (einschließlich Country). Selbst bei seiner Reise zurück über den Teich kann man die British Invasion als Form schwarzer Rückführung betrachten.

Brown sugar
shit pour
rundown
asswipe
shit covered horizontal '69

BROWN SUGAR RUNDOWN, 1999

Durants Bauminstallation nimmt gerade die Entlarvung jener dunklen Wurzeln in Angriff, es findet eine Entwurzelung statt, genau wie bei der Weide, die in meinem Garten umstürzte und dabei beinahe mein Haus traf. Stundenlang starrte ich den Baumwipfel an und tat dabei so, als sei ich der Himmel, beobachtete die Vögel, die noch immer in den heruntergefallenen Ästen saßen. Durants Songauswahl, von Billie Hollidays »Strange Fruit« und Public Enemys »Fear of a Black Planet« bis hin zu to Robert Johnsons »Crossroad Blues«, schont uns nicht und zeigt Stürze einer anderen Art.

Seine Umkehrungen, zu denen ich später mehr sagen werde, verweisen nicht nur auf die Kunstgeschichte, sondern auf die Geschichtsgeschichte, deren umgekehrter Stammbaum (*Standing on Our Head*, 2001) eine andere Version darstellt. Eine Ent-Hüllung (engl. uncover, Anm. d. Übers.). In seinen verschiedenen Arbeiten zu Altamont beleuchtet Durant (en miniature) die Tragödie beim Stones-Konzert am Altamont Speedway, bei dem die als Sicherheitskräfte angeheuerten Hells Angels einen Konzertbesucher umbrachten. Entgegen Pauline Kael, die in ihrer damaligen Besprechung Jagger der Komplizenschaft, wenn nicht sogar einer Schuld an der Tragödie bezichtigte, glaube ich, dass Jagger und die Stones den Todesfall eher dunkel wahrgenommen haben. Diese Empfindungen, die zwischen Entsetzen über einen Unglücksfall und Reue pendelten, wurden in *Gimme Shelter* (1970), dem großartigen Film der Maysles-Brüder, aufgezeichnet. Während wir wie Jagger, für den der Film mehrmals zurückgespult wird, die Szene immer wieder sehen, erkennen wir, das die Gewalt sich weniger ausbreitet als vielmehr explodiert, wie man hätte wissen müssen (in diesem Fall handelt es sich um das genaue Gegenteil einfacher Nostalgie, es ist eher der Tanz, den Durant zwischen unmöglicher Nostalgie und nicht zu beneidender Wurzellosigkeit vollführt). Unausweichlichkeit und Ironie verschmelzen miteinander, als Jagger im Sternen-T-Shirt »Sympathy for the Devil« singt und die Menge ausrastet.

Die dann folgende visuelle Wiederholung der Gewalt – dadurch, dass die Filmemacher selbst den Horror ständig wiederholen – verstärkt nur das Gefühl unserer Unfähigkeit, ihn noch zu verhindern. Während man im Film allerdings das Publikum als Zuschauer in das Geschehen verwickelt sieht, beobachtet Kael, wie die Stones und die Filmemacher naiv ein Ereignis orchestrieren und schlicht als »Zuschauer« dabei sind, als das Unvermeidliche geschieht. Ihrer Ansicht nach wird in *Gimme Shelter* »versucht, das Ereignis (Altamont) zu mythologisieren und die Beteiligten (die Rolling Stones sowie die Filmemacher) von

ANDY WARHOL
ELVIS I & II, 1964
SYNTHETIC POLYMER PAINT, ALUMINUM PAINT, AND SILKSCREEN INK ON CANVAS; TWO PANELS, 82 x 82 INCHES EACH
COURTESY THE ANDY WARHOL FOUNDATION, INC./ART RESOURCE, NY

jeglicher Kenntnis dessen, wie es dazu kam, freizusprechen«[1], obwohl der Akteur Jagger tatsächlich die voyeuristische Gefahr zum Tanz auffordert. Wie auch immer man dien Vorfall sehen mag, so wurde doch in vielen der Beschreibungen versäumt zu erwähnen, dass der von den Hells Angels Erstochene schwarz war. Diese Erkenntnis weist auf die Fremdheit des Ereignisses hin, gleichzeitig aber auch auf seine entsetzliche Identität: als die Hells Angels, die während des Auftritts auch gegen andere Zuschauer gewalttätig vorgegangen waren, beschlossen, einen schwarzen Konzertbesucher zu töten (der offenbar bewaffnet war), erscheint die Intimität des Mordes, seine Plötzlichkeit und doch Verschwommenheit zutiefst vertraut. In diesem Punkt markiert die Tragödie von Altamont, so lautet die allgemeine Erkenntnis, das Ende der Sechziger – umso mehr, als die Gewalt jener Zeit, und zwar gerade die rassistische Gewalt, bei Woodstock ein Jahr zuvor auf wundersame Weise ausgeblieben war und nun etwas heimsuchte, das eigentlich als weiterer fantastischer Augenblick geplant war.

Durants von weißem Schaum bedeckte und »Brown Sugar« abspielende Arbeit *Proposal for Monument at Altamont Raceway, Tracy, CA* enthüllt den Rassenhintergrund des Erfolgs der Stones sowie der Tragödie am Altamont Speedway selbst (dabei erscheint der Wunsch, mit der Musik der Stones die schwarzen Wurzeln zu ehren oder gar zu befreien, in Anbetracht gerade von »Brown Sugar«, jenem wollüstigen Wiegenlied des Plantagenbesitzers, ziemlich abwegig). Ebenso enthüllend geht Durant vor, wenn er das in den Songtiteln zum Ausdruck kommende Begehren (das der Stones und unseres) betont. Diese Songtitel verdichtet er in der Arbeit *Gimme Shelter* (1998) zu einer Collage, die den Eindruck einer Tondichtung des Verlangens oder gar der Verzweiflung erweckt.

Eine solche Verzweiflung ist wesentlich für die Tragödie von Altamont und ironischerweise vielleicht sogar der Kern einiger der größten Stones-Hits wie »Sympathy for the Devil«, »Gimme Shelter«, »Brown Sugar« und selbst »Satisfaction«, auch wenn der Unterschied zwischen der Version der Rolling Stones und der von Otis Redding eben gerade der zwischen einem niemals-zu-befriedigen-Sein und einem niemals-befriedigt-Sein, zwischen, Ennui und Agita ist. Beide Fassungen von »Satisfaction« signalisieren selbstverständlich tiefere und umfassendere kulturelle Unzufriedenheiten, die in Bedeutungen widerhallen, die womöglich gar nicht beabsichtigt waren (wie immer bei guter Kunst). Das Ausgeschlossen-

1. Pauline Kael, »The Current Cinema: Beyond Pirandello«, *The New Yorker* 46, Nr. 44, 19 Dezember 1970, S. 112

sein von allgemeiner Kultur (und nicht nur die Unzufriedenheit mit ihr) kennt allerdings nur eine Konsequenz. Mag man dem Teufel doch Sympathie geben, mir soll man in meinem Heimatort einen Hamburger geben.

Letztendlich liegt die Wirksamkeit von Durants *Proposal for Monument at Altamont* in der Rauheit dieses nicht einmal 30 cm hohen Objektes aus Sperrholz, Stahl und diesem jämmerlichem Schaum, auf das wir gottgleich oder wie ich damals auf den umgestürzten Baum herabschauen. Wir sehen die zwei Gebilde, die den ominösen und doch peinlichen Eindruck von Licht- und Soundanlage vermitteln, als Symbol für das, was am Ende des Films passieren wird, nicht aber am Ende des Ereignisses, das, so die Behauptung von Durants Denkmal, noch andauert. Ist ein Ereignis beendet, sobald wir es zum Denkmal erklären? Oder, um einen Ausspruch von Robert Lowell zu einem Gedicht wiederzugeben: ist ein Denkmal nicht mehr als die Aufzeichnung eines Ereignisses, nämlich selbst ein Ereignis? Brauchen wir ein Denkmal, um zu gedenken?

Oder auf einer tieferen Ebene: brauchen wir die Version der Stones von »Love in Vain«, um das Original zu hören? Vielleicht ja, falls T. S. Eliot Recht hatte, als er behauptete, ein neuartiges Kunstwerk liefere nicht nur einen Beitrag zur Tradition, sondern verändere diese, so dass wir unter Umständen die metaphysischen Dichter erst nach der Lektüre von Eliots Coverversion aus dem zwanzigsten Jahrhundert angemessen erfassen können. Dieses Argument wird immer zur Rechtfertigung der Stones-Cover bemüht, ich bin mir allerdings ob seiner Überzeugungskraft nicht ganz sicher. Zunächst sollte darauf hingewiesen werden, dass es bei schwarzer Musik aus dem Mund eines Weißen in Anbetracht der für die Geschichte der Schallplattenindustrie so charakteristischen ungleichen Verteilung von Macht und Geld häufig um mehr geht als nur um eine poetische Hommage. Dennoch ist der Vorwurf der Vereinnahmung nicht nur davon abhängig, welche Hautfarbe der covernde Künstler hat, sondern ebenso von der Art der Transformation: dem weißen Künstler Bob Dylan gelingt es, den Blues zu zitieren und dabei einen neuen »Blues« zu kreieren, der auch ohne bloße Entlehnung sein Eigentum ist. Songs wie »Bob Dylan's Blues« oder »Like a Rolling Stone« erreichen eine Synthese, die alt und neu, folkig und rockig zugleich klingt, traditionell (was häufig von schwarzer Musik beeinflusst bedeutet) und doch transformiert.

Das ultimative und schwer zu erreichende Ziel der Kunst liegt möglicherweise in einer paradoxen organischen Synthese, man könnte sagen in einer Veredlung, bei der die Fruchtbarkeit erhalten bleibt, egal ob die Wurzeln honoriert oder verborgen werden. In seltenen Momenten kann man diesen Durchstoß heraushören – etwa bei den ersten Akkorden von »Smells Like Teen Spirit« von Nirvana, bei »When Doves Cry« von Prince oder *Three Feet High and Rising* von De La Soul, *The »Royal Albert Hall« Concert* von Dylan – , wenn man schon beim ersten Hören durch die Fremdheit der Sounds und durch eine Andeutung dessen aufgerüttelt wird, was eines Tages vertraut klingen könnte, wie unterdrückt auch immer. Später empfinden wir nicht lediglich Nostalgie beim Wiederhören dieser Songs und bei der Erinnerung an jenen ersten erregenden Augenblick der Begegnung mit dem Neuen, sondern es stellt sich eine Art doppelter Nostalgie ein, bei der wir sowohl den Ursprung von etwas Neuem heraushören (Dylan, der zum elektrifizierten Dylan oder Jazz, der Bebop wird) als auch das Alte, auf das es aufgepfropft wurde (die Volksmusiktradition von Blues und Ballade, aus der beides entstand). Durant re-inszeniert die sich auf die Kraft jener erstmaligen, aufregenden Synthese und die von ihr gehuldigten Tradition richtende doppelte Nostalgie ebenso wie das Wehklagen über eine kommerzialisierte Beliebigkeit, die nur allzu häufig auf derartige Durchbrüche folgt (Bebop wird Beat, mit Dylan geht es bergab, und Grunge wird Pop, so oder so ähnlich verläuft die Geschichte). Dies ist schwieriger, als es klingen mag, und selbst das Riff von »Satisfaction« ist durch seine Wiederholung bis zum Erbrechen längst seiner ursprünglichen Kraft beraubt. Trotz der Millionen an Gewinnen ist nichts als ein schaler Rückstand übrig geblieben. Wie kann die ursprüngliche (bzw. kopierte)

Kraft zurückgewonnen werden? Weder als Kopie noch als Klon kann eine Coverversion zu etwas völlig neuem und doch altem werden und dabei ihre Urkraft wiedererlangen (die ironischerweise durch die Milliarden von schwachen Coverfassungen verloren ging, die bis heute entstanden sind). Wie Otis Reddings Version liegt auch die Kraft von Cat Powers »Satisfaction« aus ihrem treffend betitelten Album *The Covers Record* gerade im Ungesagten: durch das Weglassen des Refrains, den jeder mechanisch mitsingen kann, drückt der Song noch stärker oder einmal mehr das Gefühl des Verlangens aus.

Organische Synthese, doppelte Nostalgie, ein freigelegter Sound: all das ist am Werk (und im Spiel) bei Durants Arbeit, in der Traditionen sowohl anerkannt als auch transformiert werden, entweder durch ihre Vermischung (*Glue Horizon*, 1999) oder ihre Reduktion auf ein verschwommenes Bild (sein Cobain-Portrait mit dem Titel *Into the Black/Rockstar*, 1998). Im Mittelpunkt steht dabei immer der Versuch, die ursprüngliche Kraft des Musikstücks oder Kunstwerks oder eine Kraft selbst erneut zu behaupten. Bei diesem Vorgang werden die Stones zum Negativbeispiel und unglaubwürdigen Kollaborateur, umso unglaubwürdiger, da gerade die covergeilen Stones die Technik des Sampelns als unwürdig erachten: man rufe sich nur ihren jüngsten, erfolgreichen Prozess gegen die englische Band The Verve in Erinnerung, die verklagt wurden, weil sie ohne Genehmigung ein Loop aus einem Schnipsel eines autorisierten orchestralen Stones-Covers für eines ihrer eigenen Stücke verwendet hatten. Eine »Bitter Sweet Symphony« fürwahr. Dies führte dazu, dass man den Song in Zukunft auf keiner Greatest Hits-Platte von The Verve finden wird. Warum ist das »Sampeln« eines Songs schlimmer als das Covern desselben? Hat es mit musikalischem Können oder der bequemen Verfügbarkeit der Technik zu tun? Oder regt sich Widerspruch, weil die Kultur in Sachen Rasse, Geld oder Macht in die falsche Richtung geht?

Durants Methode der Konzentration auf Rasse und Rassismus kann so spielerisch und direkt ausfallen wie bei »Like a Rolling Stone«, wenn es heißt: *How does it feel?*, oder aber auch so anregend wie im Falle jenes Muddy Waters-Songs, der als Namensgeber für den Dylan-Song wie für die britische Band fungierte. Durant nimmt um zu machen, vergleichbar seinem ebenfalls in Seattle geborenen Kollegen Kurt Cobain oder auch Dylan. Er produziert etwas Neues, das aber aufgrund seiner Vertrautheit eine umso größere Kraft entwickelt. All dies zusammengenommen führt uns nach Los Angeles: nicht nur die Stadt der Engel und der Hells Angels oder des für Hollywood und Gangsta Rap typischen Hyperrealismus, sondern auch von Okies and Exodusters und der von ihnen mitgebrachten Folk-Musik, die sich später zu Westcoast Country und Spaceage Funk entwickelte. Bezeichnenderweise ist L.A. auch die Heimatstadt von Beck, bei dessen Versuchen, den schwarzen Stil und dessen Wesen einzufangen, gelegentlich den zuvor Genannten eine Gunst erwiesen wird. Auch wenn es sich bei Becks Album *Midnite Vultures* um einen reinen Pastiche des Frühachtziger-Funk von Prince handelt, könnte man ebenso gut *Dirty Mind* von Prince auflegen und wäre bedient. Trotzdem ist Becks countryhafter Song »Rowboat« Hommage und gleichzeitig Original – was durch die Tatsache unterstrichen wird, dass Johnny Cash den Song auf seinem Album *Unchained* von 1998 coverte –, während die weniger bekannte Indie-Platte *One Foot in the Grave* von einer Welt aus Blues-Nachahmungen und LoFi-Pannen, lockeren Originalen und Coverversionen, die die Arbeit des Kollegen Angeleno Durant wiederspiegeln, beseelt ist.

Natürlich ist Kalifornien auch die Heimat von Altamont und nun auch von Durants Altamont-Denkmal: all dieser weiße Schaum, der wie Schnee oder ein Schleier einen Ort bedeckt, der nicht gerade für Schnee bekannt ist. Wie der Terminus schon andeutet, ersetzt und verdeckt die Coverversion ein Ereignis – auch wenn das Cover einer guten Platte oder eines guten Buchs zum Öffnen einlädt, zur Aufbewahrung eines weiteren Totems dient; bevor man dieses zurückspult, die Nadel auf-setzt oder auf Play drückt, um die Worte noch einmal zu hören.

BOBBY SEALE, CO-FOUNDER OF THE BLACK PANTHER PARTY FOR SELF-DEFENSE, 2001

HEAP OF LANGUAGE
BLACK PANTHERS

Bei Durants *Inversion, Proposal for the Five Dollar Bill (Huey Newton, Founder of the Black Panther Party for Self-Defense)* aus dem Jahr 2001 handelt es sich um eine geistreiche Arbeit, die Huey Newton und Abraham Lincoln Kopf-an-Kopf miteinander verknüpft. Man könnte annehmen, dass ihre Verbindung in der beiden gemeinsamen Vision von der Freiheit der Schwarzen oder der Tatsache, dass beide ermordet wurden, liege. Machen wir einen Unterschied zwischen einem Mord, der vorgeblich aus Drogenmotiven und einem, der aus politischen Gründen verübt wurde? Wichtiger allerdings ist die Idee der »Umkehrung«, hier wörtlich genommen, die häufig in der schwarzen Kultur anzutreffen ist, in der »bad« gut heißt, »cool« das Gegenteil von »hot« ist und »black« vom Status her entweder als Beleidigung oder als Abgrenzung zu »weiß« verwendet wird. Limonen in der Limonade; Lincoln in Newton. Hier stellt sich die Frage, wo oben ist und wann welche Art von Umkehrung stattfindet.

Anders als beim Umdrehen von einer Seite auf die andere, die für Schallplatten und Geld—zwei von Durants Themen—charakteristisch ist, findet hier eine Umkehrung von oben nach unten statt. Dies betrifft auch den Unterschied zwischen einem Buch und der Historie: es geht nicht darum, von links nach rechts oder von vorne nach hinten zu lesen, sondern darum, uns als Betrachter dazu zu bringen, die Dinge erneut zusammenzusetzen und sie wieder in die richtige Reihenfolge zu bringen. In Durants *Inversion* findet das Zusammentreffen von Newton und Lincoln über Geld statt, das für manche eine Form von Freiheit repräsentiert und für andere einen langsamen, symbolischen Mord. Indem Durant die zwei Figuren nur auf einem dünnen Grat aufeinandertreffen lässt, stellt er die Frage danach, auf welche Art ein Aufeinandertreffen der beiden sonst noch möglich wäre. Und: Welchen Nutzen könnte ihr Treffen für uns haben?

DIKTAT
FÜR WILLIAM O'NEIL
FBI-INFORMANT

Bring dir selbst das Schwimmen bei. Ein Auto
für einen Tag ausborgen, mach eine Spritztour, acht Meilen
über die Staatsgrenze. Greif dir den Augenblick
bevor die Pigs dich greifen, die weißen Hände

am Steuer. Du hast das Recht zu bleiben
usw. Officer Le Fervour von der Bruderschaft
der Polizei wird dir auf die Finger klopfen
dich überzeugen, den Panthers beizutreten. Du wirst

lernen, dir deine Mahlzeiten zu merken, Unterhaltungen
aufzuzeichnen, in Spiegelschrift zu schreiben
ohne Licht. Beobachte genau jede ruchlose
Aktivität, das Kinder-Frühstücksspeisung

das Rührei. Entspann Dich, und dein Körper
wird natürlich fließen. Wenn du Minister
für Staatssicherheit bist, wird dich Special Agent M ab und zu
kontaktieren, um Informationen zu Waffenlagern einzuholen

und zu Müslikartons. Die ganze Milch muss rechtzeitig
verbrannt sein. Gib deinem Bruder Schlaf-
Tabletten in Wasser aufgelöst, damit er unser Feuer
nicht hört; wenn seine Akte geschlossen wird, wirst du die Pläne

der Hauptquartiere*Schrägstrich*Schlafzimmer sehen
die wir hervorziehen. Nicht einmal hast du
die Faust erhoben. Nimm die zweihundert Knochen
für die Jahre vorbildlich geleisteten Dienstes

und schwimm weiter, vergiss nicht zu atmen.

Kürzlich sah ich das mit dem Pulitzer-Preis ausgezeichnete Theaterstück *Topdog/Underdog* von Suzan-Lori Parks, in dessen Titel sich ebenjene Dichotomien und Dialektiken erkennen lassen, die Durant visualisiert. In dem Stück geht es um zwei Brüder namens Booth und Lincoln, Opfer der Familie wie der Gesellschaft, um das Glücks- bzw. Trickbetrügerspiel Three-Card Monte und um Stolz. Jeffrey Wright spielt einen Schwarzen, der sich (mit weiß geschminktem Gesicht) als Abraham Lincoln verkleidet und gegen Geld dessen Ermordung nachstellt, sein Spiel ist exakt und aufreibend. Es wird die Frage gestellt, welcher Preis für Erfolg, Scheitern oder Familie zu hoch ist – fünfhundert Dollar? Ein Lincoln-Penny? Ein Fünfer, auf dem Lincoln sich bereits befindet, wie wir vielleicht vergaßen? Oder die sechs Dollar, die Eldridge Cleavers Buch *Soul on Ice* inzwischen wert ist, wie wir in Durants *Heap of Language (Soul on Ice)* von 2001 erfahren?

Durch die Verschmelzung der beiden gefallenen Anführer – oder auch durch die liebevollen, fast fotografisch genauen Porträts von Bobby Seale und die verschiedenen Ausgaben von *Soul on Ice* – enthüllt Durant das von den Black Panthers ausgehende Versprechen ebenso wie ihr aufrührerisches Potenzial (und die hauptsächlich von außen kommende Sabotage derselben). Interessant erscheint mir der stimmungsmäßige Unterschied zwischen der leicht ironischen Arbeit über Cleaver und Durants ehrenwerturtümlichen Porträts von Newton und Seale. Man könnte wie Joan Didion in ihrem Aufsatz »The White Album« sagen, dass es hier um den allzu kommerzialisierten Stil der Los Angeles Panthers (sowie die grundlegenden Widersprüche der Sechzigerjahre) auf der einen Seite und den idealistischen Kern des von Seale und Newton in Oakland gegründeten Zweigs der Black Panthers auf der anderen Seite geht. In jedem Fall fängt Durant den Sinn der Panthers für Stolz und Handlungsmöglichkeiten ein (eine doppelte Nostalgie), ebenso aber auch die davon ausgehende Bedrohung, die auf einen Sprachhaufen hinausläuft, reduziert auf ein bloßes Symbol und den Ausverkauf durch eine Kultur und einen Markt, die eine Entwertung der Wörter, der schwarzen Schrift auf einer weißen Seite, betreibt.

In seinem gesamten Werk scheut sich Durant nicht, auf die Präsenz von Rasse in der Popkultur (und Pop Art) sowie auf den von der Kultur so oft geleugneten und doch geförderten Rassismus hinzuweisen. Als ich *Topdog/Underdog* sah, fühlte ich mich an eine weitere sehr geläufige Dopplung und Umkehrung in der Gestalt der Spielkarte erinnert: in Parks' Theaterstück ist es die Pik-Zwei, auf die Publikum und Figuren am Ende hoffen; auf dem Spiel steht nicht nur das bei Three-Card Monte gesetzte Geld, sondern auch, ob wir wirklich das »Schwarze«, die Brüderlichkeit wollen. Wenn Durant mittels einer *Inversion* Newton und Lincoln verbindet, macht er sie zu Brüdern, wobei der Begriff »Blut« in einem lokalen und metaphorischen Sinne verwendet wird, bzw. zu Spiegelbildern, ähnlich vielleicht dem König zweier »Farben« auf ein und derselben Spielkarte – man könnte sie auch Rassenkarte nennen (engl. race card, eigentlich »Rennprogramm«, Anm. d. Übers.). Für Durant befinden sich beide historischen Gestalten in einem ständigen Fluss begriffen und sind wie die Börse Hochs und Tiefs ausgesetzt. Dieses Gefühl von Umkehrung kann ich vielleicht am besten durch eines meiner Gedichte verdeutlichen:

NEGATIV

Aufwachen und alles schwarz vorfinden
was weiß war, alles um-
gekehrt—weiße Dienstmädchen im Fernsehen, schwarze

Sitcoms mit weißen Zwergen
süß wie Perlmuttknöpfe. Schwarze Präsidenten
Schwarze Häuser. Weiße

Schafe. Alle Bleichmittel färben
Kleider schwarz. Straßen
so weiß wie du, weiße Songs

im Radio, die schwarze Bands geklaut haben
wie geheime Pfannkuchenrezepte, weiße Background-
sängerinnen, Basketballspieler & Boxer, ganz

weiß wie Teer. Küken mit Federn
so schwarz wie alles, kochen im Topf
den man Kettle Honky nennt. Selbst

das Weiße in den Augen wird schwarz, Pupillen
klar & wechselnd wie bei einer Katze.
Haben wir das gewollt

& darauf gewartet? Schnee zu sehen
der alles mit Schwarz
wie Weihnachten bedeckt, dunkle Seiten mit

weißer Schrift? All unsere Sonnenfinsternisse hell
dunkle Sternschnuppen, die über den blassen
Himmel ziehen, glimmend wie Asche im Feuer, gehen nieder

auf jede Haut. Nur das Geld bleibt
grün, wächst & brennt noch wie Gras
im dunklen Tageslicht.

LIKE, MAN, I'M TIRED OF WAITING (FOR WADSWORTH FACADE), 2002
ELECTRIC SIGN AND VINYL LETTERS; 81 x 88 INCHES
INSTALLATION AT WADSWORTH ATHENEUM MUSEUM OF ART, HARTFORD, CONNECTICUT

Beim Betrachten von Durants Arbeiten erinnere ich mich oft daran, dass Basquiat sein Werk häufig buchstäblich als eine Art von Alchemie sah, was sich darauf bezog, dass er genau in dem Moment begann, Geld zu machen, als er das Wort »Money« auf seine Bilder schrieb. Man könnte auch an J. S. Boggs denken, dessen Werk sich auf präzise Weise mit Geld und der Frage nach dem Unterschied zwischen falsch und echt, zwischen einem Abbild von Geld und Geld selbst beschäftigt. Durant stellt viele derselben Fragen, während er genau zeigt, dass das von Geld Repräsentierte nicht bloß dessen Wert, sondern auch dessen Macht ist. Seine Arbeit stellt die Frage nach dem Unterschied zwischen Cleaver, einem Bild von Cleaver auf dem Buchumschlag von of *Soul on Ice* und dem von Durant selbst gecoverten *Soul on Ice*.

Letzten Endes leistet Durants Arbeit genau das, was eine gute Coverversion leisten muss: sie erkennt Traditionen, während sie sie transformiert, sie zu etwas Neuem und Ganzem macht, ohne sie auszulöschen oder zu verhüllen. Dies mag simpel klingen und unterscheidet sein Werk doch grundsätzlich von allen Stones-Songs, die, egal ob Eigenkompositionen oder nicht, eben wie die Stones klingen – als hätte man sie stonifiziert. Das verleiht dem Werk ein Unterscheidungskriterium (oder zumindest ein Markenzeichen) und steht zur gleichen Zeit in einem extremen Gegensatz zur fast chamäleonhaften Vielseitigkeit eines Bob Dylan oder Miles Davis, bei denen Vielseitigkeit und der Wunsch nach ständiger Selbsttransformation zu einem radikal eklektischen und, zumindest oberflächlich gesehen, in sich selbst widersprüchlichen Oeuvre führte. Dennoch fügt sich das Gesamtwerk schließlich zu einer Einheit durch den Unterschied und das Verhältnis zu allem (auch im eigenen Werk) Vorhergegangenen. Bei seinen Transformationen von Rasse, Pop und Kunstgeschichte in eine gleichermaßen vertraute und fremde Kunst steht für Durant das Vorher auch immer für das Jetzt. Es stellt sich heraus, dass auch die Geschichte über eine Musik verfügt, die er entwurzeln, spiegeln, zurückspulen und für sich – und letztlich auf intime Weise auch für uns – vereinnahmen kann.

Übersetzung: Ralf Schauff

Kevin Young ist Dichter und lehrt als Ruth Lilly Professor of Poetry an der Indiana University. Er ist der Verfasser des Gedichtbandes *To Repel Ghosts* (2000). Sein neues Buch *Jelly Roll* erscheint 2003.

ACKNOWLEDGMENTS

Sam Durant is an artist whose work gets much international attention. The Museum of Contemporary Art, Los Angeles, and the Kunstverein für die Rheinlande und Westfalen, Düsseldorf, invited Durant to participate in two distinct but almost simultaneous exhibitions. The cooperation of both institutions made this catalogue possible and for the first time offers an extensive survey of the artist's work.

Sam Durant has built up a provocative and challenging body of work over the last decade that promises much more for the future. Many people recognized the importance of this project, foremost among them MOCA Director Jeremy Strick and Chief Curator Paul Schimmel, who were advocates of the MOCA exhibition from the start. Paul selected Sam for inclusion in the important 2000 exhibition "ForWart" in Brussels, and has had a sustained interest in his work. This exhibition has been generously supported by Audrey M. Irmas, whose commitment to artists and the museum is unparalleled, and by the MOCA Contemporaries, Janet Karatz Dreisen, and David Hockney, who have likewise proven to be strong advocates for young artists.

The Board of the Kunstverein für die Rheinlande und Westfalen, particularly Chair Georg Kulenkampff, supported the idea of inviting Durant for a solo exhibtion with enormous energy and helped in innumerable ways to make the Düsseldorf exhibition possible. Very special thanks go to the Stiftung für Kunst und Kultur des Landes Nordrhein-Westfalen for generously funding the show—Durant's first solo institutional exhibition in Germany. President Ilse Brusis and General Secretary Regina Wyrwoll realized the relevance of the exhibition and were engaged supporters from the beginning. The Stadtwerke Düsseldorf, a partner of the Kunstverein, also provided tremendous support.

This publication owes its existence to the talents of graphic designer Conny Purtill and his collaborator, Jenelle Porter, who worked closely with Durant and the curators to ensure that the artist's first monograph would be relevant and rewarding for many years to come. The book is enhanced by a poignant and entertaining contribution by Kevin Young, an outstanding writer and poet with whom it has been a privilege to work. MOCA's editorial staff—Senior Editor Lisa Mark, Editor Jane Hyun, and Assistant Editor Elizabeth Hamilton—provided the close reading and organizational rigor necessary to make a publication of this caliber. Former Curatorial Assistant Tami Simonian's dedication to this project made the process all the more enjoyable. Editorial input from the artist, Russell Ferguson, Midori Matsui, and others helped fine-tune the content and style of the texts. Hans-Jürgen Schacht and Ralf Schauff brought their thoughtfulness and sensitivity to the task of translation. Finally, partnership with Hatje Cantz has not only yielded a beautifully printed book, but a network of distribution that will bring the work of Sam Durant to a diverse international audience.

MOCA and the Kunstverein have many generous lenders to thank for the powerful work in their respective exhibitions, including Matt Aberle; Maria and Tim Blum; Blum & Poe; Paolo Consolandi; Creative Artists Agency; Sam Durant; Emi Fontana; Galerie Nordenhake; Galleria Emi Fontana; André and Jocelyne Gordts-Vanthournout; Clementina Hegewisch; Michael Heins; Kevin Heppner and Heather Convey; La Gala; Raffaele Martinelli; Mike Mehring, MOCA; Maurizio Morra Greco; G. Papadimitriou; Kelly and Jeffrey Poe; Laurence A. Rickels; Michael Ringier; Gaby and Wilhelm Schürmann; Barry Sloane; Barbara Thumm; Dean Valentine and Amy Adelson; Roberto Vollono; Joel Wachs; and two collectors who wish to remain anonymous. Mehring, Wachs, and the Schürmanns have donated to MOCA extraordinary works by the artist over the years, for which we are extremely grateful. Tim Blum and Jeff Poe of Blum & Poe were incredibly helpful in locating work and providing pertinent information about it.

Safe and efficient delivery of the work to MOCA is due to the efforts of Assistant Registrar Karen Hanus. The installation was overseen with utter professionalism and sensitivity by Brian Gray, Jang Park, Zazu Faure, David Bradshaw, Barry Grady, Jason Storrs, Valerie West, Tina Bastajian, Monica Gonzalez, Annabelle Medina, and a great crew of part-time installers. The enthusiasm and support of the curatorial department at MOCA was also much appreciated throughout the development of this project, and thanks are due to Ann Goldstein, Connie Butler, Brooke Hodge, Alma Ruiz, Stacia Payne, Lynda Bunting, Rebecca Morse, Julia Langlotz, Virginia Edwards, and Beth Rosenblum. Vigorous fundraising efforts by MOCA's development department—including Paul Johnson, Aandrea Stang, Michelle Bernardin, and Stephanie Graham—also ensured the realization of this project.

At the Kunstverein, Assistant Curator Anette Freudenberger was deeply involved in realizing this exhibition from the very beginning. Without her input the exhibition would have been impossible. She committed herself to this project and engaged in every step, from first contacting the artist to the transport and installation of the exhibition. Doris Rother and Sigrid Konopka worked with tremendous dedication on the organizational issues of the exhibition, and Ralf Werner, Klaus Wenner, and Siegfried Verheyden professionally and sensitively installed Durant's complex works. We warmly thank all of them, as well as Rainer Zimmermann, Kunstverein board member and CEO of BBDO Group Germany, for his committed support in numerous ways. Above all we owe our thanks to collector Wilhelm Schürmann, who introduced Durant's work to the Kunstverein years ago. He as well as Michael Kapinos generously shared their knowledge and were helpful in every respect.

We are most thankful for the wonderful partnership we have shared with Sam Durant and hope that many more people will come to appreciate the richness of his work through these two exhibitions and this publication.

MICHAEL DARLING
ASSISTANT CURATOR, THE MUSEUM OF CONTEMPORARY ART, LOS ANGELES
RITA KERSTING
DIREKTORIN, KUNSTVEREIN FÜR DIE RHEINLANDE UND WESTFALEN, DÜSSELDORF

DANK

Sam Durant ist ein Künstler, dessen Werk international viel Beachtung erfährt. Das Museum of Contemporary Art, Los Angeles und der Kunstverein für die Rheinlande und Westfalen, Düsseldorf haben Sam Durant zu zwei unterschiedlichen, fast gleichzeitigen Einzelausstellungen eingeladen, und es freut alle Beteiligten, dass durch die Kooperation beider Institute der vorliegende, umfangreiche Katalog möglich wurde, der erstmals einen umfassenden Überblick über die Arbeit des Künstlers gibt.

Sam Durant hat im Laufe des vergangenen Jahrzehnts ein provokatives und herausforderndes Werk aufgebaut, das für die Zukunft viel erwarten lässt. Die Bedeutung dieses Projektes wurde von vielen erkannt, doch waren vor allen Jeremy Strick, der Direktor des MOCA, und Chefkurator Paul Schimmel von Anfang an Verfechter der Ausstellung im MOCA. Großzügige Unterstützung erfuhr diese Ausstellung von Audrey M. Irmas, deren Engagement für den Künstler und das Museum ohnegleichen ist, und von den MOCA Contemporaries, Janet Karatz Dreisen und David Hockney, die ihre nachdrückliche Befürwortung des jungen Künstler gleichermaßen unter Beweis stellten.

Die Idee, Sam Durant zu einer Einzelausstellung einzuladen, wurde vom Vorstand des Kunstvereins für die Rheinlande und Westfalen, insbesondere vom Vorsitzenden Georg Kulenkampff unterstützt, der mit unermeßlicher Energie und auf vielfältige Weise half, die Düsseldorfer Ausstellung möglich zu machen. Besonderer Dank gilt der Stiftung Kunst und Kultur des Landes Nordrhein-Westfalen für die großzügige Unterstützung Durants erster institutioneller Einzelausstellung in Deutschland. Präsidentin Ilse Brusis und Generalsekretärin Regina Wyrwoll erkannten die Relevanz dieser Ausstellung und waren von Beginn an engagierte Förderer. Auch die Stadtwerke Düsseldorf, Partner des Kunstvereins, zeichneten sich durch enorme Unterstützung des Projektes aus.

Diese Publikation verdankt ihre Existenz dem Talent des Grafikers Conny Purtill (mit Jenelle Porter), der eng mit Durant und den Kuratoren zusammenarbeitete, um sicherzustellen, dass die erste Monografie des Künstlers auch für die Zukunft relevant und lohnend bleiben wird. Es war eine besondere Ehre mit dem hervorragenden Schriftsteller und Dichter Kevin Young zu arbeiten. Sein treffende und unterhaltsame Beitrag hat das Buch wesentlich bereichert. Die Redaktion im MOCA, vor allem Chefredakteurin Lisa Mark, Redakteurin Jane Hyun, und Redaktionsassistentin Elizabeth Hamilton, trugen durch eingehendes Lektorieren und mit der notwendigen organisatorischen Exatheit dazu bei, eine Veröffentlichung dieses Formats zu schaffen. Die ehemalige kuratorische Assistentin Tami Simonian widmete sich diesem Projekt machte die Arbeit daran zu einem Vergnügen. Der redaktionelle Einfluss des Künstlers, Russell Fergusons, Midori Matsuis und anderer trugen dazu bei, den Inhalt und Stil der Texte zu verfeinern. Hans-Jürgen Schacht und Ralf Schauff haben die Übersetzung mit Bedachtsamkeit und Sensibilität vorgenommen. Schließlich war es die Partnerschaft mit Hatje Cantz, die nicht nur ein hervorragend produziertes Buch hervorgebracht hat, sondern obendrein ein Vertriebsnetz bereitstellt, das die Arbeiten Sam Durants einem vielfältigen internationalen Publikum zugänglich macht.

Das MOCA und der Kunstverein sind vielen Sammlern für die großzügigen Leihgaben dieser faszinierenden Arbeiten in der jeweiligen Ausstellung zu Dank verpflichtet, darunter Matt Aberle; Maria und Tim Blum; Blum & Poe; Paolo Consolandi; Creative Artists Agency; Sam Durant; Emi Fontana; Galerie Nordenhake; Galleria Emi Fontana; André und Jocelyne Gordts-Vanthournout; Clementina Hegewisch; Michael Heins; Kevin Heppner und Heather Convey; La Gala; Raffaele Martinelli; Mike Mehring, MOCA; Maurizio Morra Greco; G. Papadimitriou; Kelly und Jeffrey Poe; Laurence A. Rickels; Michael Ringier; Gaby und Wilhelm Schürmann; Barry Sloane; Barbara Thumm; Dean Valentine and Amy Adelson; Roberto Vollono; Joel Wachs; und zwei Sammlern, die anonym bleiben möchten. Tim Blum und Jeff Poe von Blum & Poe waren bei der Lokalisierung von Arbeiten äußerst hilfreich und besorgten die einschlägigen Informationen.

Die sichere und zügige Auslieferung der Arbeiten an das MOCA verdanken wir der Umsicht der Registrarassistentin Karen Hanus. Beaufsichtigt wurde die Installation mit äußerster Professionalität und Sensibilität von Brian Gray, Jang Park, Zazu Faure und David Bradshaw. Die Realisierung dieses Projektes wurde von den Mitarbeitern des Development Department des MOCA, im besonderen von Paul Johnson, Aandrea Stang, Michelle Bernardin und Stephanie Graham durch unermüdliche Bemühungen um die Finanzierung sichergestellt.

Im Kunstverein war die wissenschaftliche Mitarbeiterin Anette Freudenberger an der Realisierung dieser Ausstellung von den ersten Schritten an grundlegend beteiligt. Ohne ihr Engagement wäre die Ausstellung nicht möglich gewesen. Doris Rother und Sigrid Konopka widmeten sich unermüdlich den organisatorischen Herausforderungen der Ausstellung, und Ralf Werner, Klaus Wenner und Siegfried Verheyden installierten die komplexen Arbeiten Durants professionell und mit Feingefühl. Ihnen allen sei sehr herzlich gedankt, ebenso wie Vorstandsmitglied Rainer Zimmermann und der BBDO Germany für vielfältige engagierte Unterstützung. Vor allem aber schulden wir dem Sammler Wilhelm Schürmann Dank, der uns vor Jahren die Arbeit Durants vorgestellt hat. Sowohl er als auch Michael Kapinos teilten ihr Wissen freigiebig und waren in jeder Hinsicht äußerst hilfreich.

Besonders dankbar sind wir für die wunderbare Zusammenarbeit mit Sam Durant und hoffen, daß durch die beiden Ausstellungen und diese Veröffentlichung ein weites Publikum die Reichhaltigkeit seines Werkes schätzen lernt.

Übersetzung: Hans-Jürgen Schacht

SELECTED EXHIBITION CHRONOLOGY
AUSSTELLUNGEN (AUSWAHL)

M.F.A., California Institute of the Arts, Valencia, California, 1991
B.F.A., Massachusetts College of Art, Boston, 1986
Lives and works in Los Angeles

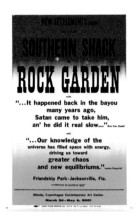
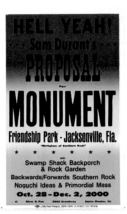
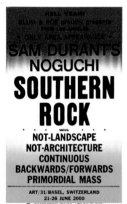
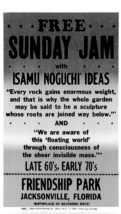
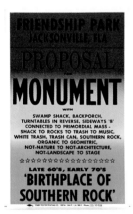

FRIENDSHIP PARK POSTERS, 2000/2001

SOLO EXHIBITIONS
EINZELAUSSTELLUNGEN

2003
Artist-in-Residence Installation, Walker Art Center, Minneapolis
Kunstverein für die Rheinlande und Westfalen, Düsseldorf (cat.)

2002
Blum & Poe, Santa Monica, California
Institute of Visual Arts, University of Wisconsin, Milwaukee
The Museum of Contemporary Art, Los Angeles (cat.)
Wadsworth Atheneum Museum of Art, Hartford, Connecticut

2001
Consciousness Raising Historical Analysis, Pain Plus Time Separated and Ordered with Emphasis on Reflection, Kunsthof Zürich, Zurich
Southern Tree, Tree of Knowledge, Dead Tree (part one), Galleria Emi Fontana, Milan

2000
Proposal for Monument in Friendship Park, Jacksonville, FL, Blum & Poe, Santa Monica, California
Tomio Koyama Gallery, Tokyo

1999
Altamont, Blum & Poe, Santa Monica, California
Into the Black, Kapinos–Galerie für Zeitgenössische Kunst, Berlin

1998
Ohio, Dogenhaus Projekte/Kapinos–Galerie für Zeitgenössische Kunst, Berlin (with Andrea Bowers)

1997
California Displacement Project: You Project Is What You Get, Curt Marcus Gallery, New York
MDF, Particle Board, Projection, Confusion, Grid-Like Structuring, Blum & Poe, Santa Monica, California

1995
Blum & Poe, Santa Monica, California
Roger Merians Gallery, New York

1994
Food House, Santa Monica, California

1992
Pardon Our Appearance..., Bliss, Pasadena, California
Right Now, Richard Green Gallery, Santa Monica, California

SELECTED GROUP EXHIBITIONS
GRUPPENAUSSTELLUNGEN (AUSWAHL)

2002

Artists Imagine Architecture, The Institute of Contemporary Art, Boston (cat.)

From the Observatory, Paula Cooper Gallery, New York (cat.)

Out of Place: Contemporary Art and the Architectural Uncanny, Museum of Contemporary Art, Chicago (cat.)

Prophets of Boom: Werke aus der Sammlung Schürmann, Staatliche Kunsthalle, Baden-Baden (cat.)

Rock My World: Recent Art and the Memory of Rock 'n' Roll, California College of Arts and Crafts Institute, San Francisco (cat.)

2001

Extra Art: A Survey of Artists' Ephemera, 1960–1999, California College of Arts and Crafts Institute, San Francisco (cat.)

Hemorrhaging of States, TENT., Rotterdam (cat.)

In Between: Art and Architecture, MAK Center for Art and Architecture, Los Angeles

New Settlements, Nikolaj Copenhagen Contemporary Art Center, Copenhagen

Playing Amongst the Ruins, Royal College of Art Galleries, London (cat.)

Recent Acquisitions Featuring the Norton Gift, Berkeley Art Museum, Berkeley, California

Record All-Over, Musée d'Art Moderne et Contemporain, Geneva

Superman in Bed: Kunst der Gegenwart und Fotografie, Die Sammlung Gaby und Wilhelm Schürmann, Museum am Ostwall, Dortmund, Germany

Take Two/Reprise, Ottawa Art Gallery, Ottawa, Canada (cat.)

You Don't Have to Have Cows to Be a Cowboy, Galerie im Parkhaus, Berlin

2000

All Things, Everything True, CRG Gallery, New York

D, Sandra Gering Gallery, New York

ForWart, L'Espace Culturel BBL, Brussels

L.A., Ileana Tounta Contemporary Art Centre, Athens

00: Drawings 2000 at Barbara Gladstone Gallery, Barbara Gladstone Gallery, New York (cat.)

1999

COLA: 1998-99 Individual Artists Grants Exhibition, Los Angeles Municipal Art Gallery, Barnsdall Art Park, Los Angeles (cat.)

Conceptual Art as Neurobiological Praxis, Thread Waxing Space, New York

i me mine, Luckman Fine Arts Gallery, California State University, Los Angeles

A Living Theatre, Salzburger Kunstverein, Salzburg (cat.)

Making History, Center for Curatorial Studies, Bard College, Annandale-on-Hudson, New York

Matthew Antezzo, Sam Durant, Dave Muller, Blum & Poe, Santa Monica, California

Other Narratives: Fifteen Years, Contemporary Arts Museum, Houston (cat.)

The Perfect Life: Artifice in L.A. 1999, Duke University Museum of Art, Durham, North Carolina (cat.)

Proliferation, The Museum of Contemporary Art, Los Angeles

What Your Children Should Know About Conceptualism, Neuer Aachener Kunstverein, Aachen, and Brandenburgischen Kunstverein, Potsdam, Germany

1998

Architecture & Inside, Paul Morris Gallery, New York

Entropy at Home, Suermondt Ludwig Museum, Aachen, Germany (cat.)

Family Viewing: Selections from the Permanent Collection, The Museum of Contemporary Art, Los Angeles

L.A. or Lilliput?, Long Beach Museum of Art, Long Beach, California (cat.)

Obviously 5 Believers, Action:Space, Los Angeles

Slipstream, Centre for Contemporary Art, Glasgow

Summary, Galerie Hoffman & Senn, Vienna

Trash, Los Angeles Municipal Art Gallery, Barnsdall Art Park, Los Angeles

Urban Romantics, Lombard-Freid Fine Arts, New York

1997

Chill, The Art Gallery, University of California, Irvine, California

Elusive Paradise: Los Angeles Art from the Permanent Collection, The Museum of Contemporary Art, Los Angeles

Her Eyes Are a Blue Million Miles, Three Day Weekend, Malmö, Sweden

Next, Blum & Poe, Santa Monica, California

Places That Are Elsewhere, David Zwirner, New York

Quartzose: 20 Los Angeles Artists, Galleri Tommy Lund, Odense, Denmark

Sam Durant and Anne Walsh, Four Walls, San Francisco

Scene of the Crime, UCLA at the Armand Hammer Museum of Art and Cultural Center, Los Angeles (cat.)

Summer of Love, Fotouhi Cramer Gallery, New York

1996

a/drift, Center for Curatorial Studies, Bard College, Annandale-on-
 Hudson, New York (cat.)

All Work–No Play, Acme, Santa Monica, California

*Just Past: The Contemporary in MOCA's Permanent Collection,
 1975–96*, The Museum of Contemporary Art,
 Los Angeles

Mod Squad, Spanish Box, Santa Barbara, California

The Palace of Good Luck, Burnett Miller Gallery, Los Angeles,
 California

*The Power of Suggestion: Narrative and Notation in Contemporary
 Drawing*, The Museum of Contemporary Art,
 Los Angeles (cat.)

Open House (with Andrea Bowers), Alyce de Roulet Williamson
 Gallery, Art Center College of Design, Pasadena,
 California (cat.)

True.BLISS., Los Angeles Contemporary Exhibitions,
 Los Angeles (cat.)

1995

Couldn't Get Ahead, Independent Art Space, London (cat.)

The Friendly Village, The Milwaukee Institute of Art & Design,
 Milwaukee

1994

The Game Show, Riverside Art Museum, Riverside, California

Gone, Blum & Poe, Santa Monica, California

Thanks, Three Day Weekend, Los Angeles

Thanks Again, Food House, Santa Monica, California

1993

Germinal Notations, Food House, Santa Monica, California

Heaven Missing: Young Art L.A., José Freire Fine Art, New York

Loose Slots, Temporary Contemporary, Las Vegas

Melancholic Consolation and Cynicism, Künstlerhaus Bethanien, Berlin,
 and Ruth Bloom Gallery, Santa Monica, California

Newport Biennial, Newport Harbor Art Museum, Newport Beach,
 California

1992

FAR Bazaar, Foundation for Art Resources, Federal Reserve
 Building, Los Angeles

Good Design, Nomadic Site, Pasadena, California

1991

4 Person Show, Parker Zanic Gallery, Los Angeles

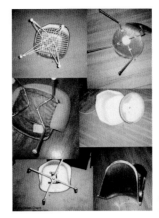

LEFT: *UPSIDE-DOWN CHAIRS*, 2000
OFFSET PRINT; 23 ½ x 16 ½ INCHES
COURTESY OF THE ARTIST AND BLUM & POE, SANTA MONICA

RIGHT: *CALIFORNIA DISPLACEMENT PROJECT: YOU PROJECT IS WHAT
YOU GET*, 1997
OFFSET PRINT; 22 x 17 INCHES
COURTESY OF THE ARTIST AND BLUM & POE, SANTA MONICA

NICHT-ORT, SKATOLOGIE, KATASTROPHEN TOD HABE ETWAS MITLEID, 1999
OFFSET PRINT; 23 ¼ x 34 INCHES
COURTESY OF THE ARTIST AND BLUM & POE, SANTA MONICA

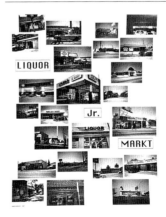

LEFT: *LIQUOR JR. MARKT*, 1997
OFFSET PRINT; 22 ½ x 17 INCHES
COURTESY OF THE ARTIST AND BLUM & POE, SANTA MONICA

RIGHT: *YOUR I WILL*, 1994
OFFSET PRINT; 22 x 17 INCHES
COURTESY OF THE ARTIST AND BLUM & POE, SANTA MONICA

CHECKLIST OF THE EXHIBITIONS
ARBEITEN IN DEN AUSSTELLUNGEN
* Denotes work in Kunstverein exhibition

Coffee Table, 1994–96
collage on photocopy
8 1/2 x 10 7/8 inches
THE MUSEUM OF CONTEMPORARY ART, LOS ANGELES. GIFT OF THE ARTIST

Karaoke, 1994
collage on photocopy
9 x 7 3/8 inches
COLLECTION OF BARRY SLOANE, LOS ANGELES

Kiddie's Room, 1994
mixed media on photocopy
10 1/2 x 8 1/4 inches
THE MUSEUM OF CONTEMPORARY ART, LOS ANGELES. GIFT OF THE ARTIST

Love Seat, 1994
collage on photocopy
8 1/2 x 7 1/2 inches
THE MUSEUM OF CONTEMPORARY ART, LOS ANGELES. GIFT OF THE ARTIST

Modern Moon, 1994
collage on photocopy
7 1/2 x 10 inches
THE MUSEUM OF CONTEMPORARY ART, LOS ANGELES. GIFT OF THE ARTIST

Solid Bodies, 1994
acrylic on photocopy
7 1/2 x 10 1/4 inches
COLLECTION OF LAURENCE A. RICKELS, LOS ANGELES

Abandoned House #1, 1995
foam core, cardboard, Plexiglas, tape, spray enamel, wood, and metal
30 x 30 1/4 x 5 inches
COLLECTION OF DEAN VALENTINE AND AMY ADELSON, LOS ANGELES

Abandoned House #2, 1995
foam core, cardboard, Plexiglas, tape, spray enamel, wood, and metal
33 x 42 1/2 x 4 3/4 inches
COLLECTION OF BARRY SLOANE, LOS ANGELES

Abandoned House #3, 1995
foam core, cardboard, Plexiglas, tape, spray enamel, wood, and metal
32 x 32 x 4 1/2 inches
THE MUSEUM OF CONTEMPORARY ART, LOS ANGELES
GIFT OF MICHAEL A. MEHRING

Abandoned House #4, 1995
foam core, cardboard, Plexiglas, tape, spray enamel, wood, and metal
25 1/2 x 41 x 4 1/2 inches
THE MUSEUM OF CONTEMPORARY ART, LOS ANGELES
GIFT OF MICHAEL A. MEHRING

Abandoned House #5, 1995
foam core, cardboard, Plexiglas, tape, spray enamel, wood, and metal
19 1/2 x 43 x 8 1/2 inches
COLLECTION OF THE ARTIST

Abandoned House #6, 1995
foam core, cardboard, Plexiglas, tape, spray enamel, wood, and metal
30 1/2 x 23 3/4 x 4 1/2 inches
THE MUSEUM OF CONTEMPORARY ART, LOS ANGELES
GIFT OF MICHAEL A. MEHRING

Beer Bong, 1995
collage on photocopy
8 x 10 inches
COLLECTION OF MARIA AND TIM BLUM, LOS ANGELES

Cabinets, 1995
collage on photocopy
four pieces; 10 1/2 x 8 1/4 inches each
COLLECTION OF CREATIVE ARTISTS AGENCY, BEVERLY HILLS

Chair A, 1995
collage on photocopy
13 3/4 x 11 1/4 inches
COLLECTION OF MATT ABERLE, LOS ANGELES

Chair B, 1995
collage on photocopy
13 3/4 x 11 1/4 inches
COLLECTION OF MATT ABERLE, LOS ANGELES

Chair #1–6, 1995
c-print; edition 3/3
six works, 16 x 20 inches each
COURTESY OF BLUM & POE, SANTA MONICA

Chandelier, 1995
collage on photocopy
10 7/8 x 8 3/8 inches
COLLECTION OF KELLY AND JEFFREY POE, MAR VISTA, CALIFORNIA

Chester Field, 1995–96
collage on photocopy
10 3/4 x 8 3/8 inches
THE MUSEUM OF CONTEMPORARY ART, LOS ANGELES. GIFT OF THE ARTIST

Desert Chair, 1995
collage on photocopy
6 3/4 x 7 inches
THE MUSEUM OF CONTEMPORARY ART, LOS ANGELES. GIFT OF THE ARTIST

Entertainment Center, 1995
collage on photocopy
10 5/8 x 7 3/4 inches
THE MUSEUM OF CONTEMPORARY ART, LOS ANGELES. GIFT OF THE ARTIST

Jack in the Box, 1995
collage on photocopy
10 $^7/_0$ x 8 $^3/_0$ inches
COLLECTION OF BARRY SLOANE, LOS ANGELES

Knoll Chandelier, 1995
collage on photocopy
8 x 8 inches
THE MUSEUM OF CONTEMPORARY ART, LOS ANGELES. GIFT OF THE ARTIST

Known Associate, 1995
collage on photocopy
7 $^1/_2$ x 9 $^7/_8$ inches
COLLECTION OF THE ARTIST

Pie, 1995
collage on photocopy
9 $^1/_2$ x 12 $^1/_2$ inches
COLLECTION OF JOEL WACHS

Pink House, 1995
watercolor and paint on photocopy
10 $^7/_8$ x 8 $^1/_2$ inches
THE MUSEUM OF CONTEMPORARY ART, LOS ANGELES. GIFT OF THE ARTIST

Yellow Lamp, 1995
collage on photocopy
10 $^7/_8$ x 8 $^3/_4$ inches
THE MUSEUM OF CONTEMPORARY ART, LOS ANGELES. GIFT OF THE ARTIST

Formless, Swirling, 1998
graphite on paper
30 x 22 inches
COLLECTION OF MICHAEL RINGIER, ZURICH

Gimme Shelter, 1998
graphite on paper
20 x 24 inches
COLLECTION OF THE ARTIST

Into the Black/Rockstar, 1998
graphite on paper
30 x 22 inches
COLLECTION OF DEAN VALENTINE AND AMY ADELSON, LOS ANGELES

It's Better to Burn Out Than Fade Away, 1998
graphite on paper
22 x 30 inches
COLLECTION OF DEAN VALENTINE AND AMY ADELSON, LOS ANGELES

**Landscape #1 (Soul Survivor)*, 1998
graphite on paper
22 $^1/_2$ x 30 inches
COLLECTION CLEMENTINA HEGEWISCH, BERLIN
COURTESY KAPINOS GALERIE, BERLIN

Let It Loose/Woodshed, 1998
graphite on paper
22 x 30 $^1/_2$ inches
GABY AND WILHELM SCHÜRMANN, AACHEN, GERMANY

**Live Rust #1 (Woodshed)*, 1998
graphite on paper
30 x 22 $^1/_2$ inches
COLLECTION CLEMENTINA HEGEWISCH, BERLIN
COURTESY KAPINOS GALERIE, BERLIN

**1970 (May 4th Kent/Woodshed)*, 1998
graphite on paper
22 $^1/_2$ x 30 inches
COLLECTION CLEMENTINA HEGEWISCH, BERLIN
COURTESY KAPINOS GALERIE, BERLIN

**Partially Buried 1960s/70s Utopia Reflected
(Wavy Gravy at Woodstock)*, 1998
*Partially Buried 1960s/70s Dystopia Revealed
(Mick Jagger at Altamont)*, 1998
mirror, dirt, and audio system
20 x 84 x 40 inches each
COURTESY OF BLUM & POE, SANTA MONICA

Quaternary Field/Associative Diagram, 1998
graphite on paper
22 x 29 $^1/_2$ inches
GABY AND WILHELM SCHÜRMANN, AACHEN, GERMANY

Rosalind Krauss, 1998
graphite on paper
30 x 22 inches
COLLECTION OF BARBARA THUMM, BERLIN

**Twelve Dirt Lump Drawings*, 1998
Dirt Lump #1 (4 Dead in Ohio Mirrored)
Dirt Lump #2 (Out of the Blue Upside Down)
Dirt Lump #3 (Formless, Gimme Shelter)
Dirt Lump #4 (Part. Buried 4 Dead in Ohio)
Dirt Lump #5 (What's My Name)
Dirt Lump #7 (It's Better to Burn Out Mirrored)
Dirt Lump #8 (Entropy Mirrored)
Dirt Lump #9 (Kent State)
Dirt Lump #10 (Allegorical Landscape)
Dirt Lump #11 (Salt of the Earth)
Dirt Lump #12 (Entropy)
Dirt Lump #13 (You're to Blame)
graphite on paper
22 $^1/_2$ x 30 inches each
GABY AND WILHELM SCHÜRMANN, AACHEN, GERMANY

**We're Finally*, 1998
graphite on paper
22 x 30 $^1/_2$ inches
GABY AND WILHELM SCHÜRMANN, AACHEN, GERMANY

*What's Underneath Must Be Released and
Examined to Be Understood*, 1998
mirrors, earth, fog machine, and mixed media
32 x 44 1/2 x 64 1/2 inches
GABY AND WILHELM SCHÜRMANN, AACHEN, GERMANY

Altamont, 1999
mirror and felt
60 x 324 x 8 inches
COURTESY GALERIE NORDENHAKE, BERLIN

Brown Sugar Rundown, 1999
graphite on paper
22 x 30 inches
COURTESY OF BLUM & POE, SANTA MONICA

Cave-In Model Projection Site, 1999
c-print; edition 2/3
40 x 50 inches
GABY AND WILHELM SCHÜRMANN, AACHEN, GERMANY

Counterclockwise, 1999
graphite on paper
22 x 30 inches
COLLECTION OF KEVIN HEPPNER AND HEATHER CONVEY, CHICAGO

Glue Horizon, 1999
graphite on paper
22 x 30 inches
THE MUSEUM OF CONTEMPORARY ART, LOS ANGELES. PURCHASED WITH
FUNDS PROVIDED BY THE ANDY WARHOL FOUNDATION FOR THE VISUAL ARTS,
INC., AND COUNCILMAN JOEL WACHS

Into the Black, 1999
mirror and felt
34 x 240 x 8 inches
COLLECTION OF CLEMENTINA HEGEWISCH, BERLIN
COURTESY KAPINOS GALERIE, BERLIN

It's Better to Burn Out Than Fade Away (Smithson/Stones), 1999
graphite on paper
30 x 22 inches
GABY AND WILHELM SCHÜRMANN, AACHEN, GERMANY

Landscape/Shit Covered, 1999
graphite on paper
22 x 30 inches
COURTESY OF BLUM & POE, SANTA MONICA

Model I, 1999
cardboard, wood, and mirror
44 3/4 x 30 1/2 x 5 3/4 inches
COLLECTION OF CLEMENTINA HEGEWISCH, BERLIN
COURTESY KAPINOS GALERIE, BERLIN

Neil Young #2, 1999
graphite on paper
30 x 22 inches
GABY AND WILHELM SCHÜRMANN, AACHEN, GERMANY

Proposal for Monument at Altamont Raceway, Tracy, CA, 1999
polyurethane foam, acrylic, wood, steel, speakers, CD player,
and hardware
69 x 74 x 100 inches
THE MUSEUM OF CONTEMPORARY ART, LOS ANGELES. PARTIAL GIFT OF
GABY AND WILHELM SCHÜRMANN

Reflected Upside Down and Backwards, 1999
wood, acrylic, asphalt, and CD players
26 x 84 x 50 inches
GABY AND WILHELM SCHÜRMANN, AACHEN, GERMANY

Taste Good/Mirrored, 1999
graphite on paper
22 x 30 inches
THE MUSEUM OF CONTEMPORARY ART, LOS ANGELES. PURCHASED WITH
FUNDS PROVIDED BY THE ANDY WARHOL FOUNDATION FOR THE VISUAL ARTS,
INC., AND COUNCILMAN JOEL WACHS

Tranference, 1999
c-print; edition 3/3
40 x 50 inches
COLLECTION OF G. PAPADIMITRIOU, ATHENS

Upside Down and Backwards, Completely Unburied, 1999
wood, asphalt, roofing, acrylic, CD players, and CDs
dimensions variable
COLLECTION OF DEAN VALENTINE AND AMY ADELSON, LOS ANGELES

What's the Opposite of Entropy?, 1999
c-print; edition 2/3
40 x 50 inches
COLLECTION ANDRÉ AND JOCELYNE GORDTS-VANTHOURNOUT,
KORTRIJK, BELGIUM

Akari and Rock Pile, 2000
ink on paper
18 x 23 1/2 inches
COURTESY OF BLUM & POE, SANTA MONICA

Backporch Combination, 2000
ink and collage on paper
18 x 24 inches
COLLECTION OF MIKE MEHRING, LOS ANGELES

Cabin, Rock Garden, Trash Can, 2000
collage and adhesive tape on photocopy
8 1/2 x 11 inches
COURTESY OF BLUM & POE, SANTA MONICA

Fiberglass Rock Garden, 2000
collage and adhesive tape on photocopy
8 1/2 x 11 inches
COURTESY OF BLUM & POE, SANTA MONICA

Friendship Park Posters, 2000/2001
offset lithographs
five works; 22 x 14 inches each
COURTESY OF THE ARTIST AND BLUM & POE, SANTA MONICA

Friendship Park–Primordial Mass, 2000
ink and collage on paper
18 x 23 ¹/₂ inches
COURTESY OF BLUM & POE, SANTA MONICA

Friendship Park Stage Sets, 2000
ink and collage on paper
18 x 23 ¹/₂ inches
COURTESY OF BLUM & POE, SANTA MONICA

Friendship Park Vocabulary, 2000
ink and collage on paper
18 x 24 inches
COLLECTION OF MIKE MEHRING, LOS ANGELES

Friendship Park with Flags, 2000
ink and collage on paper
18 x 23 ¹/₂ inches
COURTESY OF BLUM & POE, SANTA MONICA

Friendship Park/Y'all Shine, 2000
ink and collage on paper
18 x 23 ¹/₂ inches
COURTESY OF BLUM & POE, SANTA MONICA

Garden and Waste Receptacle, 2000
collage and adhesive tape on photocopy
11 x 8 ¹/₂ inches
COURTESY OF BLUM & POE, SANTA MONICA

Major Connections, 2000
ink and collage on paper
18 x 23 ¹/₂ inches
COURTESY OF BLUM & POE, SANTA MONICA

Noguchi with Breakthrough/Trashcan, 2000
collage and adhesive tape on photocopy
11 x 8 ¹/₂ inches
COURTESY OF BLUM & POE, SANTA MONICA

Noguchi's Scatological and Erotic, 2000
ink and collage on paper
18 x 23 ¹/₂ inches
COURTESY OF BLUM & POE, SANTA MONICA

Parson's House with Cabin, 2000
collage and adhesive tape on photocopy
8 ¹/₂ x 11 inches
COURTESY OF BLUM & POE, SANTA MONICA

**Progression from Organic to Geometric*, 2000
(sound with Takeshi Kagami)
fiberglass, audio system, and CD soundtrack; edition 1/2
48 x 48 x 225 inches
GABY AND WILHELM SCHÜRMANN, AACHEN, GERMANY

Proposal for Monument in Friendship Park, Jacksonville, FL, 2000
wood, fiberglass, paint, aluminum, glass, paper, audio
system, turntables, record albums, plastic, metal, trash can,
and miscellaneous hardware
dimensions variable
COURTESY OF BLUM & POE, SANTA MONICA

Wandering Rocks with Noguchi, 2000
collage on photocopy
8 ¹/₂ x 11 inches
COURTESY OF BLUM & POE, SANTA MONICA

**Bobby Seale, Co-Founder of the Black Panther Party
for Self-Defense*, 2001
graphite on paper
50 x 38 inches
PRIVATE COLLECTION, TURIN
COURTESY GALLERIA EMI FONTANA, MILAN

**A Garbage Dump Doesn't Need to Grow Trees to Reach the Heavens,
the Fumes Rise and Rise*, 2001
graphite on paper
50 x 38 inches
COLLECTION ROBERTO VOLLONO, NAPLES

**Heap of Language (Soul on Ice)*, 2001
graphite on paper
38 x 50 inches
COLLECTION RAFFAELE MARTINELLI, MILAN

**Language Ceaselessly Reinstates the New Terrain
on the Oldest Order*, 2001
graphite on paper
50 x 38 inches
COLLECTION MAURIZIO MORRA GRECO, NAPLES

**Like, Man, I'm Tired of Waiting*, 2001
electric sign and vinyl letters; edition 3/3
59 ¹/₈ x 65 ³/₄ x 8 ⁵/₈ inches
GABY AND WILHELM SCHÜRMANN, AACHEN, GERMANY

**Standing on Our Head*, 2001
graphite on paper
50 x 38 inches
COLLECTION PAOLO CONSOLANDI, MILAN

**Standing Upside Down*, 2001
graphite on paper
50 x 38 inches
PRIVATE COLLECTION, ROME
COURTESY GALLERIA EMI FONTANA, MILAN

To Change Terrain, Discontinuous and Irruptive, by Brutally Placing Oneself Outside, 2001
graphite on paper
50 x 38 inches
COLLECTION LA GALA, CUNEO

Atlanta, 1960, 2002
graphite on paper
20 x 15 inches
COURTESY BLUM & POE, SANTA MONICA, AND GALLERIA EMI FONTANA, MILAN

Civil Rights March, Wash. DC, 1963, 2002
graphite on paper
15 x 20 inches
COURTESY BLUM & POE, SANTA MONICA, AND GALLERIA EMI FONTANA, MILAN

Direction Through Indirection (Outerspace Employment Agency by Sun Ra), 2002
fiberglass, polyurethane, acrylic, wood, and audio system
38 x 52 x 56 inches
COURTESY GALLERIA EMI FONTANA, MILAN

Echoplex Joseph Beuys Ideas/Crash, Fat, Felt, Amerika, Politics, Recovery, Monument, 2002–03
vitrines, books, audio equipment, video, polyurethane foam, synthetic felt, magazines, paper, photocopies, plastic, and acrylic
dimensions variable
COURTESY OF THE ARTIST

Freedom March from Selma to Montgomery, 1965, 2002
graphite on paper
15 x 20 inches
COURTESY BLUM & POE, SANTA MONICA, AND GALLERIA EMI FONTANA, MILAN

Justice, 2002
electric sign and vinyl letters; edition 1/3
38 x 70 inches
COURTESY BLUM & POE, SANTA MONICA, AND GALLERIA EMI FONTANA, MILAN

Let's Judge Ourselves as People, 2002
electric sign and vinyl letters; edition 1/3
69 x 48 inches
COURTESY BLUM & POE, SANTA MONICA, AND GALLERIA EMI FONTANA, MILAN

Miss America Pageant, Atlantic City, 1968, 2002
graphite on paper
15 x 20 inches
COURTESY BLUM & POE, SANTA MONICA, AND GALLERIA EMI FONTANA, MILAN

See You in Chicago in August, 2002
electric sign and vinyl letters; edition 1/3
53 1/2 x 44 inches
COURTESY BLUM & POE, SANTA MONICA, AND GALLERIA EMI FONTANA, MILAN

Student Strike, UC Berkeley, 1969, 2002
graphite on paper
20 x 15 inches
COURTESY BLUM & POE, SANTA MONICA, AND GALLERIA EMI FONTANA, MILAN 119

Tell It Like It Is, 2002
electric sign and vinyl letters; edition 1/3
58 x 64 inches
COURTESY BLUM & POE, SANTA MONICA, AND GALLERIA EMI FONTANA, MILAN

Untitled, 2002
graphite on paper
20 x 15 inches
COURTESY BLUM & POE, SANTA MONICA, AND GALLERIA EMI FONTANA, MILAN

Upside Down: Pastoral Scene, 2002
fiberglass, wood, mirror, acrylic paint, and audio equipment
twelve works: mirrors 48 x 48 inches each; trees 36 to 55 x 60 to 30 inches each
COURTESY OF BLUM & POE, SANTA MONICA. PROJECT SUPPORTED IN PART BY THE CALIFORNIA INSTITUTE OF THE ARTS SCHOOL OF ART FACULTY DEVELOPMENT FUND

U.S. Historians, 2002
electric sign and vinyl letters; edition 1/3
40 x 82 inches
COURTESY BLUM & POE, SANTA MONICA, AND GALLERIA EMI FONTANA, MILAN

U.S. History (Blues for Abraham Lincoln), 2002
fiberglass, wood, acrylic, mirror, and audio system
44 x 44 x 53 inches
COLLECTION EMI FONTANA

Wash. DC, 1968, 2002
graphite on paper
15 x 20 inches
COURTESY BLUM & POE, SANTA MONICA, AND GALLERIA EMI FONTANA, MILAN

Welcome Back, 2002
electric sign and vinyl letters; edition 1/3
48 x 58 inches
COURTESY BLUM & POE, SANTA MONICA, AND GALLERIA EMI FONTANA, MILAN

What Is the State? (Police State by Dead Prez from Let's Get Free, 2000 Loud Records), 2002
fiberglass, wood, acrylic, mirror, and audio system
44 x 42 x 50 inches
COLLECTION MICHAEL HEINS, AACHEN, GERMANY

SELECTED BIBLIOGRAPHY
BIBLIOGRAPHIE (AUSWAHL)

Auerbach, Lisa Anne. "Sam Durant at Blum & Poe." *Artforum* 34, no. 5 (January 1996): 89.

Campbell, Clayton. "Sam Durant at Blum & Poe." *Flash Art* 33, no. 210 (January/February 2000): 118.

Coles, Alex. "Revisiting Robert Smithson in Ohio: Tacita Dean, Sam Durant and Renée Green." *Parachute*, no. 104 (October/December 2001): 128–37.

Comer, Stuart. "Interview with Sam Durant." *Untitled* (London), no. 24 (spring 2001): 7–9.

Greene, David A. "Sam Durant at Blum & Poe," *Art issues*, no. 41 (January/February 1996): 46.

Hettig, Frank-Alexander. "Sam Durant." *Metropolis M* (Amsterdam) (June/July 2000): 50–53.

Ichihara, Kentaro. "Sam Durant." *Bijutsu Techō* (Tokyo) (March 2001): 146–52.

Joyce, Julie. "Sam Durant at Blum & Poe." *Art issues*, no. 60 (November/December 1999): 45.

Kastner, Jeffrey. "Sam Durant at Roger Merians, New York." *frieze*, no. 23 (summer 1995): 69–70.

Knight, Christopher. "Deconstruction." *Los Angeles Times*, 28 October 1995, F6.

Mariño, Melanie. "Sam Durant at Roger Merians." *Art in America* 83, no. 7 (July 1995): 82–83.

Meyer, James. "Impure Thoughts: The Art of Sam Durant." *Artforum* 38, no. 8 (April 2000): 112–17.

Miles, Christopher. "Sam Durant: Going with the Flow." *art/text*, no. 63 (November 1998/January 1999): 48–53.

———. "Sam Durant at Blum & Poe." *Artforum* 38, no. 3 (November 1999): 148.

Pagel, David. "Self-Help Culture Skewered at Food House." *Los Angeles Times*, 21 April 1994, F7.

———. "Sam Durant Takes a Look Back(ward) at Social History." *Los Angeles Times*, 24 September 1999, F26.

Schmerler, Sarah. "Sam Durant at Curt Marcus." *Artnews* 96, no. 10 (November 1997): 226.

Schöllhammer, Georg. "A Living Theater." *Springerin* (Vienna) (September/November 1999): 72–73.

PHOTOGRAPHY CREDITS
FOTONACHWEIS

All photographs appear courtesy of the artist and Blum & Poe, Santa Monica. The following list, keyed to page numbers, applies to images for which a separate acknowledgment is due:

Collection Walker Art Center, Minneapolis, McKnight Acquisition Fund, 1998, pp. cover, 14, 54–55; Courtesy The Museum of Contemporary Art, Los Angeles, photo: Brian Forrest, pp. 5, 16–17, 25, 40, 42, 46 right, 56 bottom, 58, 86, 101; Courtesy Creative Artists Agency, Beverly Hills, p. 8; Courtesy the artist and Patrick Painter, Inc., Santa Monica, p. 12 center and right; © Estate of Robert Smithson/Licensed by VAGA, New York, pp. 19 bottom, 24 bottom, 28, 63 bottom; Josh White, pp. 19 center, 20–21, 24 top, 26 bottom, 77–78, 84, 99; Courtesy JPMorgan Chase Archives, p. 26 center both; © Roberto Marossi Fotografo, Milano, pp. 30, 52 all, 63 top, 71, 89, 105; Courtesy Metro Pictures, p. 34 left; Courtesy The Library of Congress, p. 49 top left; © Kevin Noble, published with permission of The Isamu Noguchi Foundation, Inc., p. 49 bottom; Shigeo Anzai, p. 51; Courtesy Wadsworth Atheneum Museum of Art, photo: John Groo, pp. 53, 109; © Museum of Contemporary Art, Chicago, p. 56 top; © 2002 Estate of Gordon Matta-Clark/Artists Rights Society (ARS), New York, p. 66; © James Isberner Photography, Chicago, p. 73; © Manfred Tischer, Düsseldorf/VG Bild-Kunst, Bonn 2002, p. 79; and © 2002 The Andy Warhol Foundation for the Visual Arts/Artists Rights Society (ARS), New York. Elvis and Elvis Presley are registered trademarks of Elvis Presley Enterprises, Inc., p. 102.